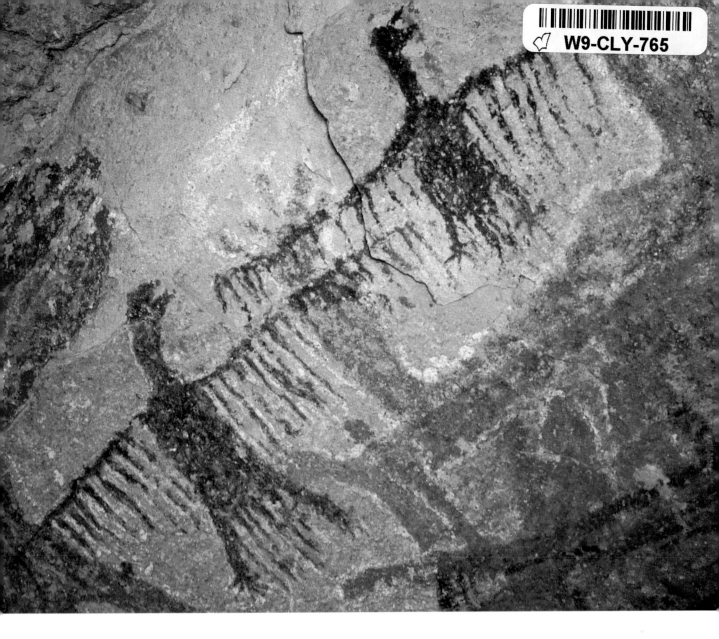

World Rock Art

Jean Clottes

Translated from the French by Guy Bennett

The Getty Conservation Institute
Los Angeles

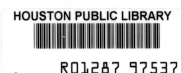
The Getty Conservation Institute works internationally to advance conservation and to enhance and encourage the preservation and understanding of the visual arts in all of their dimensions—objects, collections, architecture, and sites. The Institute serves the conservation community through scientific research; education and training; field projects; and the dissemination of the results of both its work and the work of others in the field. In all its endeavors, the Institute is committed to addressing unanswered questions and promoting the highest possible standards of conservation practice.

This is the sixth volume in the Conservation and Cultural Heritage series, which aims to provide information in an accessible format about selected culturally significant sites throughout the world. Previously published are *El Pueblo: The Historic Heart of Los Angeles* (2002); *Cave Temples of Mogao: Art and History on the Silk Road* (2000); *Palace Sculptures of Abomey: History Told on Walls* (1999); *The Los Angeles Watts Towers* (1997); and *House of Eternity: The Tomb of Nefertari* (1996).

Copyright 2002 The J. Paul Getty Trust
Getty Publications
1200 Getty Center Drive
Los Angeles, California 90049-1682
www.getty.edu

Chris Hudson, *Publisher*
Mark Greenberg, *Editor in Chief*
Ann Lucke, *Managing Editor*

Tevvy Ball, *Project Editor and Series Editor*
Sheila Berg, *Copy Editor*
Jim Drobka, *Designer*
Anita Keys, *Production Coordinator*
Vicki Sawyer Karten, *Series Designer*

Library of Congress Cataloging-in-Publication Data

Clottes, Jean.
 [Musée des roches. English]
 World Rock Art / Jean Clottes ; translated from the French by Guy
Bennett.
 p. cm.
 Includes bibliographical references.
 ISBN 0-89236-682-6 (pbk.)
 1. Art, Prehistoric. 2. Rock paintings. 3. Cave paintings.
 I. Title.
 N5310 .C5813 2002
 709′.01′13—dc21

 2002008893

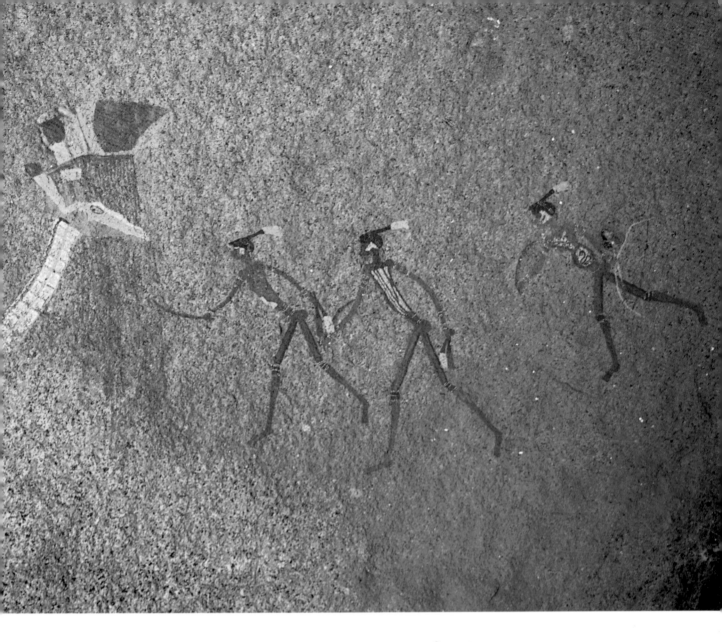

Contents

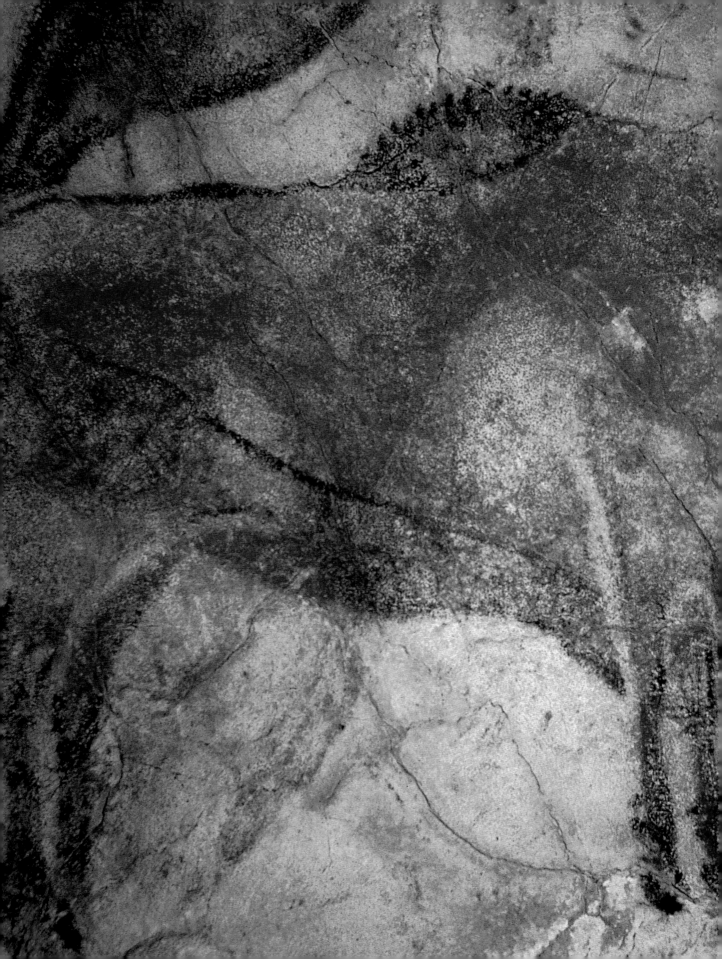

A MYSTERIOUS ART

One afternoon in 1879, a young girl was accompanying her father while he was excavating a cave at Altamira, in Santander Province in northern Spain. No doubt slightly bored, Maria started looking around, and she soon noticed strange images of animals that, in the glowing light of the lantern she was holding, seemed to dance across the ceiling (FIGURE 1.1). "Look, Papa," she excitedly exclaimed. "Oxen!"

FIGURE 1.1
This red and black bison is one of many covering the Great Ceiling of the Altamira cave, in Spain.
Photo by L. de Seille

Maria's father, Marcelino Sanz de

Sautuola, was a well-known lawyer and an enthusiastic amateur archaeologist who had an estate nearby—the main reason he had chosen to excavate here. The cave had been discovered in 1868, when a dog, followed soon by its master, ventured inside, but nobody had really explored it until Sanz de Sautuola began working some ten years later. He had recently visited the 1878 Universal Exhibition in Paris, where he had seen exhibits of movable art—images on bones, antlers, and so on—dating to the Old Stone Age. Some of these featured images of bison, a species that had long vanished from Spain. Now, after hearing his daughter's exclamation, when he beheld the spectacular paintings of bison and other animals thronging the low ceiling, he realized that they must also be from the Paleolithic—specifically, from the most recent Ice Age, more than twelve thousand years earlier.

To admit that the stupendous art on the ceiling at Altamira was in fact this old required an extraordinary conceptual leap. Scientific dating techniques would not be

developed for rock art for more than a century. And although a few painted caves from the Ice Age had already been found in France, they had not yet been recognized as the first known examples of an art stretching over millennia back into remote prehistory. In 1880, with characteristic courage and modesty, Sanz de Sautuola published *Breves apuntes sobre algunos objetos prehistóricos de la provincia de Santander* (Brief notes about a few prehistoric finds in Santander Province). The publication would generate a heated controversy about the authenticity of the paintings he had found, and it would eventually result in a thorough reappraisal of the artistic abilities of our prehistoric forefathers.

By this time paintings and engravings on stone had already been noticed in various parts of the world. In Sweden, for example, in the seventeenth century, a schoolmaster named Peder Alfssön had made copies of prehistoric rock carvings in the Bohuslän area, which has since gained wide recognition and is now a UNESCO World Heritage site. Important rock art sites had also attracted attention in countries as distant as China, Australia, and South Africa. In the course of the next century, many decorated caves would be discovered throughout the world. Those in France and Spain, such as Lascaux, discovered in 1940, Chauvet, discovered in 1994, and, of course, Altamira, have gained particular renown. Important new sites are still being found, such as Cussac, discovered in 2000 in the Périgord region of France.

While many books exist for rock art specialists, and there are fine, richly illustrated volumes covering particular areas and sites, there currently exist few illustrated surveys for a general audience of this remarkable heritage worldwide. This is likely because a fully comprehensive treatment would be virtually impossible, owing to the vastness of the subject. It is possible, however, to provide

FIGURE 1.2
A startling profusion of animal and human figures crowds this immense mural at Cueva Pintada, a 500-foot-long recess in a cliff in the Sierra de San Francisco, Baja California Sur, Mexico. The rock art of Baja was made by a prehistoric people who lived in the region many hundreds—or perhaps thousands—of years ago and who have long since disappeared. They are now known largely through the remarkable paintings they left behind. The rock art of Baja is on the UNESCO World Heritage List.
Photo by J. Clottes

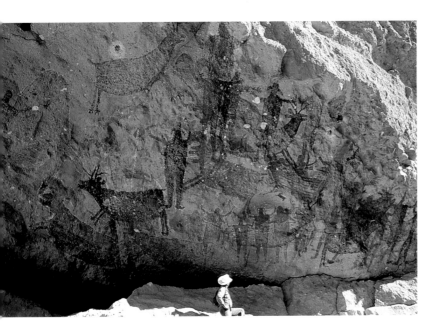

an overview that might help people to understand and appreciate this unique form of cultural and aesthetic wealth (FIGURE 1.2).

The term *rock art* refers to the oldest form of artistic expression, examples of which exist on all continents and in all eras. Rock art can be found from the Arctic Circle to the tip of South America, from the caverns of southwestern France and the arid deserts of Africa to the deep canyons of the southwestern United States. It stretches in time from perhaps forty thousand or fifty thousand years ago, although precise dates are still uncertain, to the nineteenth and even the twentieth century. Probably beginning with Cro-Magnon man, the direct ancestor of modern humans, it reflects the origins of our artistic sensibility, of the basic human impulse to communicate, to create,

to depict, to influence the course of life. In short, rock art offers a testimony provided by no other form of artistic representation.

Art is used here in the broadest sense. Any drawing made on a stone surface, whatever the technique used to create it, is generally considered rock art. The genre includes pictograms (paintings) and petroglyphs (engravings) of recognizable forms, splendidly realistic depictions of animals and humans, mysterious abstract motifs, and complex geometric patterns. It also includes scrawls, cupules (small hollows), and lines that do not bear any obvious meaning or present any recognizable aesthetic interest for us today. Indeed, many specialists take issue with the word *art* used in this context, even if for convenience they themselves use it (FIGURE 1.3).[1]

FIGURE 1.3
A great frieze of engravings adorns this cliff face in Chad, in the southern Sahara. The carved silhouettes of cattle have been filled in with geometric patterns and images of people. Although their exact age is unknown, these petroglyphs date to what is called the Pastoral Period, five or six thousand years ago, when much of the Sahara, irrigated by a northward expansion of equatorial monsoons, was much more verdant than it is today.
Photo by David Coulson, Trust for African Rock Art (TARA)

Moreover, in certain traditional societies there is no word for *art* or *artist*. For them, the creative act is more important than the result. Certain Australian aboriginal groups, for example, while fascinated by the meanings and beauty of these images on stone, believe that the individual artist who created them "is only an agent of the Dreaming"— the collective ancestral past that "instituted all the aspects of their culture,"[2] existing before humans and yet reaching into and influencing the present. As opposed to modern Western society, whose emphasis is on individual artistic vision and the consumer culture surrounding the artistic object, art for them is the expression of ancient group values.

Rock art, therefore, must be considered in its cultural context. The cultures that produced it have done so within the framework of their worldviews and their customs. For contemporary indigenous peoples, this art is still a living thing, an inherently sacred part of their beliefs that links them to their ancestors and to the domain of supernatural spirits. In Australia, the repainting of the art is occasionally practiced today as a way of ensuring its continuing "power." Rock art also still plays an important role in traditional cultures in some areas of the western United States, Africa, and South America. For example, contemporary rituals to ward off catastrophes such as drought or famine have recently been reported at a rock art site situated on an island of Lake Victoria in Kenya.[3] In Bolivia, the Aymara have testified to contemporary sacrifices of sheep and llamas at rock art sites.[4] In the 1980s, during a rebellion of the Tuareg in Niger, thousand-year-old engravings in the Aïr Mountains in the northeast of the country, where the rebellion was centered, were painted white, supposedly to increase their power (FIGURE 1.4 A,B).[5] In the Bhimbetka, not far

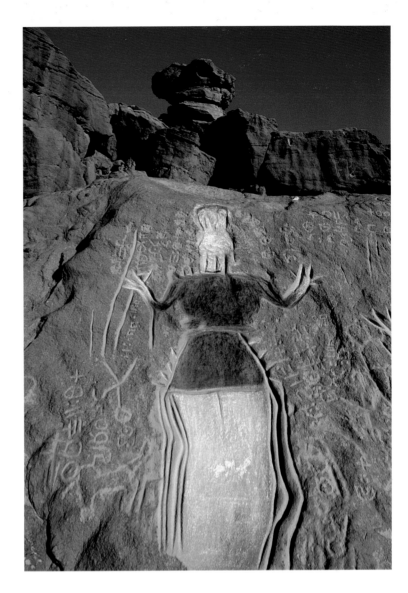

from Bhopal in central India (Madhya Pradesh), daily offerings are made in painted shelters.[6] Clearly, for such people, rock art continues to bear meaning and power.

But questions remain. Why do we, who belong to other civilizations and may not share these beliefs, although we certainly respect them, take from this art such a feeling of the sacred? Why are we stirred by emotion when we encounter these ancient, mysterious engravings and paintings? What could possibly be relevant about this often incomprehensible art? Is it the domain of those who specialize in lost civilizations, or might it interest anyone? What values can it have in our modern culture? And why do

FIGURE 1.4 A,B
These thousand-year-old engravings, seen in long view (opposite) and in detail (above), apparently portray dancing women. Located near the summit of a mountaintop ridge in the Aïr Mountains of Niger, they have recently been painted in black and white—according to some accounts, by passing caravans to bring them good luck; according to others, by local people as part of certain rituals. Bullet holes suggest that the figures may have been used for target practice, probably during a recent rebellion.

Photos by David Coulson, Trust for African Rock Art (TARA)

FIGURE 1.5
In South Africa, the vast landscapes of the veld dwarf the figures of a group of researchers, who have come to study the extraordinary rock art found in the shelters of the great escarpments of the Drakensberg.

Photo by Neville Agnew

ever-growing numbers of visitors, driven by motivations conscious or instinctive, travel to rock shelters located in some of the world's remotest places? This art must evoke a wide range of experiences.

First, there is the feeling of mystery and pathos. Visitors are intrigued; they attempt to decipher the images, to recognize the figures shown. They inevitably have endless questions about what the art means. They become aware of the passage of time, of the mortality of cultures, of the disappearance of former ways of life. In the painted shelters of the Drakensberg in southern Africa, which overlook the unchanged grassland of the veld, we feel the nearby presence of the San. Primeval hunter-gatherer inhabitants of these deserts, they gradually lost their lands to the advance of pastoralists and agriculturalists. Their tragic fate, evoked in scenes depicted here, never fails to move us. For thousands of years their rock art showed their rituals, including the power animals, such as the eland, that played such an important part in them. In the course of the nineteenth century, paintings appeared depicting Europeans and rifles that spit flames. Then the art stopped. The San were killed off or driven from their lands. Nobody paints on the rocks anymore, and the San surviving elsewhere have lost all memory of the wonderful art that their forefathers created. These are now deserted places, with forbidding escarpments overlooking the timeless expanses below (FIGURES 1.5, 1.6).

Here, as so often, the places where rock art is found speak to our soul. This experience is quite different from that of being in a museum, viewing paintings by great masters in an artificial space. Rock art is part of nature, and it achieves its full significance in the context of the landscapes—frequently spectacular and grandiose—that contain it. Whether in the veld of southern Africa, the canyons of Utah or Baja California, the caverns of Europe, the gigantic cliffs of China, or the rim of Norwegian fjords, these are sacred sites. The people who decorated them sought access to the supernatural, to the world of spirits that inhabited these special places—the depths of the earth, the heights of mountains, the convergence of land and sea.

Rock art sites, in other words, have in virtually every instance been chosen according to aspirations that have a universal character. This art is a phenomenon shared by all humanity, on all five continents, for tens of thousands of years. Everywhere it bears witness to sophisticated systems of thought and to the essential unity of the human spirit.

One might think, therefore, that the extraordinary art painted and engraved on stone would be considered in the same way throughout the world, irrespective of where and when it was made. Yet there are significant differences in how this heritage is viewed and valued. Generally, the cave art of the European Ice Age arouses more interest than the petroglyphs and pictographs of the American Southwest or of other countries.

For example, when the discovery of the Grotte Chauvet was announced in January 1995, it made the front page of the *New York Times* and the *Washington Post* and the cover of *Time* magazine. Has the discovery of a great rock art site anywhere else in the world enjoyed such instant and lasting celebrity?

Strangely enough, a similar bias often is found in academic circles. In the United States, for example, it has long been easier to obtain funding for research on European cave art than for research on American rock art. Although a great many scientific articles and some general books have been published on the subject and the American Rock Art Research Association (ARARA) hosts well-organized and well-attended meetings every year, the study of rock art is

FIGURE 1.6
A row of human figures, shown probably in ritual ceremony, adorn this wall of a rock shelter in the Drakensberg mountains of South Africa. Rock painting began here many millennia ago. It continued until perhaps the end of the nineteenth century, when the San people ceased to exist in the area. Along with ethnographic records of the San oral tradition, the rock art of this now deserted region is part of the sparse surviving testimony to the vibrant culture that once flourished here.
Photo by Neville Agnew

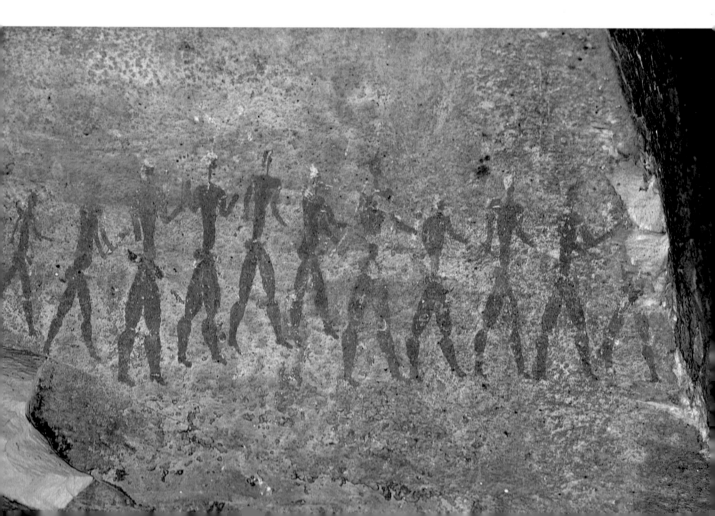

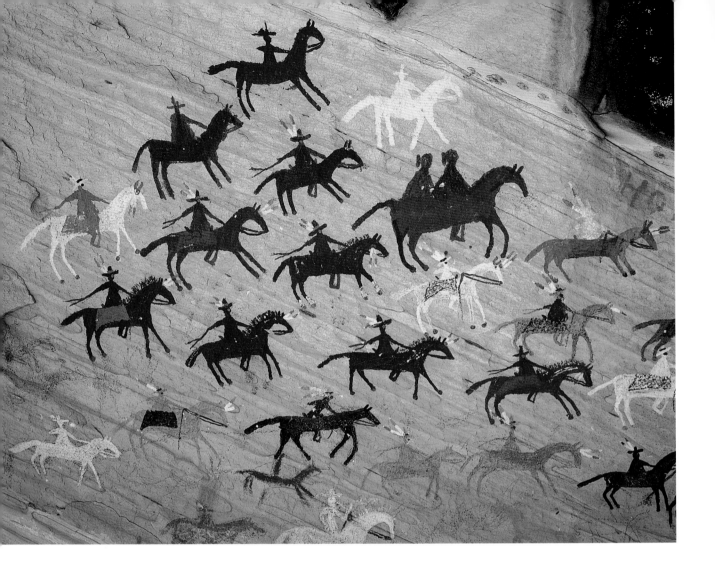

FIGURE 1.7
Native Americans widely
practiced rock painting
and engraving for thou-
sands of years. This
mural in a shelter near
Canyon de Chelly,
Arizona, is thought to
depict a Ute or a Navajo
raiding party. The pres-
ence of horses, which
were brought to the
region by the Spanish in
the sixteenth century, is
one indication that these
images are relatively
recent. They may date to
the nineteenth century.
Photograph by Alain Briot © 2002

still not considered part of mainstream
archaeology in many American universities.
Thus, although this situation recently has
begun to improve, relatively few in-depth site
studies have been carried out and published.
The work that has been done in the United
States and in other countries has shown
conclusively that a site can be known only
superficially if its art has not been traced in
its entirety and its archaeological context
fully studied. Photographs, sketches, and
descriptions are not enough. This would per-
haps be less disconcerting were we certain
that these sites will endure. But we are not
(FIGURE 1.7).

The history of our knowledge of rock art
helps to explain why it has been regarded in
such different ways. The late nineteenth cen-
tury saw the first great flowering of archaeol-

ogy. In the heated controversy that developed
about the paintings Sanz de Sautuola discov-
ered at Altamira in 1879, a number of leading
specialists quite naturally became involved.
Gabriel de Mortillet, a French archaeologist,
vehemently denied both their antiquity and
their authenticity. Emile Cartailhac, editor
of *Matériaux pour l'Histoire Primitive et
Naturelle de l'Homme*, then France's princi-
pal journal of prehistory, was also skeptical,
as were several prominent Spanish archaeol-
ogists. However, a few experts agreed with
Sanz de Sautuola, including Juan Vilanova
y Piera, a professor at the University of
Madrid, and Edouard Piette, a French justice
of the peace. Like Sanz de Sautuola, Piette
was a well-known amateur archaeologist; the
Altamira paintings seemed consistent with
portable art he had discovered on bone

fragments buried in archaeological layers dating to the Magdalenian Age, during earlier excavations of several Paleolithic sites in the Pyrenees (FIGURE 1.8).

The primary reason for the widespread incredulity and cautiousness of many contemporary academic prehistorians was fear of a hoax that would expose their nascent discipline to public ridicule. In the wake of Charles Darwin's *Origin of Species*, published in 1859, prehistory was still a very young science, under fierce attack from the religious establishment. Writing to his friend and colleague Cartailhac in May 1881, for example, de Mortillet expressed his concern that they were being set up; that, when the hoax was exposed, everybody would "laugh at gullible paleontologists and prehistorians." He suspected that his old enemies, the Spanish Jesuits, were at the bottom of this unsavory affair. Were the Altamira paintings to prove fake and the most prominent prehistorians of the time taken in, a major blow would be dealt to the credibility of prehistoric studies.

Sadly, Sanz de Sautuola died in 1888, still widely discredited. In the next few years, as several more painted caverns were discovered in France, the opinion of experts such as Cartailhac gradually began to change. The discovery in 1901 of two important caves in the Dordogne region, Les Combarelles and Font-de-Gaume, decided the matter. The following year Cartailhac acknowledged his error and published "Mea Culpa of a Skeptic." He then visited Altamira, which until then he had refused to do, and he went on to become one of the leading European experts on cave art.[7]

Cartailhac was aided in his studies of the painted caves at Altamira, along with others newly discovered in France at Niaux and Gargas, by a young priest who was both a good draftsman and an experienced archaeologist, the Abbé Henri Breuil. Others, all

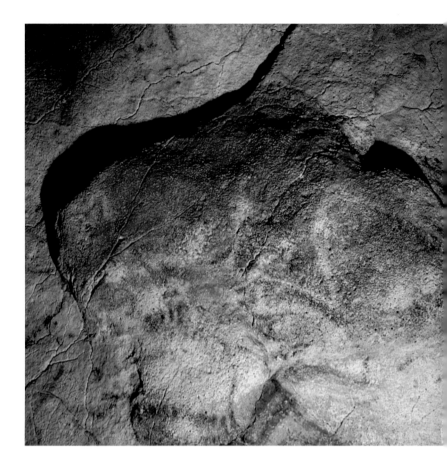

"dirt" archaeologists—there was no other kind—followed suit. Eventually, Breuil, who would be nicknamed "the Pope of Prehistory," became the undisputed—although not necessarily infallible—dean of Upper Paleolithic archaeology.

The controversy over Altamira conferred considerable importance on the paintings and drawings in the European caves, which quickly came to be regarded as *the* prototype of prehistoric art. This helped rock art gain a place in the pantheon of archaeology. Another factor was the important body of movable art—spectacular finds of carved bones, antlers, and stones—that had been retrieved from the caverns and shelters of the Pyrenees and Périgord earlier in the nineteenth century. They were usually reasonably well dated, both because of their association

FIGURE 1.8
On the Great Ceiling in the cave at Altamira, Spain, some paintings of bison were ingeniously modeled by the Ice Age artists who made them to fit bosses, or bumps, on the rock surface. This bison, which appears to be crouching, and others were the ones first noticed by Maria Sanz de Sautuola in 1879.
Photo by L. de Seille

THE "WHITE LADY" OF THE BRANDBERG

The shelter of the White Lady is situated in a deep ravine of the Brandberg, an erosion-carved granite mountain that rises to an altitude of almost 9,000 feet above the deserts of Namibia. More than one thousand painted sites have been found in the Brandberg, ranging in age from perhaps more than three thousand to some eight hundred years old.

When the French researcher the Abbé Breuil went to South West Africa, as Namibia was then called, in 1947, he carefully traced the splendid art he saw. He attributed the paintings to travelers from the Mediterranean, perhaps from Egypt or Crete. This was "an art very superior to that of the Bushmen [now known as the San]," Breuil noted. "It is the art of a red-haired people (with Semitic profiles) who painted hundreds of rock shelters." One tracing, of an imposing female figure, became particularly renowned.

Years later the rock art specialist Harald Pager began working in the Brandberg. He devoted his life to the task of studying and carefully tracing tens of thousands of San rock paintings in southern Africa. Pager's copy of the White Lady revealed that the head is African and the figure has a penis. It is in fact a San male. Other studies since have confirmed Pager's analysis. The shelter has kept its original name, even though, as the renowned scholar David Lewis-Williams has famously remarked, the White Lady of the Brandberg "is neither white nor a lady."

The Brandberg, where the White Lady is located, has many other rock shelters containing impressive panels of paintings.
Photo by David Coulson, Trust for African Rock Art (TARA)

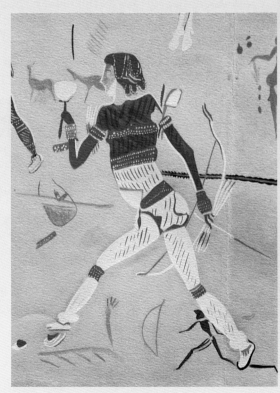

Henri Breuil's famous rendering of the White Lady.

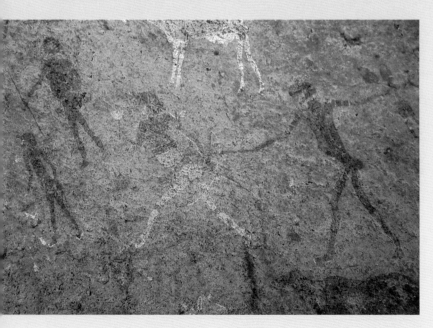

Although protected today, the White Lady has faded over the years, largely because tourists have thrown water on the paintings in order to intensify the colors for photography.
Photo by David Coulson, Trust for African Rock Art (TARA)

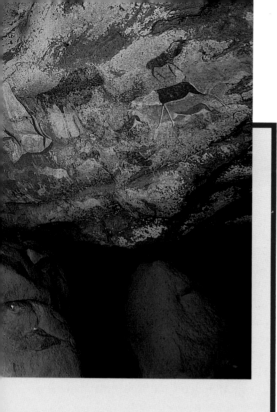

Harald Pager's drawing of the White Lady.

with other well-known bone or flint artifacts and because some of the animals portrayed belonged to long-extinct species whose bones could be found in the same or similar archaeological strata. And they had been unearthed in the course of excavations, that most typical of archaeological activities. For well over a century, all European prehistoric art—including rock art—has been considered part of the archaeological record.

There are other reasons for the prominence of European rock art. Until now the oldest dates for rock art have been obtained in France and Spain. This will no doubt change, and we may expect older dates from Africa, Asia, and Australia, but it has helped to give European cave art an aura that is lacking elsewhere. Another reason is less acknowledged and much less rational— Eurocentricism on the part of the American public. Some Americans may still feel that their cultural roots are in Europe; Native American or other indigenous rock art, as a consequence, may mistakenly be seen as somehow less interesting.

Rock art is a heritage that often has been misunderstood or disdained. One reason is because it is so widespread and, often, so remotely situated. Another can be traced to the earliest Western encounters with this art form. When Europeans first discovered rock art in Africa (and elsewhere) in the eighteenth and, particularly, nineteenth centuries, European colonial empires were at their height. Non-Western peoples, who had quite different and—to Europeans—occasionally shocking practices and beliefs, were widely considered "primitive," even inferior. When faced with the undeniable aesthetic accomplishment of a true artist, therefore, early European researchers often assumed that the rock art they had discovered was the

The Australian rock art tradition is thought to have continued virtually uninterrupted for tens of millennia. Among the most intriguing paintings are the Bradshaw silhouettes, called Gwion Gwion by the aborigines of the Kimberleys region, where the murals were made several thousand years ago. The precise meaning of these marvelously inventive images—long, slender figures adorned with fanciful costumes, feathers, and other paraphernalia—remains a mystery.
Photo by J. Clottes

work of Western travelers rather than of the indigenous peoples of Africa, Australia, and the Americas who had actually created it. This attitude persisted for many years and was shared, indeed promoted, by some of the world's eminent experts.

Such attitudes are unfortunate. Rock art the world over claims the same kind of beauty, grandeur, and abiding significance. It can provide vital information on the rituals, myths, and thought of complex societies. It reflects the richness and range of human diversity; its forms and meanings are as original and as numerous as the conceptions that have inspired them. These images provide a unique window into the past, all the more tantalizing for their often mysterious beauty.

This brings us to another important reason that rock art moves us so—the admiration it elicits. Countless paintings, engravings, and sculptures—on all continents—are true masterpieces. The marvelous inventiveness of the elegant Gwion Gwion (also known as the Bradshaw) silhouettes in the Kimberleys, complete with all sorts of strange paraphernalia and appendages, stir our imaginations (FIGURE 1.9). The bichrome miniatures in the shelters on the heights of the Brandberg, in Namibia, amaze us with their accuracy and grace. In Siberia and China, there are tens of thousands of engravings on stone depicting a wide range of scenes and strange figures. Like so many others around the world, these works are in no way inferior to the famous Paleolithic images in European caves. They are the common heritage of humankind. Time little matters where beauty is.

Today, more and more people are coming to visit rock art sites throughout the world. Such growing popularity, however, is not without its own dangers. Mass tourism

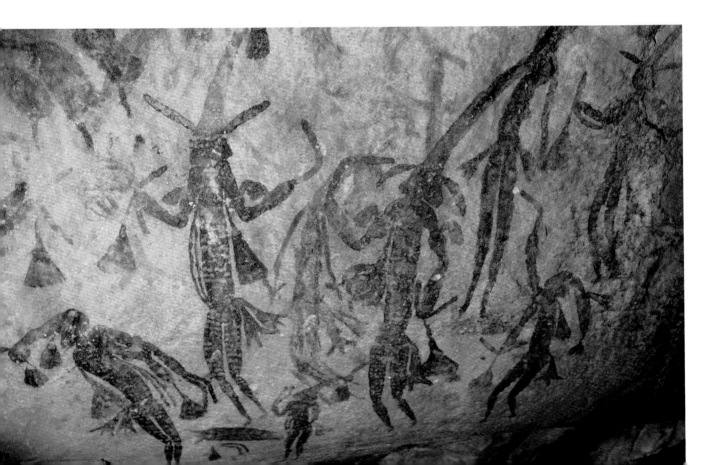

brings graffiti and sometimes the removal and destruction of painted and engraved rocks. In addition, mining, intensive farming, deforestation, and unchecked development have caused considerable damage to these immemorial works, which for the most part are out in the open, unprotected. Today, this remarkable heritage is constantly under threat. Much of it has already vanished.

In response to this danger, various organizations have mobilized. ARARA is working to improve the study and understanding of American rock art. The Trust for African Rock Art is dedicated to preserving rock art throughout that continent. In Baja California, the Getty Conservation Institute (GCI) has carried out several field campaigns in collaboration with three Mexican partner organizations. Their aims encompassed

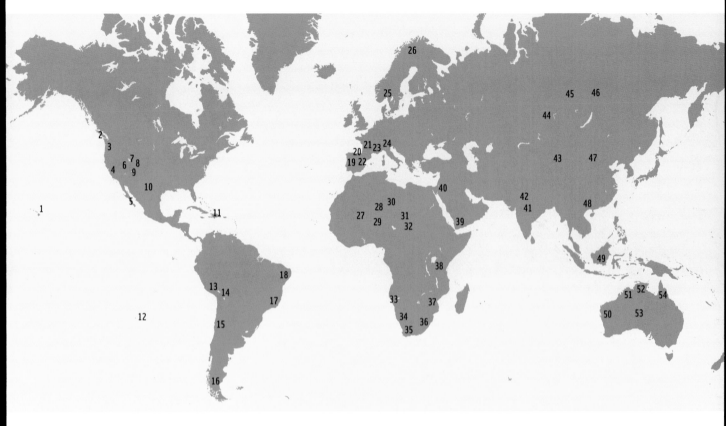

Major rock art regions and sites discussed in this book.

1. Hawaii
2. Vancouver Island
3. Horsethief Lake
4. Coso Range, Mutau Flat
5. Sierra de San Francisco
6. Canyon de Chelly
7. Great Gallery, Monument Valley, Head of Sinbad, Sego Canyon, Temple Mountain Wash
8. Canyonlands
9. Comanche Gap
10. Pecos River, Three Rivers
11. Borbón
12. Easter Island
13. Toro Muerto
14. Pultuma
15. Atacama
16. Cueva de las Manos
17. Rio Peruaçu
18. Capivara, Piaui
19. Foz Côa
20. Altamira
21. Lascaux
22. Spanish Levant
23. Chauvet
24. Mont Bégo, Valcamonica
25. Bohuslän, Vitlycke
26. Alta
27. Adrar of the Iforas
28. Tassili-n'Ajjer
29. Aïr
30. Acacus, Messak
31. Tibesti
32. Ennedi
33. Brandberg
34. Apollo 11
35. Cedarberg
36. Lesotho, Drakensberg
37. Matopos Hills
38. Kondo-Singida
39. Yemen
40. Sinai
41. Bhimbetka
42. Kumaon Hills
43. Altai
44. Valleys of the Tom and Ienissei
45. Valley of the Angara
46. Valley of the Lena
47. Helan Shan
48. Hua Shan
49. Borneo
50. Pilbara
51. Kimberleys
52. Arnhem Land, Kakadu
53. Ayers Rock
54. Laura

FIGURE 1.10
These enigmatic figures
on the wall of a shelter
in Canyonlands National
Park, Utah, were created
by Native Americans
who lived in the region
centuries ago. Thought
to be at least seven
hundred years old, the
images may represent
personages linked to
fertility or rainmaking
rituals. The faces were
rendered by scraping
the rock surface smooth
before painting.

Photograph by Alain Briot © 2002

documentation and conservation, the development of a management plan for a wide area, and the training of Latin America specialists in rock art conservation. In northeastern Portugal, at Foz Côa, the building of a dam threatening to flood and destroy thousands of Ice Age petroglyphs was stopped in 1995; the rock art was preserved, and a research and documentary center open to the public was created. Work is also being done in Spain and France, where the climate of major caves, such as Altamira, Lascaux, and Chauvet, is being monitored to prevent changes that would damage the art on the walls. For such efforts to succeed, the general public must be informed of the value rock art holds for humankind and of the absolute need for its preservation. If this is done, then perhaps those who come after us will also be able to study and enjoy these mysterious images on stone, which reflect worldviews that today have all but disappeared but that modern research can help bring to light and preserve for future generations (FIGURE 1.10).

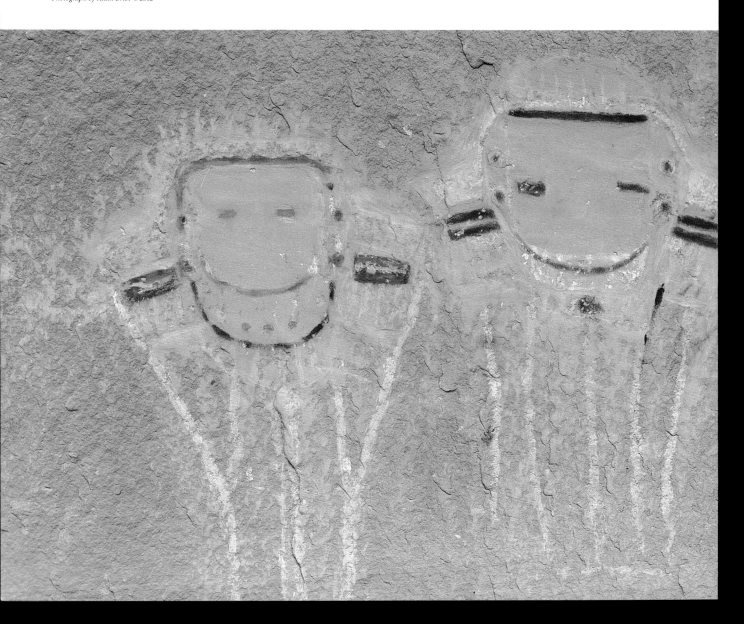

NOTES

1 Nontraditional, contemporary forms of expression such as tags, graffiti, advertisements, even modern sculpture (Mount Rushmore in the United States, for example) are excluded from this genre. The grotto paintings and sculptures celebrating major religions—such as Christianity in Europe or Buddhism in Asia—are also excluded, as the motifs found in their rock art are more prevalent in statues and manmade buildings such as churches and temples. C. Munier, *Sacred Rocks and Buddhist Caves in Thailand* (Bangkok: White Lotus, 1988).

2 G. Chaloupka, *Journey in Time: The World's Longest Continuing Art Tradition. The 50,000-Year Story of the Australian Aboriginal Rock Art of Arnhem Land* (Chatswood: Reed, 1993), 238.

3 O. Odak, in E. Anati, ed., *Preservation and Presentation of Rock Art, 1981–1983* (Paris: UNESCO, 1984), 31.

4 R. Querejazu Lewis, "Contemporary Indigenous Use of Traditional Rock Art at Yarque, Bolivia," *Rock Art Research* 11, no. 1 (1994): 3–9.

5 D. Coulson, "Ancient Art of the Sahara," *National Geographic*, June 1999.

6 E. Anati, *L'art rupestre dans le monde: L'imaginaire de la préhistoire* (Paris: Bordas, 1997), 42.

7 On the discovery of Altamira, see P. A. Saura Ramos and A. Beltrán, eds., *Altamira* (Paris: Le Seuil, 1998); and L. G. Freeman and J. González Echegaray, *La grotte d'Altamira* (Paris: La Maison des Roches, 2001).

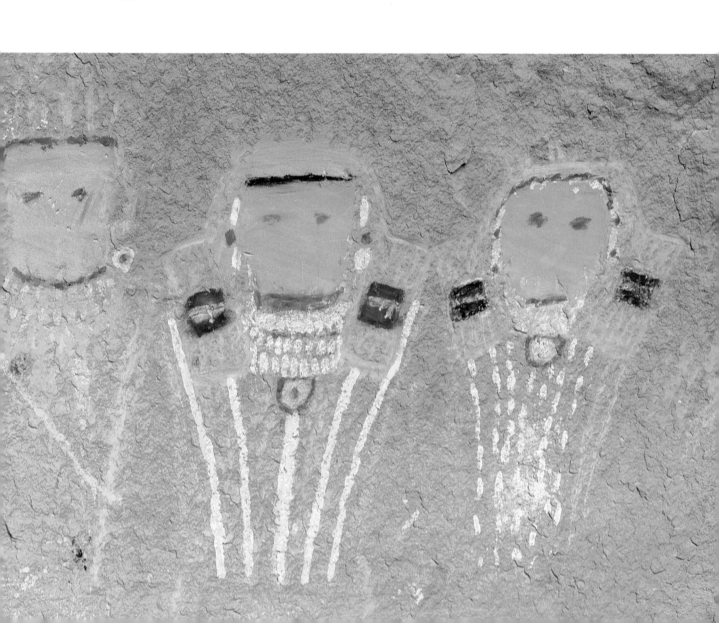

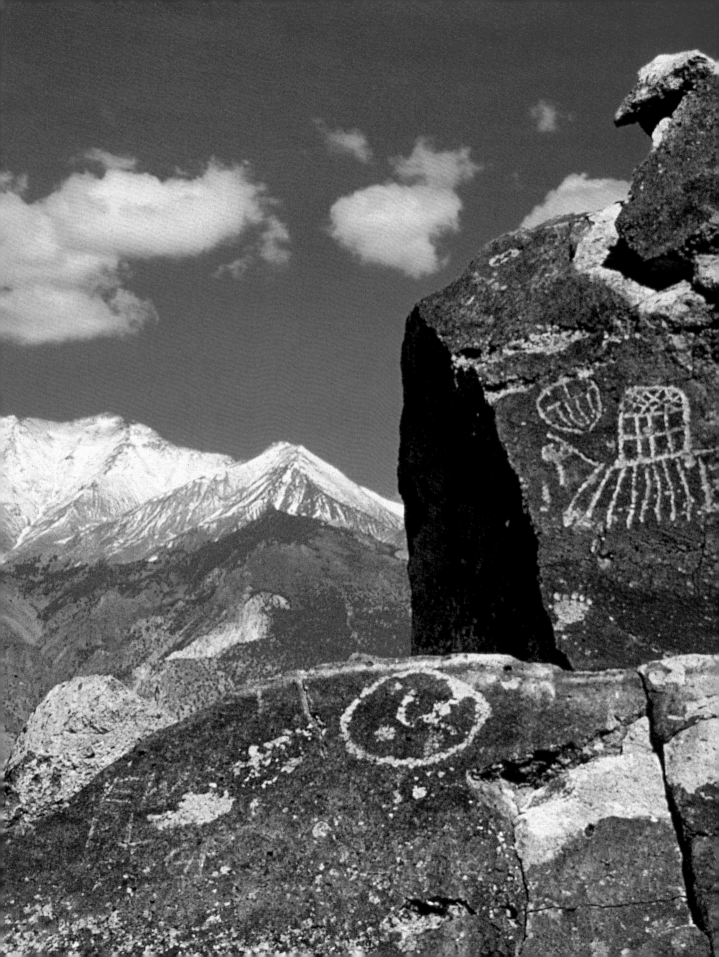

A WORLD OF IMAGES

David Mowaljarlai, a contemporary Australian aborigine, was astonished when a missionary explained to him that in the Christian religion the Ten Commandments are considered extremely important, whereas the mountain on which they were revealed to Moses is not. Such a concept was totally foreign to Mowaljarlai. In his mind, the Commandments should have been inextricably linked to the place. When he asked if the missionary had ever gone there, he was every bit as incredulous to discover that the missionary had never visited so sacred a site.[1]

FIGURE 2.1
Rock art sites are often located in spectacular settings. The snow-capped Sierra Nevada looms beyond these Native American engravings at Red Canyon, near Bishop, California.
Photo by J. Clottes

Westerners are accustomed to seeing art in museums and galleries, where great works of all kinds, often brought from distant places, are on display. Rock art cannot be thus transported, however, without losing virtually all its meaning. It belongs to the place where it was created, to the immutable landscapes that so often helped inspire its making and that, centuries and millennia later, surround it still (FIGURE 2.1). These sites were selected by prehistoric and traditional peoples, and, as we might expect from an art so ubiquitous, they vary considerably. Rock art was fashioned in virtually every conceivable kind of terrain where there were stone surfaces to decorate— in the depths of dark caves, on desert outcrops, on cliff faces in deep canyons, in mountain shelters.

Faced with the unlimited possibilities offered by rock surfaces, humans throughout the world, since time immemorial, have chosen which rocks to decorate according to their beliefs and aspirations. The complexity of these beliefs, linked to the sacred places where the art was located, never ceases to amaze us. Paintings and engravings were generally created in one place or another depending on the role assigned to them. The paintings on the walls surrounding a permanent dwelling in a rock shelter, such as Canyon de Chelly in Arizona, for example, will undoubtedly have a significance entirely different from those marking an isolated rock that bears special meaning in tribal myths. The shamanistic function the art often had was also linked to the place it was made. In such cases the site was seen as a door that opens—for certain favored individuals—on the spirit world. For the Algonquin of Canada's Ottawa River valley, for example, the universe was structured into four distinct domains: Sky, Earth, Underground, and Underwater. Certain lakes, shelters, caves, and fissures were considered passageways, to be used only by specially designated people. Paintings were found in places where the artist had experienced a dream. Gifted shamans, it was believed, could enter the rock and trade tobacco for medicine with the spirits who lived there.[2]

Such power of place was not to be found only at decorated sites. A spring, a boulder with a particular shape, a whirlpool in a river—all are also a part of the sacred landscape and exercise a similar function. Among peoples throughout the world, the physical environment and the supernatural environment were regarded as one, as inextricably intertwined, and rock art sites, along with many other elements, as part of them (FIGURE 2.2).[3]

Indeed, sometimes the environment was seen as more important than the art itself. At a site in central Australia, for example, not far from Alice Springs, an archaeologist noticed that when the wind came up— which it often did—tree branches would beat against the rock paintings, gradually destroying the art. She pointed this out to the traditional aboriginal keepers of the site and suggested that the offending branches be cut off. The aborigines were utterly horrified at this idea, because for them the trees had a spiritual value at least equal to that of the pictographs. For them, the trees represented the souls of the dead. To cut them off would have been a serious crime against their ancestors.

FIGURE 2.2 (opposite) The Three Rivers area of New Mexico has one of the world's highest concentrations of petroglyphs. Between twenty thousand and thirty thousand of these mysterious engravings adorn the landscape, which no doubt had special significance for the Pueblo people who made them hundreds of years ago.
Photograph by Alain Briot © 2002

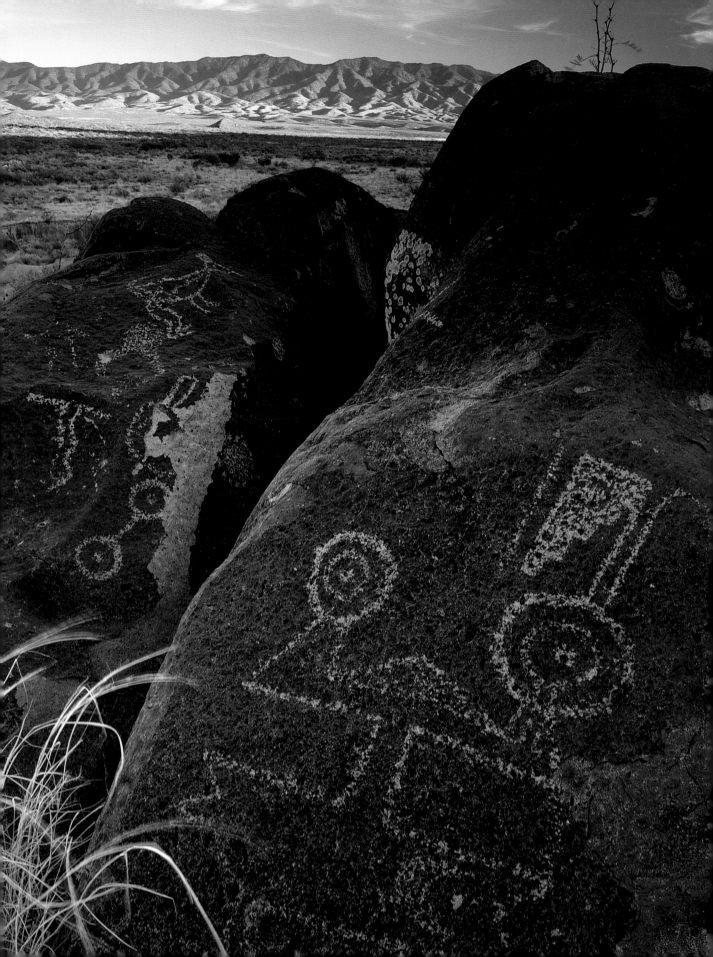

An Art on All Continents

No one knows exactly how many rock art sites there are in the world. Indeed, the very notion of a "site" is ambiguous. The word can mean a vast region with tens of thousands of rock carvings, such as the Early Bronze Age sites at Mont Bégo, in southeastern France, and at Toro Muerto, in Peru, whose indigenous names in the Quechua and Aymara languages meant "drawing" or "writing." A site can also be a small, shallow cave or shelter with only a few wall paintings. Thousands of such places exist in Asia, Australia, Africa, and the Americas. In spite of this ambiguity, it is useful to have an idea, approximate though it may be, of the total number of sites and their general distribution. All in all, we estimate that there are three hundred fifty thousand to four hundred thousand rock art sites scattered, rather unequally, throughout the world. As to the total number of images, they must range in the tens of millions.

Although Europe's rock art, for historical and economic reasons, has been studied in more depth than any other in the world, it has only a few thousand sites—fewer than on all other continents. Such sites as Lascaux, Altamira, and Chauvet certainly merit their celebrity. However, only about three hundred fifty European caves, rock shelters, and open-air sites (many recently discovered, such as Foz Côa in Portugal) date to the Ice Age, and the importance we attribute to them is disproportionate to their number. The major groups of European rock art are more recent.

In Scandinavia and, more widely, in northern Europe and Russia (Lake Onega), a particular kind of rock art was created in the Neolithic, roughly between six thousand and four thousand years ago, by the first farmers-fishermen-animal breeders and their successors in the Bronze and Iron Ages. It consists mostly of petroglyphs, but the existence of

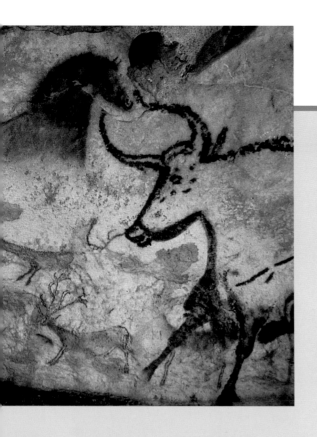

HALL OF THE BULLS
Lascaux, France

Lascaux is the most famous of all rock art sites because of the exceptional quality, size, sophistication, and antiquity (20,000 years before the present [B.P.]) of its paintings. We shall never know exactly what ceremonies took place in the cave, but it must have been very meaningful for people to have taken such pains to cover its walls and ceilings with such magnificent images. Lascaux was discovered in 1940 by four boys who were out for a walk and followed their dog into the interior. The discovery generated considerable publicity. The site was open to the public until 1963, when it was found that the large number of visitors was causing changes in the cave's climate, resulting in the deterioration of the paintings. An exact replica of several of its main chambers, known as Lascaux II, was built next to the original cave, and this replica continues to be visited today.

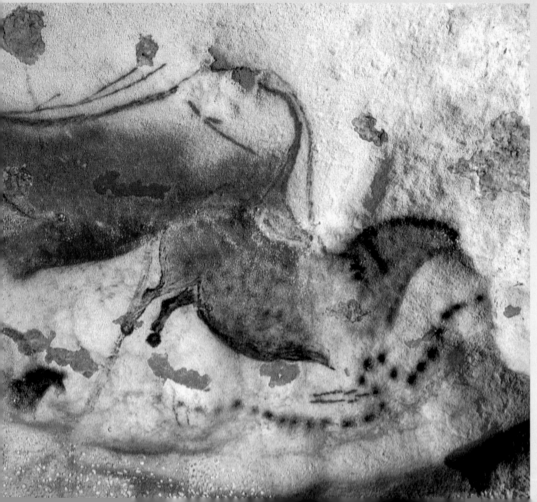

In the Hall of the Bulls, the walls are covered with an array of bulls, horses, and deer of various sizes.
Photo by Norbert Aujoulat

On this panel, a large red cow turned to the left seems to move among several smaller horses turned in the other direction. Several questions remain unanswered: Were those animals painted in relation to one another? What is the meaning of the geometric sign consisting of black dots at the bottom right?
Photo by Norbert Aujoulat

a few paintings on cliffs tells us that many thousands of others must have been destroyed by the harsh climate.

Most art of the alpine crescent, especially in France and Italy, dates from the same periods. It includes a few particularly important places, such as Mont Bégo and Valcamonica (FIGURE 2.3), where tens of thousands of images engraved on the valley's glacial rocks depict a variety of subjects, including deer, houses, and humans, who are sometimes engaged in duels, warfare, or hunting. The Fontainebleau forest near Paris also has an important group of more

than a thousand sites that are decorated with engravings.

In the Spanish Levant (FIGURE 2.4), where more than eight hundred painted shelters cross Spain from north to south on its Mediterranean side, the art follows in direct chronological sequence that found in caverns and continues right up to the beginning of the Metal Age. Levantine art primarily consists of small red naturalistic figures, humans and animals (deer, wild boars), painted outdoors on the walls of shallow shelters. It was replaced by a more abstract, schematic art, which covers the entire Iberian Peninsula.

FIGURE 2.3 (opposite)
A rare fishlike figure (bottom right) has been pecked on this glacier-polished rock at Fontanalba, near Mont Bégo, France.
Photo by J. Clottes

FIGURE 2.4 (above)
This painting in the Tio Garoso shelter, at Alacón, in eastern Spain, shows a running figure carrying some kind of weapon.
Photo by J. Clottes

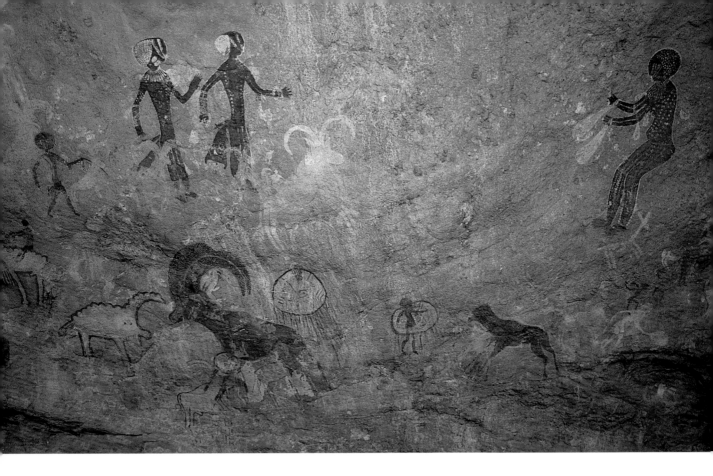

FIGURE 2.5 (above)
Algeria's Tassili-n'Ajjer is one of the world's richest regions for rock art. The paintings seen here are part of an immense panel that dates back thousands of years. Images have been superimposed in multiple layers. At left, two adults, wearing ornaments, are followed by a child. Painted over and below them are images of sheeplike animals and other mythical creatures. At right, a figure seems to float in space.

Photo by David Coulson, Trust for African Rock Art (TARA)

FIGURE 2.6 (right)
A Tuareg guide stands in front of recently discovered engravings in the Kori Elailei, in the Aïr Mountains, Niger.

Photo by J. Clottes

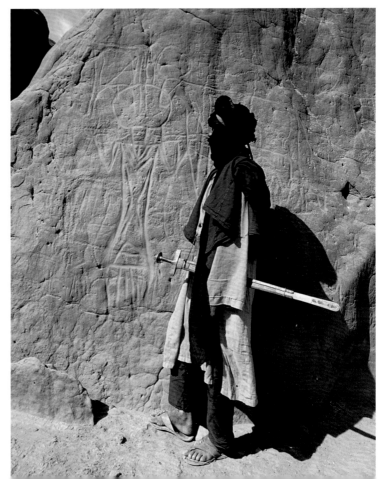

Africa is perhaps the ultimate continent for rock art, with more than one hundred thousand known sites, and probably twice that number. Many are of considerable importance, by virtue of both the number and the artistic quality of the paintings and engravings they contain. Most belong to relatively recent eras, as shelters were still being painted in southern Africa as late as the nineteenth century. Roughly two vast areas of great interest can be distinguished: the Sahara and its farthest reaches and southern Africa.

The major Saharan concentrations include those of Tassili-n'Ajjer, in Algeria (FIGURE 2.5), on UNESCO's World Heritage List, and the sites of the Acacus (also on the World Heritage List) and the Mathendous, in Libya. Also in Libya, there are the Messak Mellet and Settafet, which have extraordinarily diverse carvings of humans in lively scenes and long-vanished animals such as crocodiles and elephants. The Ennedi and Tibesti Mountains in Chad, the Aïr (FIGURE 2.6; see also FIGURES 3.4, 4.11) and Djado regions in

Niger, and the Adrar of the Iforas in Mali are less spectacular but contain thousands of engraved sites. In northern Africa, a considerable number of sites are found in the Atlas and Anti-Atlas Mountains of Algeria and Morocco as well as in Mauritania and, less well-known, in Egypt.

In southern Africa, roughly from Tanzania in the east to Angola and Namibia in the west, approximately eighty thousand sites have been recorded. Among the most extraordinary are those in Namibia. The Brandberg, a towering mountain rising out of the desert, with more than one thousand painted shelters in its valleys and upper ridges, must have been a sacred place to the San (FIGURE 2.7). In South Africa, the vivid paintings of the Drakensberg and those of the Cedarberg also played a major role in San culture. In Lesotho, Tanzania (Kondo-Singida), Botswana, and Zimbabwe (Matopos Hills), many thousands of sites have been recorded; approximately thirty thousand are reckoned to exist in Zimbabwe alone.

FIGURE 2.7
Jumbled figures of humans, giraffe, antelope, and other animals cover this shelter, on top of the Brandberg massif, in Namibia. Today this forbidding mountain, once a stronghold of the San people, is uninhabited.

Photo by David Coulson, Trust for African Rock Art (TARA)

FIGURE 2.8
Horsemen and animals painted in two colors in Jhiri shelter no. 7, in the Bhopal region of India. Many images, of which these are the most recent and most visible, have accumulated in superimposition on this panel, suggesting that the site was used for a long time.

Photo by P. Vidal

FIGURE 2.9
Engravings of deer and people at Elangash, in the Altai region of Russia.

Photo by P. Vidal

The rock art of Asia is not as well known to Western scholars, and most of it is not yet dated. This vast continent must include tens of thousands of sites, but it is still impossible to give even a rough estimate. Many regional subdivisions, according to both geography and local traditions, would be necessary. Arbitrarily, we can distinguish five vast principal areas: the Middle East, central Asia, India, China, and Indonesia.

Nearly all Middle Eastern countries contain examples of rock art, especially in the form of engravings. Recent research has brought to light the art of Yemen, of the United Arab Emirates and Qatar, of the Negev Desert in Israel, and of Saudi Arabia, which has more than one thousand sites. Depictions of humans, often accompanied by animals in various hunting and domestic scenes, are plentiful in rock art of the Middle East.

In India, rock art may be found all the way into the Himalayas, where schematic figures have been discovered at Kumaon Hills, an area that covers one-sixth of the state of Uttar Pradesh. However, the most important sites are in the center of the country, such as the numerous richly painted caves of the Bhimbetka (FIGURE 2.8; see also FIGURE 3.9).

In central Asia, the valleys of the Lena, Angara, Ienissei, and Tom Rivers in southern Siberia are covered with petroglyphs. Petroglyphs also abound in the Altai (FIGURE 2.9), rugged mountains between Mongolia and China, as well as in many other parts of this immense region. Moose, reindeer, and ibex figures are abundant.

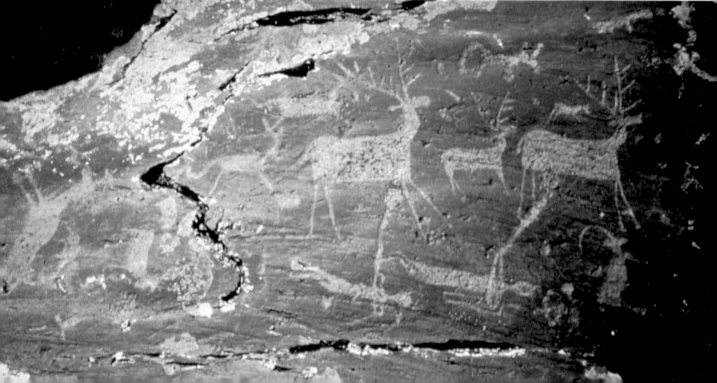

THE MOUNTAIN OF ENGRAVINGS
Helan Shan Petroglyphs, China

China is one of world's richest countries in terms of rock art. Many sites have been found and studied by our Chinese colleagues, but few studies have been published in other languages. One should expect some sites to date to the Pleistocene, of similar antiquity to the oldest sites in Europe and Australia, but so far none this old have been discovered.

In the Helan Shan range in the Ningxia and Inner Mongolia provinces, thousands of petroglyphs, probably fashioned over thousands of years, have been discovered, often in spectacular deep valleys, like the one at Helanku. These images depict a wide range of subjects, including masks, animals such as cervids and caprids (often with wildly developed horns or antlers), and humans, who are sometimes shown in hunting scenes.

One of the numerous engraved masks at Helanku in the Helan Shan. It is supposed to date to the Shang dynasty between 1700 and 1050 B.C.; the script on its left was done much later. Such masks are said to represent ancestral spirits.
Photo by J. Clottes

Mythical animal more than two meters long on a cliff in the Helan Shan (China).
Photo by E. Anati, Centro Camuno di Studi Preistorici

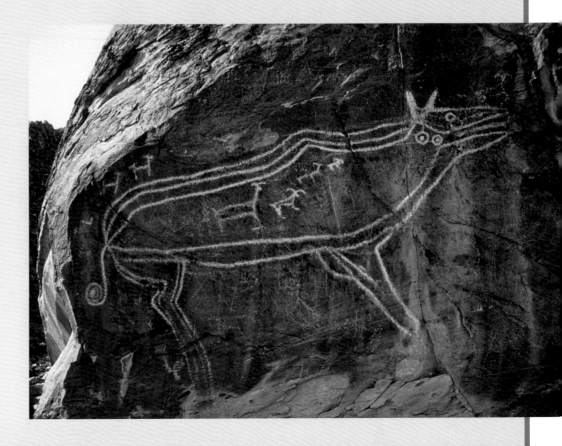

The rock art of China, studied locally for ages, has only recently been revealed to the Western world.[4] There are more than ten thousand known sites. Engravings seem to dominate in the north, at such places as Helan Shan in Ningxia and Inner Mongolia. Paintings are more numerous in the south; at the imposing Hua Shan site, hundreds of works, some of which are 2,100 years old, occupy a cliff wall nearly two hundred meters long and more than forty meters high (FIGURE 2.10).

In Indonesia, caves with hundreds of ancient hand stencils and other designs have recently been discovered in Borneo.

Rock engravings and paintings are found throughout Oceania—the collective name for the lands of the central and southern Pacific Ocean. There are major sites of engravings in the Hawaiian Islands, often on old lava flows, as well as on Easter Island, where the rock art (FIGURE 2.11; see also FIGURE 3.3) is not as well known as the monumental statuary (moai). All in all, there must be more than one hundred thousand sites in this vast area. Most are in Australia, where, along with Africa, the world's richest repositories of rock art are found. The major rock art regions are Laura, on the Cape York Peninsula (FIGURE 2.12; see also FIGURES 3.8, 5.3); the Kimberleys (Gwion Gwion, or Bradshaw paintings, depicting humans with extraordinary costumes); the Pilbara; and Arnhem Land (Kakadu National Park). In addition, Australia has the longest uninterrupted tradition of rock art, for certain engravings could be thirty to forty thousand years old and traditional paintings were still being made there as recently as the 1960s.

The rock art of the Americas is not as well known as one would wish, although research has intensified over the last ten years. Tens of thousands of sites exist, from Canada to Patagonia. Very few have been studied in depth, and many regional surveys are still in the making.

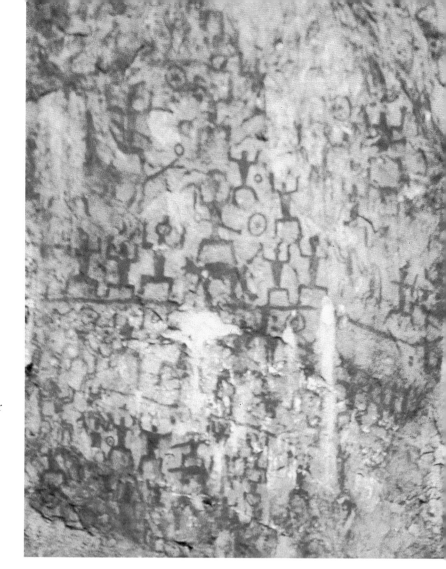

FIGURE 2.10
The great cliff face at Hua Shan, China, more than forty meters high, is covered with paintings.
Photo by J. Keyser

FIGURE 2.11
Painting of a birdman, on Easter Island (Chile). There was a very strong birdman cult on Easter Island, with various ceremonies and sacrifices. It may have sprung from the isolation of the inhabitants, and the importance of birds and bird symbolism.
Photo by F. LeBlanc

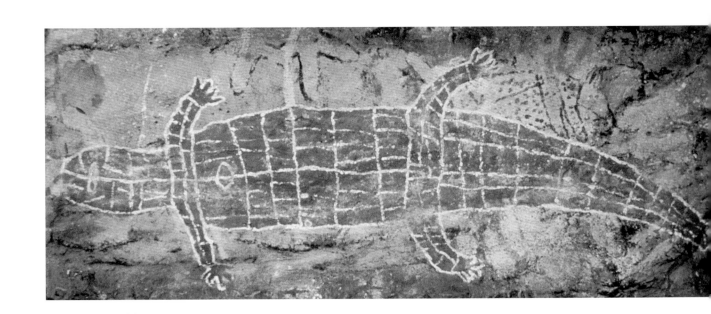

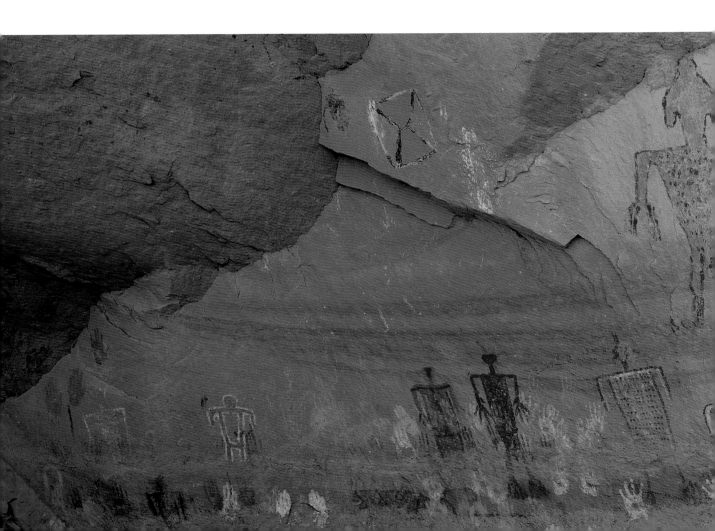

In North America, there are numerous traditions, as different from each other as the various peoples that have inhabited this immense stretch of land, ranging from the Algonquin of Canada to the Chumash of California. As a result, the rock art is diverse, with occasionally spectacular paintings and engravings (FIGURE 2.13). The gigantic, ghostly figures of the Great Gallery in Utah, attributed to the Barrier Canyon style, might have been created a few centuries or even millennia before our era. The extraordinary shamanistic representations found along the Pecos River in Texas and Mexico, also undated, depict strange-looking humans who seem to fly (see FIGURE 6.13). Tens of thousands of engravings of the Coso Range in California, close to Death Valley in that most arid of regions, are mostly of humans and bighorn sheep and were associated with rainmaking practices. Oddly enough, no site in the United States or Canada has yet been included on UNESCO's World Heritage List (the same is true of Asia), whereas those of the Sierra de San Francisco in Baja California Sur (FIGURE 2.14) have been, and rightly so.

Central and South America are equally rich in rock art, and their cultural traditions are every bit as diverse as those of North America. At Toro Muerto in Peru, there is a remarkable site of engravings spread over several thousand stone blocks. In Argentina,

FIGURE 2.12
This large crocodile is superimposed on older paintings at Mushroom Rock, in the Laura region of Australia.
Photo by J. Clottes

FIGURE 2.13
Mysterious figures painted by Native Americans hundreds of years ago adorn this rock shelter wall near Canyon de Chelly, Arizona. They are generally thought to have a ritualistic meaning, perhaps linked with shamanistic ceremonies that may have been practiced at this site.
Photograph by Alain Briot © 2002

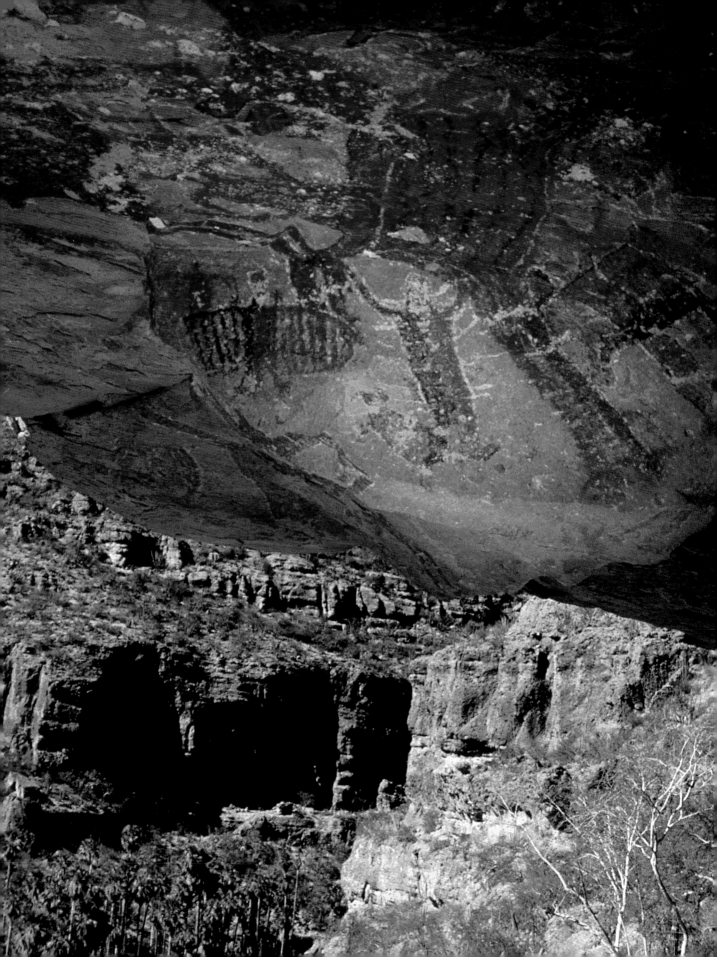

the Cueva de las Manos, with hundreds of hand stencils (see pp. 68–69), has become famous and recently has been placed on the World Heritage List. In Chile and Peru, in addition to paintings and engravings, there are huge geoglyphs—gigantic figures drawn on the ground rather than on the rocks (see p. 70). A tremendous number of sites can be found in many other countries as well: in Mexico, Cuba, the Dominican Republic, Bolivia (FIGURE 2.15), Venezuela, Colombia, and Uruguay. The oldest dates for rock paintings on the South American continent (up to 17,000 B.P.) have been reported in Brazil. However, most of these sites cannot be more than a few thousand—or even a few hundred—years old, which of course does not make them any less interesting.

Art of Light and Art of Darkness

More rock art is found in the open air than in dark caverns. In fact, people rarely painted in deep caves, because the subterranean world—the dwelling place of spirits, supernatural forces, and the dead—was thought to be dangerous. People lived underground only when they had to seek refuge in difficult times. Going underground to make drawings was a solemn act, carried out within the framework of particular religious beliefs and by relatively few ethnic groups.

While the cave art of the European Paleolithic is the most widely known, it is far from the only art fashioned underground. In the remote past, nonfigurative drawings were made in the total darkness of about one hundred caves along the southern

FIGURE 2.14
Paintings cover the overhang of the Cueva Pintada shelter, on the side of a deep canyon in the Sierra de San Francisco, Baja California Sur, Mexico.
Photo by J. Clottes

FIGURE 2.15
A painted herd of white llamas covers this wall of the great Pultuma shelter on the Altiplano in Bolivia.
Photo by D. Salamanca

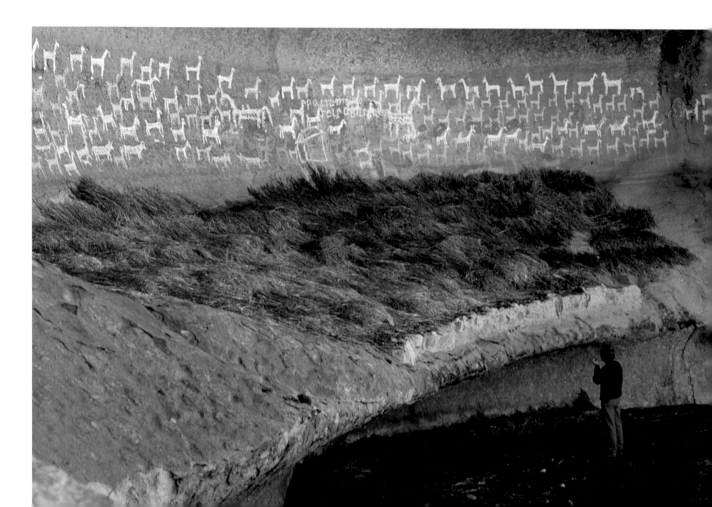

FIGURE 2.16
Over the centuries, a ghostly array of images has accumulated on this wall of the remote Deighton Lady shelter in the Laura region of Australia. In addition to the large white painting of a woman (center, right) for which the site is named, motifs include hand stencils—made by taking a mouthful of paint, placing a hand on the wall, and blowing the paint over it—and so-called "red paintings" of animals and human figures.

Photo by J. Clottes

coast of Australia (Koonalda Cave, for example). Other, more recent examples, dating from just a few centuries ago, can be found in the southern United States, such as in the mudglyph caves of Tennessee and Kentucky, so called because many of the images were made by using a finger to draw on the wet clay covering the walls. In Central America, the Maya and other cultures also used deep caves, and excellent examples of underground art are known in various countries in the region. In Cuba, many schematic figures have been drawn in caves, especially on the north coast of the province of Sancti Spiritu. In the Dominican Republic, the art in the Borbón caves was reported as early as 1854. And paintings by local cultures, the Arawak and Taino, have been found deep underground. In the Petén jungle of Guatemala, numerous sculptures of eerie faces were made on the calcite deposits of deep caverns. Very recently, decorated caves with hundreds of hand stencils have been discovered on Borneo, although they are as yet not precisely dated.

The great majority of world rock art was made outdoors, on outcrops, at the foot of cliffs, and in daylit shelters (FIGURE 2.16). Exposed both to nature and to the ways of humans, this art is much more vulnerable than cave art. As a result, it has survived only when environmental conditions have permitted. Millions of ancient works—primarily paintings—have undoubtedly disappeared.

Today, our approach to the study of rock art differs considerably, depending on where it is found and whether the local traditions that inspired it have been preserved. It is rare indeed to find areas in which people can still explain its meaning. In Europe, in almost all of Africa, and in much of Asia and the Americas, the stories and religious practices represented by this art have long since disappeared. The rock art of these areas can be studied only by using archaeological methods and by comparing it to the art and traditions of those few regions where we know the meanings of the images and the social and religious contexts in which they were created. Archaeological methods help us determine what motifs were chosen and which techniques were used. This in turn enables us to compare one body of art to another, either nearby or in a different region altogether.

In some parts of the world, however, rock art traditions have been preserved. In southern Africa and in the southwestern United

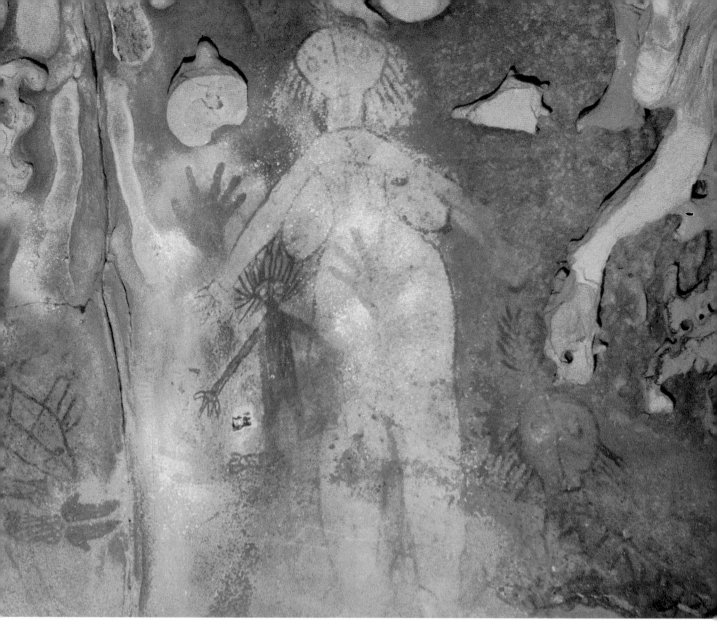

States, people were still painting on stone in the nineteenth century, and accounts of this activity still exist. Such chronicles are much more numerous in Australia, where this artistic tradition has persisted until very recently but where the remaining elders fear it will soon disappear. When living cultures have told ethnologists, missionaries, or other travelers what the art was about we have some access to its deeper meanings. Otherwise rock art would all too often remain a beautiful but baffling testimony to the beliefs and worldviews of vanished cultures.

NOTES

1 D. Mowaljarlai and J. Malnic, *Yorro, Yorro: Everything Standing Up Alive. Spirit of the Kimberley* (Broome: Magabala Books Aboriginal Corp., 1993), 83.

2 G. Rajnovich, *Reading Rock Art: Interpreting the Indian Rock Paintings of the Canadian Shield* (Toronto: Natural Heritage/Natural History, 1994), 35, 66.

3 On the importance of landscape in Native American cultures, see T. Conway, *Painted Dreams: Native American Rock Art* (Minocqua, Wis.: NorthWord, 1993).

4 Considering the enormous importance of Chinese rock art, relatively few studies have been published outside that country; see C. Zao Fu, *Découverte de l'art préhistorique en Chine* (Paris: Albin Michel, 1988).

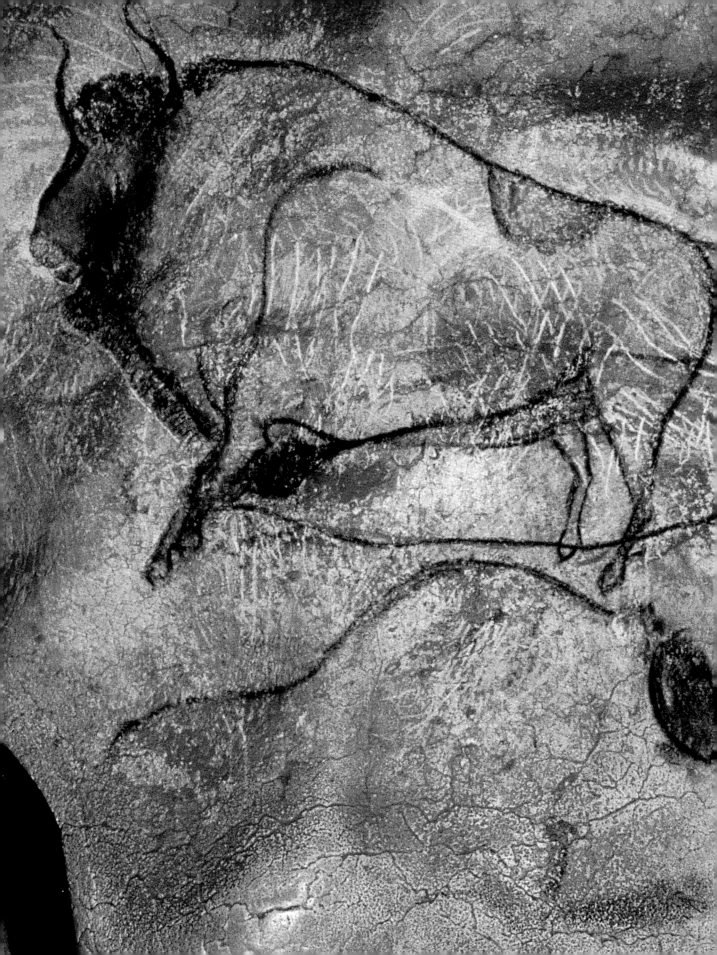

FOUR HUNDRED CENTURIES OF ROCK ART

The dating of rock art arouses deep-rooted prejudices and errors of judgment in several related areas. First, most people think that the oldest rock art is found only in Europe, in the deep caves of France and Spain (FIGURE 3.1), although rock art tens of thousands of years old is found on other continents as well. Second, there is an erroneous and widespread belief—even in academic circles—that it is next to impossible to date rock art. In fact, many different methods make it possible, although the dates are sometimes less certain than they are in other areas of archaeology.

FIGURE 3.1
The extraordinary black charcoal drawings in the Grotte Chauvet, France, have been dated using the radiocarbon method, which measures residual microradioactivity in organic matter. The large bison facing left was dated to 30,360 ± 570 B.P.
Photo by J. Clottes

Third, most people consider rock art prehistoric art, and more recent art—by far the most common—is often ignored. Engravings or paintings made in the last few centuries are met with a general lack of interest, compared to the "real" rock art that dates back to the ice ages.

The latter attitude can have serious consequences. In 1995, for example, during a controversy over engravings discovered in Portugal's Foz Côa, the problem was posed in unacceptable terms: "If it's recent, it's not worth being preserved." As if van Gogh's paintings were somehow less important because they are only a little over one hundred years old.

How Is Rock Art Dated?

The question, How old is it, and how can you tell? is frequently asked of archaeologists who study rock art. This is a typically Western reaction, characteristic of our modern era, when science and time are considered so significant. In traditional cultures the issue of age never came up. The images, it was believed, had been left by mythical beings in a vague and distant past; precise measurement of the depth of time had no importance in and of itself. In Australia, this was known as the "Dreamtime"—an ancestral past that existed long before human beings and extends into the present.[1] In northern Australia, the Wandjinas, ancestral beings who are the spirits of the life-giving rains, are believed to have created the art.[2] In Siberia, it was thought that rocks were soft in ancient times and that the heroes of the day were easily able to draw on them. In certain parts of the Sahara, the Tuareg, who still today are herders of camels and goats, claimed that mythical beings had made the art with their penises. In Canada, on Vancouver Island, it is believed to have been created by an evil spirit called Kwatiyot. Such beliefs are universal. They share a tendency to push rock art back into an indistinct past and to attribute it to fabulous beings or spirits.

Until recently, rock art was the object of whimsical attributions by Westerners who could imagine neither its age nor the possibility that indigenous peoples on distant continents had created it. In South America, for example, it was first thought by European priests and travelers that these drawings had been made by earlier European missionaries or explorers.[3] In mid-nineteenth-century Sweden, people still believed that Neolithic and Bronze Age Scandinavian rock art was purely narrative and that it traced the exploits of the Vikings, a more or less mythicized people, when it was in fact thousands of years older.

Preconceived ideas die hard. In the absence of true dates, a theoretical evolutionary model lacking any scientific foundation was adopted and long used, and it is still instinctively applied here and there. Its basic premise is that the older or more "archaic" an art is, the cruder and rougher it must be. The corollary is a belief in the linear development of artistic creation, with constant progress made over centuries and millennia. Each time it has been possible to establish solid chronologies, however, this model has proven false. Such was the case for the wall art of Paleolithic European caves, when the discovery of the Grotte Chauvet revealed that from extremely ancient times the aesthetic quality of the art was extraordinary (see sidebar, overleaf).

In the last half century, various new methods for dating rock art have been developed. One of the most widely used is the radiocarbon method, which, thanks to progress in the physical sciences, has made it possible to date directly certain paintings.

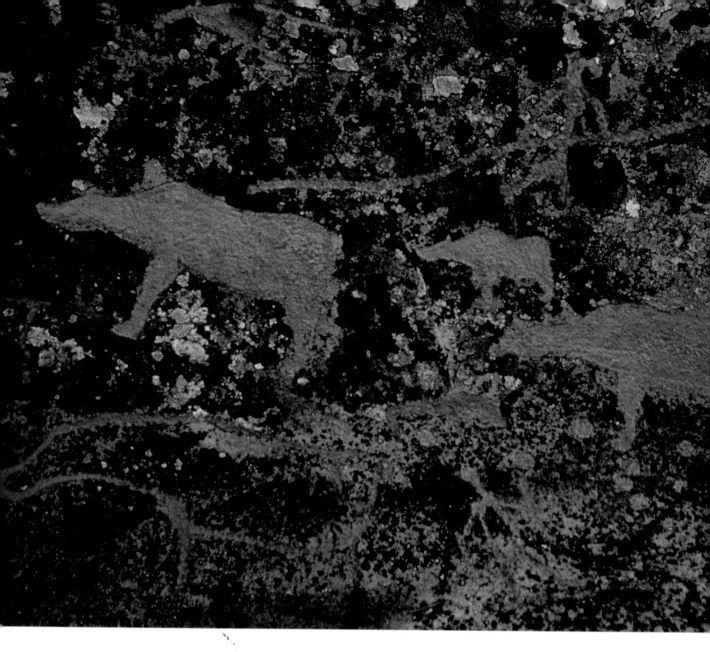

The radiocarbon method is based on the fact that all living organisms contain a very small amount of radioactive carbon (^{14}C) identical to that contained in the atmosphere. After death, the organism ceases interacting with the air, and the ^{14}C gradually disintegrates. We know that it loses half its mass in 5,568 years. Residual microradioactivity can be measured to calculate the date of the organism's death. The calculated date, which is affected by a margin of error, is a measure with statistical value.

The radiocarbon method has certain limitations. We cannot go back much farther than forty thousand years, and as we approach these limits the margin of error increases. Moreover, radiocarbon dates do not correspond exactly to real years (they are a bit more recent), and we have to correct them with a calibration curve established using other techniques. Finally, the death of the body is dated, not the act of the painter, who may have used even older charcoal.

FIGURE 3.2
Changes in the earth's climate can help us date rock art. In Scandinavia, the sea was some eighty meters higher eight thousand years ago than it is today. Engravings such as these, in Alta, Norway, at an altitude of forty meters, must therefore be of later date. These engravings have been recently painted red (see FIGURE 7.13).
Photo by J. Clottes

THE PREHISTORIC BACKGROUND

The long story of rock art unfolds against the backdrop of the gradual emergence of humankind from the mists of the prehistoric past. Since it is so easy to get lost in the immensity of prehistoric time, it is useful to sketch briefly and in broad outline the silhouette of our ancient predecessors.

Humankind slowly emerged—the fossil evidence points to Africa—several million years ago. Those very early humans had no art whatsoever. Then, roughly 2 million years ago, the Paleolithic period, also known as the Old Stone Age, began. The existence of a form of art has sometimes been posed for *Homo erectus*, descendants of these very early humans, known in Africa about 1.7 million years ago. A few hundred thousand years later, *Homo erectus* spread throughout the world, except for the Americas and Oceania. These people were nomadic hunters and gatherers who often took shelter in caves. They formed the Acheulean, a Lower Paleolithic culture with stone tools called bifaces. About 500,000 years ago, they domesticated the use of fire. The geologic age in which they lived, the Pleistocene, was the long period—from about 1.8 million to perhaps 10,000 years ago—during which glaciers occasionally spread and covered much more of the earth than they do now.

Homo erectus was succeeded by pre-Neanderthal humans, about whom we know very little, and then, about 200,000 years ago, by Neanderthals, who are known to have lived throughout Europe and the Middle East. Most of Mousterian culture—the culture of the Middle Paleolithic—is theirs.

Modern humans—*Homo sapiens sapiens*, or Cro-Magnons—emerged from Africa between 120,000 and 150,000 years ago. They spread first to the Middle East, then to Asia, and eventually, between 50,000 and 60,000 years ago, to Australia. Some 40,000 years ago, they reached western Europe, which was still inhabited by Neanderthals. Neanderthals were contemporaneous with modern humans in Europe for about 10,000 years. Probably under the influence of modern humans, Neanderthals began to make body ornaments and, possibly, some forms of movable art. No rock art has been attributed to the Neanderthals. Cro-Magnons peopled the Americas, probably between 20,000 and 30,000 years ago, coming from the north through the Bering Strait, which at that time was iced over.

By then it was the end of the Pleistocene, the last part of the latest Ice Age. Like their predecessors, Cro-Magnons were hunter-gatherers. It was they who undisputably created various forms of art, including rock art. During the European Upper Paleolithic, as the time of Cro-Magnon culture in Europe is called, the successive Cro-Magnon cultures were the Aurignacians, from 40,000 to 28,000 B.P.;

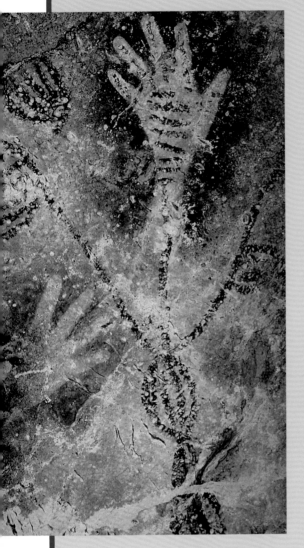

Caves with ancient art have been found deep in the jungles of Indonesia. These hand stencils, including one with inner markings, and other mysterious images are in the Gua Tewet cave, in Borneo. They have been attributed to the end of the Pleistocene or the beginning of the Holocene period.
Photo by L. H. Fage

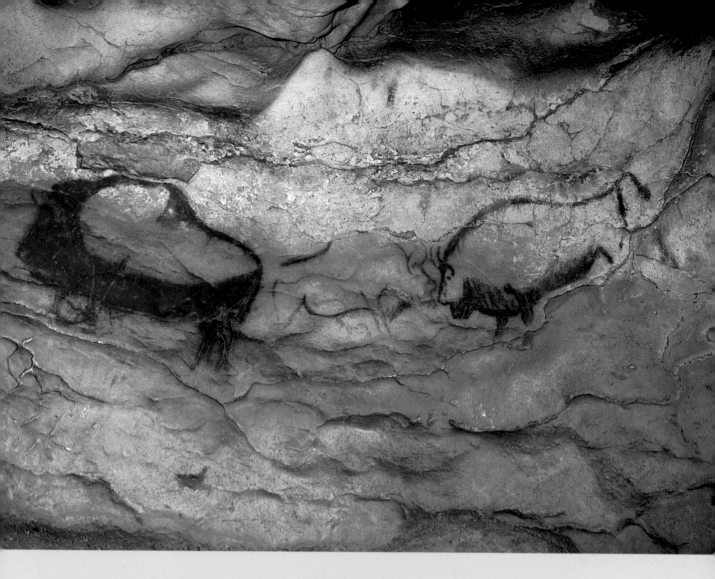

the Gravettians, from 28,000 to 22,000 B.P.; the Solutreans, from 22,000 to 18,000 B.P.; and the Magdalenians, from 18,000 to 11,000 B.P. (Traditionally, archaeologists give a particular material culture the name of the site where it was first discovered or where it is best known from its distinctive tools, weapons, and ornaments.)

The Holocene, the temperate-climate period in which we still live, followed the last Ice Age about eleven thousand years ago. It saw dramatic changes in the ways of life of people all over the world. On several continents hunter-gatherer cultures persisted—and still do in some remote regions. Other cultures, like those of the European Neolithic, or New Stone Age, became farmers or herders or both. Some invented metallurgy, such as copper during the Chalcolithic, which in some parts of the world, including Europe, was succeeded by the Bronze Age and then by the Iron Age, before the emergence of the complex societies we know now. Over the millennia, rock art was created by people who had all sorts of economies, except for our Western industrial societies.

Some of the world's most renowned ancient rock art adorns walls of caves in Europe. In this remarkable drawing in Le Portel cave, in the French Pyrenees, a female bison (right) nuzzles her calf, while an old male walks away. The scene was drawn by a Cro-Magnon artist about 13,000 years ago, at the end of the Pleistocene, during the final part of the last Ice Age.
Photo by L. de Seille

FIGURE 3.3
The lava formations on which these engravings of humans were made, at the Puapo site on the Big Island of Hawaii, have been dated as six hundred years old. This provides information on the age range of the art, which of course must be younger than the surface into which it was carved.

Photo by J. Clottes

In spite of its limitations, however, this method has yielded tremendous progress in archaeology. It has been applied to art on rock walls for about ten years, as scientific advances have made it possible to use only 0.5 milligram of carbon to establish a date, whereas in the past a much larger sample was necessary. So far, approximately eighty dates have been obtained for drawings in some ten caves in France and Spain. Other datings have been made in Australia, South Africa, and the United States, and more datings are in progress.

Nevertheless, a sufficient quantity of carbon-containing *organic* matter is indispensable for applying this method. This means that radiocarbon dating is not currently possible for engravings or sculptures, or for paintings made with mineral pigments, but only for those in which carbon was used, or those whose binding agent—the material used to give cohesion to the paint—is organic (blood, plant gum, or fat, for example) or contains an adequate amount of organic matter.

Therefore, because the vast majority of rock art cannot be dated directly, we try to date it indirectly. To do so, we can apply one of three types of research. These generally allow us to establish either a maximum possible age—"This drawing cannot be older than such and such number of years"—or a minimum age—"This drawing is at least so many years old but may be much older."

At times, geologic phenomena provide a solid point of reference. For example, we know that in Scandinavia the sea was eighty meters higher before the Neolithic, eight thousand years ago, than it is today. So if we find carvings at an altitude of forty meters, they clearly can only belong to a later period, such as the Bronze Age (FIGURE 3.2). On the

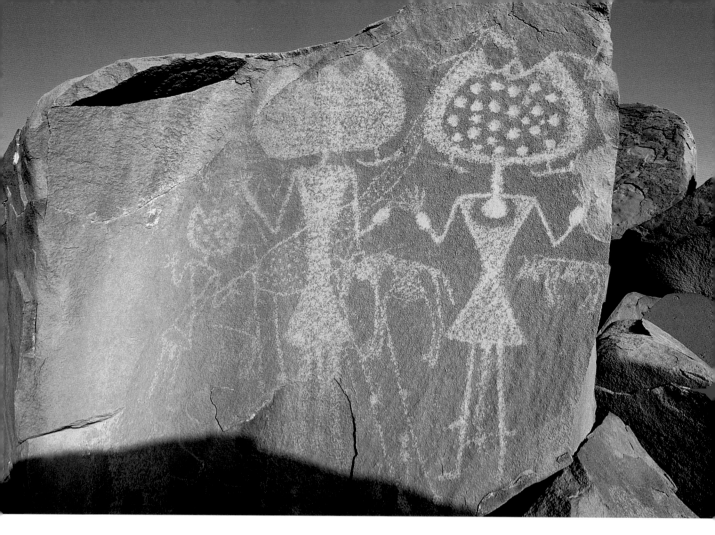

other hand, on the Big Island of Hawaii, with its very active volcano, lava dating back just six hundred years has been engraved: these engravings obviously are less than six centuries old (FIGURE 3.3).

In other cases, we can evaluate a work's age by assessing its current state or by considering its immediate environment (FIGURE 3.4). In areas such as Canada, where the climate is harsh, paintings exposed to the elements cannot be more than a few hundred years old; were they older, they would have been destroyed by wind, rain, and sleet (FIGURE 3.5). In the aridity of deserts, rock engravings change appearance over time as their patination darkens.

FIGURE 3.4
The engravings in the Aïr Mountains region of Niger have been roughly dated to between 1000 and 5000 B.P. through the study of the archaeological context—tombs, weapons, and tools of known age found nearby.
Photo by David Coulson, Trust for African Rock Art (TARA)

FIGURE 3.5
Given their exposure to the harsh climate, paintings such as this one at Pitt Lake, near Vancouver, Canada, are probably not more than a few centuries old. Were they older, they would likely be more severely degraded.
Photo by J. Clottes

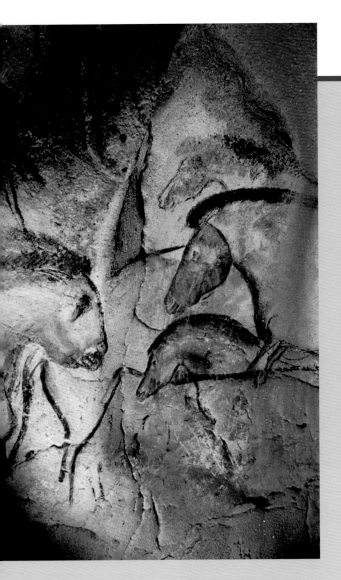

THE ORIGINS OF ART
Grotte Chauvet, France

In December 1994, three hardy speleologists were exploring the Cirque d'Estre Gorge, in the Ardèche region of southeastern France. They crawled through a small opening into a kind of antechamber, where they felt a mysterious draft. It turned out to be coming from a passageway hidden behind a pile of stones. The passageway in turn opened toward a large network of chambers eight to ten meters below. When the explorers lowered themselves down, they were astonished by what they saw. There were hearths, black with soot, that looked as if the fires had just been extinguished. There were calcite-covered bear skulls. And on the walls there were drawings and paintings—great friezes of mammoths and bears, cave lions and black horses, bison and reindeer and bulls, even a human figure, shown in complex scenes and, at times, in perspective. "Everything was so beautiful, so fresh," they later wrote. "It was as if time had been abolished."

Several radiocarbon datings of the striking charcoal drawings soon revealed that they were more than thirty thousand years old—at the time the oldest dated paintings in the world. The artists, it turned out, were Cro-Magnons, our direct ancestors. People came to the cavern perhaps to acquire the power of the great bears who hibernated here. The discovery of Grotte Chauvet has significantly altered our understanding of how the earliest currently known art of humankind evolved. This art did not begin with crude sketches some thirty-five thousand years ago, as was previously thought, and then develop gradually until it attained the mastery of the art at Lascaux and other later Paleolithic caves. On the contrary, there were great artists in the bear cave at Chauvet, more than three hundred centuries ago.

Horses are the animals most often represented in European cave art. Inner shading was used for these horses to give better relief to their heads and bodies.
Photo by J. Clottes

These two rhinoceroses have been dated to between 30,790 ± 600 and 32,410 ± 720 B.P.
Photo by J. Clottes

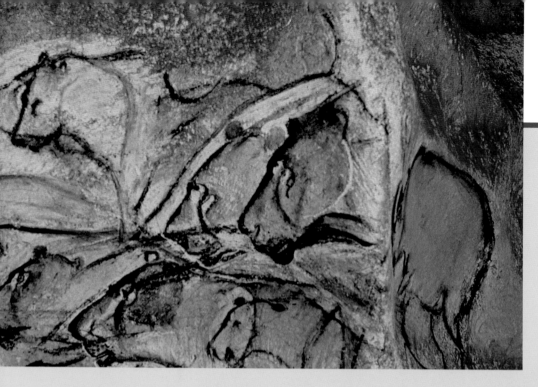

In European cave art, few scenes have been represented. This one, in the Grotte Chauvet, depicts the tense expression of a pride of lions hunting big game. To the right, a rhinoceros seems to emerge from a recess.
Photo by J. Clottes

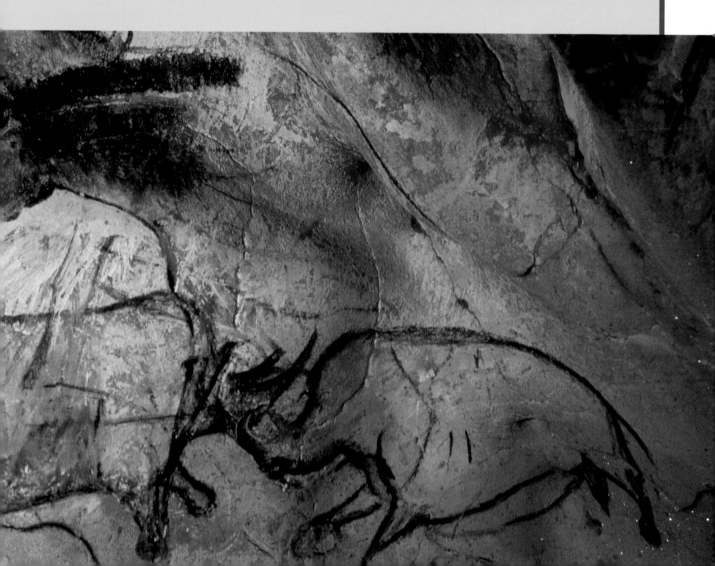

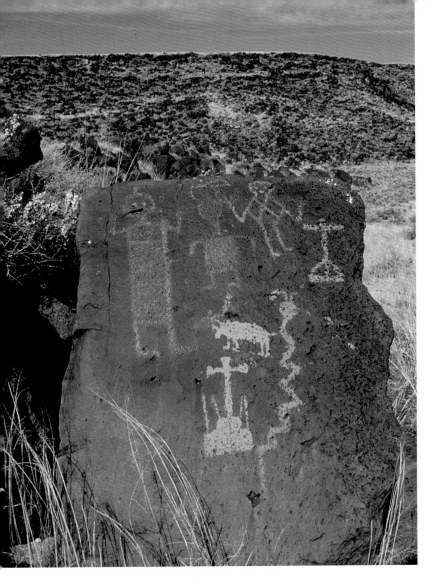

Consequently, whether in Niger or in New Mexico, the lightest carvings obviously are the most recent (FIGURE 3.6). This method, however, gives only a relative indication of age. In the United States and Australia, among other places, attempts have been made to obtain more definitive indications by radiocarbon dating old patination from the organic elements it has trapped. These methods are still experimental and controversial, for in fact it is not clear what is being dated, as the constituent elements of the varnish may have been integrated into it at various times and may therefore be of different ages.

It is also possible to establish minimal dates when paintings or engravings are partially covered by deposits that can be more faithfully dated than the patinations. In the Kimberleys and in other parts of Australia, wasp nests that have formed on drawings can, when they are very old, provide valid and useful dates (FIGURE 3.7). In other instances, dating fragments of decorated walls that have broken away, fallen, and been covered up by archaeological layers will give a minimal age, as is the case with the Early Man shelter and Carpenter's Gap in Australia, and a western Cape shelter in South Africa.[4] The same is true when habitation levels, which increase with time, eventually cover wall paintings; this has occurred at the Grotte du Placard in France. This archaeological approach proves even more precise when tools or materials used to create the drawings are discovered in a well-dated layer nearby: we then know that the date of the layer will be the date of the paintings. Such was the case with the Bidon cave in the Ardèche region of France, where splotches of red paint identical to that used in some of the paintings were discovered at the foot of the painted wall. Because the layer in

FIGURE 3.6
Different patinations, caused by the slow weathering of the rock surface, indicate that different engravings on the same rock are of different ages. The human figures on this rock at Petroglyph National Park, New Mexico, clearly are older than the other, brighter engravings, which include crosses intended to Christianize a pagan site.
Photo by J. Clottes

FIGURE 3.7
We can date the wasp nest covering this handprint at Anvil Creek, in the Selwyn Range in Australia, allowing us to establish a minimum age for the painting underneath.
Photo by J. Clottes

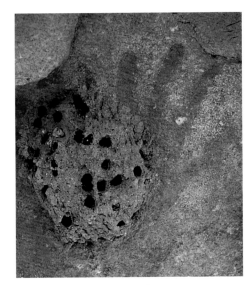

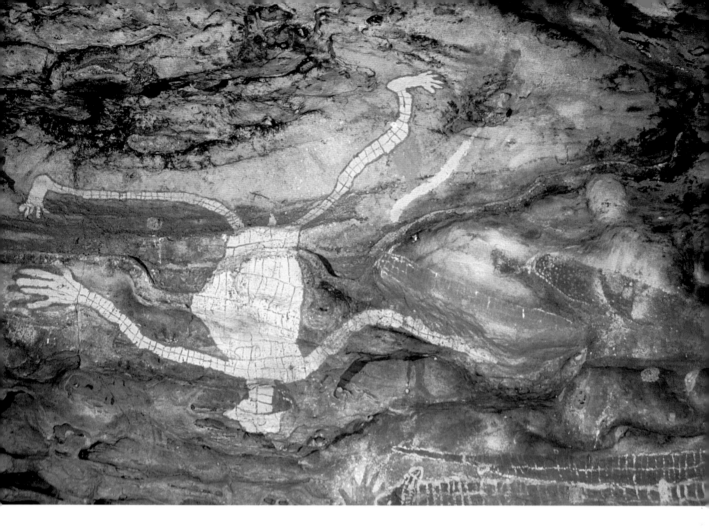

which these splotches were found included coal, the layer could be radiocarbon dated, to 21,650 ± 800 B.P., thereby permitting a precise chronological attribution of the artwork as well.

The images themselves may provide information that illuminates the date they were made. The repeated superimposition of certain kinds of images over others, when stylistic constants are observed, allows us to establish a relative chronology. That is how the Abbé Breuil tried to sort out empirically the evolution of European cave art and distinguished Magdalenian paintings from earlier ones. To apply such a method in a particular site or area, one must be able to clearly distinguish certain stylistic characteristics and figurative conventions that are always to be found in the same chronological order. Recently, this method allowed us to

distinguish two major periods in the art of the Grotte Cosquer in southern France; radiocarbon dating subsequently confirmed these observations.[5] Similarly, in the Laura region of Australia, because one can see that images of sorcery were always made after other images had already been painted on, it is possible to date the sorcery images to a relatively recent period (FIGURE 3.8).[6] This method is unreliable when one attempts to extrapolate results found at one site to the art of vast regions; for this reason, it is rather unpopular with many specialists today.

The subject matter of the paintings is itself often rich in chronological information (FIGURE 3.9). In Siberia and China, for example, comparison of motifs and conventions used in movable art, which is generally well dated, with rock art from the same area allows us to date the rock art indirectly.

FIGURE 3.8
In the Laura region of Australia, when human figures are shown upside down, it often indicates that they represent someone who has been placed under a sorcerer's spell. The person portrayed in this painting at Mushroom Rock appears to be wearing a uniform and a European-style hat, which in the late nineteenth and early twentieth century often meant that the figure was meant to be a white policeman or other person of authority. This painting would therefore be relatively recent.
Photo by J. Clottes

We can also sometimes date images by attributing them to a particular stage in the economic or social development of a given culture. For example, in the Sahara, the Bovidian Stage was defined from the many images of cattle that appear on rocks and that reflect a time when cattle were plentiful in this now-arid region.

Estimated minimal ages can be deduced from certain characteristic images as well. When animals belonging to extinct species are represented, the images cannot date from a period later than the time when these species were still living. Paintings depicting the thylacine, or Tasmanian wolf, for example, have been reported on the Australian

continent, where this animal became extinct about two thousand years ago, thereby allowing us to date these images to an earlier period.[7] However, this method has occasionally led to errors of interpretation, such as when the image of a mastodon was erroneously reported in Utah; the painting in question turned out to date from the nineteenth century and probably depicted a modern elephant.

Some drawings depict objects whose date of appearance in the culture under consideration is well established, either archaeologically or historically. The use of bows and arrows goes back to about A.D. 500 in North America, replacing the spear-thrower (atlatl)

FIGURE 3.9
We know that these paintings in Jhiri shelter no. 10, in the Bhopal region of India, are from a relatively recent period, because the horsemen's harnesses they depict were in use in recent times.
Photo by P. Vidal

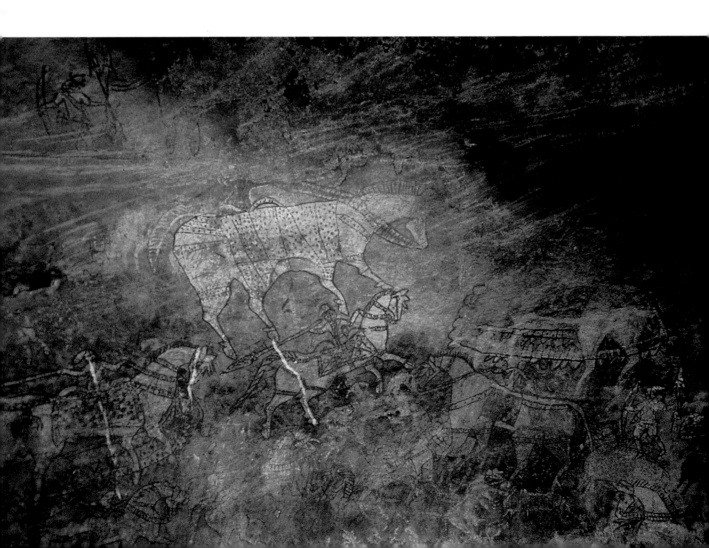

that was previously used (FIGURE 3.10). Petroglyphs showing the use of bows and arrows will have been done, therefore, after that date. Among the weapons depicted in the innumerable carvings at Mont Bégo, in France, are particular types of copper halberds—a kind of battle-ax—and daggers, which allowed specialists to attribute most of the works at this extensive site to the turning point between the Chalcolithic and the Ancient Bronze Age, more than four thousand years ago. The same way of dating rock engravings has been used in Valcamonica, in Italy (FIGURE 3.11).

In the Americas, Australia, and Africa, the arrival of Europeans deeply traumatized the indigenous populations, an experience

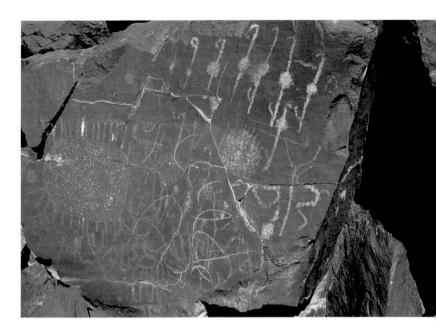

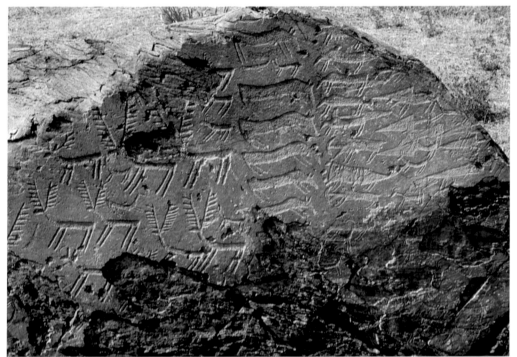

FIGURE 3.10
Engravings of atlatl, or spear-throwers, at Little Lake Duck Club in California. Because these weapons were replaced in North America by the bow and arrow around A.D. 500, we can be reasonably certain that these petroglyphs are at least fifteen hundred years old.
Photo by J. Clottes

FIGURE 3.11
The daggers depicted in the engravings on the right side of this rock, at Cemmo, in Capo di Ponte, Italy, were widely used during the Chalcolithic, allowing us to estimate the age of these petroglyphs to be about 4,500 years.
Photo by J. Clottes

FIGURE 3.12
When rock art refers to a specific historical event, generally from the period of the Contact, it is usually possible to date the art with confidence. These nineteenth-century Navajo paintings at Blue Bull Cave, Canyon de Chelly, Arizona, memorialize a tragic Spanish expedition that took place in 1805 and resulted in a terrible massacre. The gorge surrounding the cave where this occurred is known as Canyon del Muerto.
Photograph by Alain Briot © 2002

that can be seen in the rock art of these regions. On these continents there is an art of the so-called Contact Period or after, in which we see foreign ships, horsemen armed with rifles, and battle scenes, all of which can be perfectly dated. In Canyon del Muerto, in the Canyon de Chelly region of the United States, Navajo rock paintings commemorate the terrible Narbona expedition in 1805 (FIGURE 3.12), when a lieutenant named Antonio Narbona was sent north from Sonora with troops to help Spanish settlers against the Navajo; his men killed more than one hundred Navajo, including women and children who had taken refuge high up on a cliff, in a shelter that has since been called the Massacre Cave.

The Oldest Rock Art

Although it has long been believed that the oldest rock art was to be found in Europe, there is evidence that much older forms of the art exist on other continents. The systematic use of hematite, for example, a mineral prized by traditional peoples and used throughout the world to make red paint, has been established in extremely remote times.

In Acheulean sites—sites dating from almost three hundred thousand years ago—the presence of red ocher (an impure iron oxide) or of blocks of hematite has been reported in Africa, India, and Europe. The use of ocher became common only later, but still before modern humans, in particular by

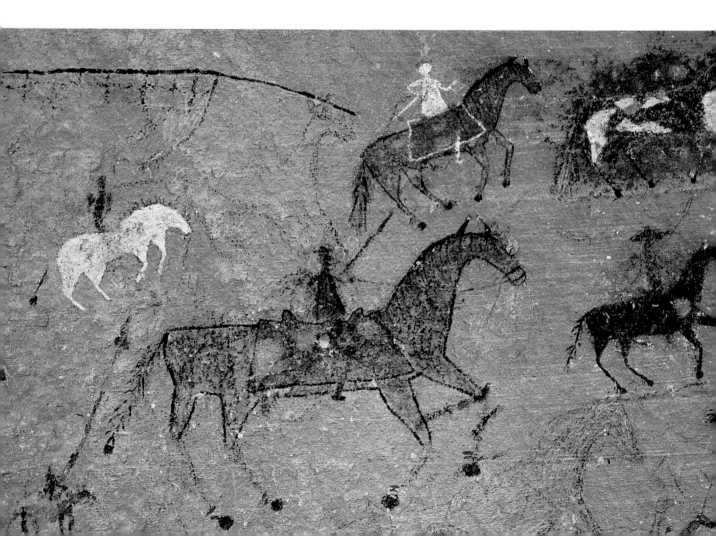

Neanderthals during the European Mouste-
rian. However, the available evidence does
not allow us to establish with certainty that
any of these cultures created rock art.

Digs in Nauwalabila in Australia's
Northern Territory have revealed chiseled
hematite blocks with striations and other
signs of use, in a layer dated to between fifty-
five thousand and sixty thousand years ago.[9]
Recently, comparable discoveries have been
made in South Africa's Blombos Cave, in a
layer dating to between eighty thousand and
one hundred thousand years ago.[10] Even if
this mineral was used in the tanning of hides,
those who did so could not have failed to
notice its pictorial properties. This is just one
step from thinking that they used it to make

paintings, for now we are talking about
modern humans, *Homo sapiens sapiens,* our
direct ancestors. Nothing in their makeup
would have prevented them from creating
true art. Formal proof of an art this old is
still lacking, which is in itself not surprising,
given that the older the art, the less likely
it is to have survived. However, in 2002 the
discovery was announced of a piece of
hematite engraved with a complex geometric
motif. It had been found in an archaeological
layer in Blombos Cave and dated to between
seventy thousand and eighty thousand
years ago.

The other oldest indisputable dating
of an engraved rock is a block covered by
approximately twenty cupules, small round
artificial hollows that may or may not be art.
Discovered in 1921 at the French site of La
Ferrassie, in the Dordogne, that block was in
a Mousterian archaeological layer that con-
tained the tomb of a Neanderthal child. The
engraved block is likely to be of comparable
antiquity—between forty thousand and fifty
thousand years old—and thus belong to a
humanity older than our own.

The oldest dates recently proposed for
cupules would place them in the Acheulean
age, for the Auditorium shelter site in
Bhimbetka, in India, and at more than one
hundred thousand years ago, for those found
at Jinmium, in Australia. In fact, the latter
date was erroneous, for the art was actually
much more recent, and the accuracy of the
chronological attribution of the Indian site
is still doubtful.[11]

The earliest dates that until now have
been established for rock art, strictly speak-
ing, are between 30,000 and 40,000 B.P.
These dates were obtained in Australia, in
the rock shelter at Carpenter's Gap in the
Kimberleys, where a wall fragment was
revealed in an archaeological layer dated
with radiocarbon.[12] The wall had been

FIGURE 3.13
This painted tablet was discovered in two pieces in Namibia in an archaeological layer dated to between 26,300 and 28,400 B.P. The discovery occurred during the flight of Apollo 11, and the shelter where it was found now whimsically bears that name. The two separate pieces underwent different patinations. Before the recent discovery of a piece of engraved hematite in the Blombos Cave in South Africa, this tablet was the oldest evidence of art found in Africa. It is now in the National Museum of Windhoek.
Photo by J. Clottes

painted red, but it collapsed, and when it was found it was not well enough preserved for us to see what was depicted on it. Dates on the order of forty thousand years old for the engravings in Olary Province, on the other hand, were obtained using experimental methods and thus cannot be accepted, at least not for the moment.

In Europe, the Aurignacians—the first Cro-Magnons to reach France and Spain, about 40,000 years ago—created rock art. More than 35,000 years ago, these people carved striations into the walls of the rock shelter of La Viña, in the Asturias region of Spain, and they also made the carvings in blocks with a variety of motifs—including cupules and vulvas—found in the Dordogne.

The most spectacular discovery was made at the Grotte Chauvet. Samples of several animals drawn with charcoal yielded ten direct dates, between 30,000 and 32,400 B.P. These are the oldest naturalistic paintings currently known in the world (see pp. 44–45).

In African art of comparable antiquity, only movable art—in this case, animals painted on stone plaquettes in the Apollo 11 rock shelter in Namibia—has been dated with any certainty (FIGURE 3.13). The layer

in which the animals drawings were found was dated to between 26,300 and 28,400 B.P. While these paintings suggest that art was made on rock walls at the same time, perhaps even earlier, we have yet to find and date it.

We encounter similar problems in Asia. Remarkable decorated objects are known to have been made in western Siberia as early as 35,000 B.P. Various kinds of such objects, only slightly more recent, have also been reported in China and India, but not a single indisputably Paleolithic rock art site has yet been documented in Asia. This is probably because of gaps in research and because of problems relating to the survival of art this old. It would not be surprising if work currently being done on this immense continent will one day reveal decorated rock shelters dating to a period at least as remote as those in Europe or Australia.

The Americas present a special case. Oddly enough, while a number of North American specialists still refuse to accept dates before 13,000 B.P. for the population of the continent by the route across the Bering Strait and while controversy has long raged on the subject, remote dates have been suggested both for carvings in the United States (16,500 years)[13] and for Brazilian paintings in the Piauí region. The Piauí paintings have been reliably dated to about 17,000 B.P.., and the archaeologist Niede Guidon, who has long worked at the site, thinks that it may contain rock art up to 46,000 years old. She bases this estimate on the discovery of fragments of a wall bearing traces of paint in dated layers.[14] Although these dates are still controversial, it is more than likely that the existence of an American rock art older than the Holocene will eventually be confirmed.

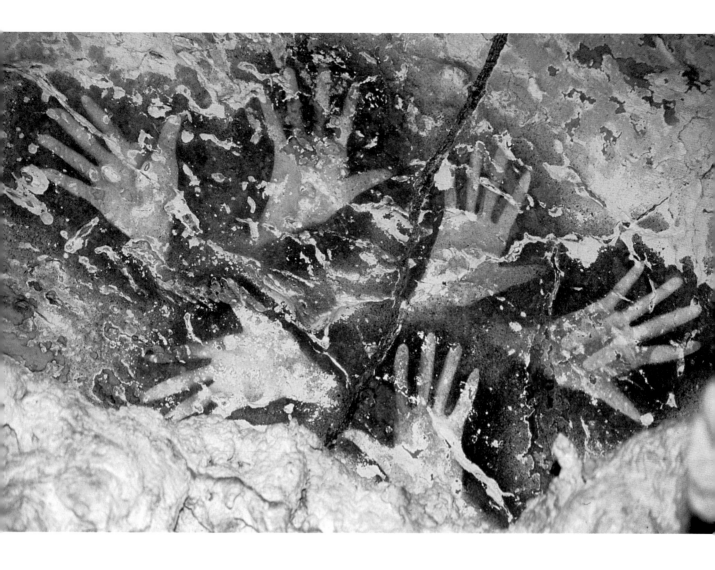

Holocene Rock Art

Most extant rock art was created during the Holocene epoch. Currently, most of this art is poorly dated if it is dated at all. When we discover paintings, say, on the walls of a cave lost in a jungle, as was recently the case in Borneo (FIGURE 3.14), or carvings on rocks in a desert, such as in Saudi Arabia, if none of the methods mentioned above can be applied, it is generally impossible to date the paintings precisely within the last ten thousand years. To do so invariably takes time, occasionally requires digs to determine the relevant archaeological context, and always requires a great deal of money and effort. There is a risk of working too quickly and perhaps developing an uncertain chronological model that will burden—and possibly long mislead—future research. Little by little, however, research methods are becoming increasingly rigorous, more specialists are working on rock art, their analyses are yielding new dates, and in-depth studies are being published on art all over the world.[15]

FIGURE 3.14
These ghostly hand stencils in the Ilas Kenceng cave, in Borneo, have not yet been dated but are probably many thousands of years old. This remote site, surrounded by dense jungle, was discovered only recently. Several other caves with hand stencils and other motifs have also been found in the area.
Photo by L. H. Fage

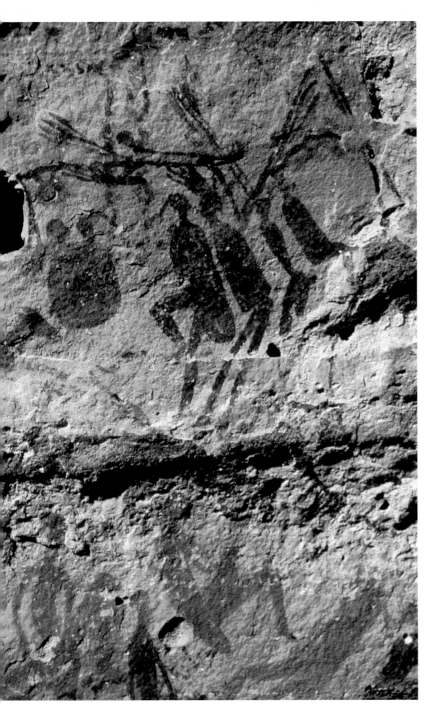

In much of the world, rock art was produced until very recently. While this is not true in Europe—Scandinavian rock art, for example, hardly continued after the Iron Age and alpine art after the Middle Ages—drawings on rocks were still being made, in the context of traditional ceremonies, in California and southern Africa well into the nineteenth century (FIGURE 3.15). During the past few hundred years, the growing influence of the West is evident in the Contact Period paintings in southern Africa, Australia, and the Americas. Then ancient practices were abandoned, and rock art became a relic of the past.

In Australia, some of the last documented paintings were created by an artist known to us. His name was Nayombolmi. The images he painted with his friends Djimongurr and Djorlom at Nourlangie Rock, in what is now Kakadu National Park, were made in 1964 (FIGURE 3.16). When he was asked why he was painting these pictures, Nayombolmi replied, "I want to put the people back into the rock-shelters."[16] It is tragic to think that the tradition of rock art, which is tens of thousands of years old, reflected original and unique conceptions of the world, and had been continuously practiced across the millennia throughout this vast continent, ended less than forty years ago.

With very few exceptions, such as the Dogon people in Mali, traditional rock art is no longer made in the world today.

FIGURE 3.15
San people living in the Drakensberg region of South Africa continued to paint in the traditional way well into the nineteenth century. Certain paintings may be relatively recent.
Photo by J. Clottes

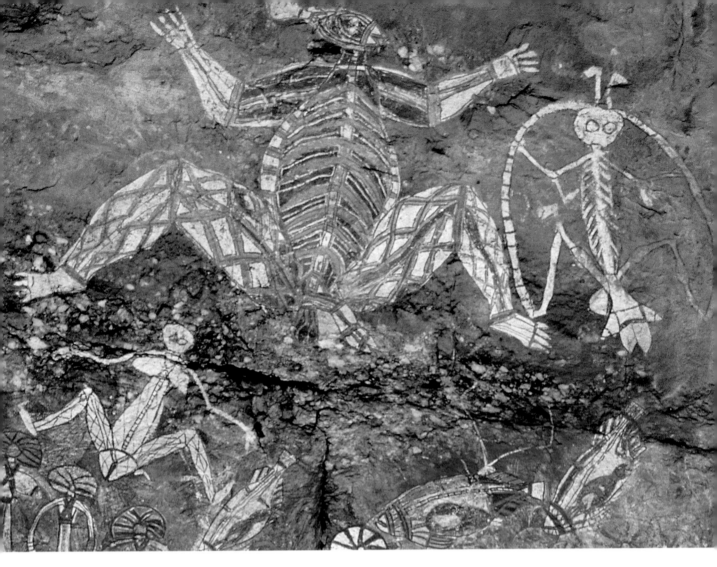

NOTES

1 J. Flood, *Rock Art of the Dreamtime* (Sydney: HarperCollins, 1997).

2 J. Flood, *The Riches of Ancient Australia: A Journey into Prehistory* (St. Lucia: University of Queensland Press, 1990), 70–71.

3 P. G. Bahn, *The Cambridge Illustrated History of Prehistoric Art* (Cambridge: Cambridge University Press, 1988).

4 D. Coulson and A. Campbell, *African Rock Art: Paintings and Engravings on Stone* (New York: Harry Abrams, 2001), 75.

5 J. Clottes and J. Courtin, *The Cave beneath the Sea: Paleolithic Images at Cosquer* (New York: Harry Abrams, 1996).

6 P. Trezise, *Dream Road* (St. Leonards: Allen & Unwin, 1993).

7 Chaloupka, *Journey in Time*.

8 On the use of ocher throughout the ages, see M. Lorblanchet, *La naissance de l'art: Genèse de l'art préhistorique dans le monde* (Paris: Errance, 1999), 103–14.

9 Flood, *Rock Art of the Dreamtime*.

10 C. Henshilwood and J. Sealy, "Blombos Cave: Exciting New Finds from the Middle Stone Age," *Digging Stick* 15, no. 1 (1998): 1–4.

11 Lorblanchet, *La naissance de l'art*, 195–202.

12 S. O'Connor, "Carpenter's Gap Rockshelter I: 40,000 Years of Aboriginal Occupation in the Napier Ranges, Kimberley, W.A.," *Australian Archaeology* 40 (1995): 58–59.

13 D. Whitley, R. Dorn, J. Francis, L. Loendorf, T. Holcomb, R. Tanner, and J. Bozovich, "Recent Advances in Petroglyph Dating and Their Implications for the Pre-Clovis Occupation of North America," *Proceedings of the Society for California Archaeology* 9 (1996): 92–103.

14 N. Guidon, *Peintures préhistoriques du Brésil* (Paris: ERC, 1991), 29.

15 To keep abreast of progress, see INORA (*International Newsletter on Rock Art*), which appears three times a year in French and English.

16 As quoted by Flood, *Rock Art of the Dreamtime*, 290.

FIGURE 3.16

These images of people and spirits were painted in 1964 in the classic X-ray style by the artist Nayombolmi and several friends in the Anbangbang shelter, at Nourlangie Rock, in the Kakadu region of Australia. They are among the last traditional rock art paintings made anywhere in the world, though repainting of rock art continues to be practiced in some areas of Australia.

Photo by J. Clottes

HOW WAS IT MADE?

Throughout the world, rock art has been created by people with limited technical means. Many were hunter-gatherers, but agriculturalists and herders used similarly rudimentary tools in making their paintings, drawings, and engravings. Throughout human history, people faced similar challenges when, for whatever reason, they sought to leave their mark on stone (FIGURE 4.1). Similar techniques, therefore, were used almost everywhere. Truly extraordinary creations, such as geoglyphs, also can be found across a wide range of places and cultures. Rock art in all its forms testifies to the limitlessness of human ingenuity.

FIGURE 4.1
Remarkable engravings of cattle, carved thousands of years ago, adorn this rock in the Sahara Desert in Algeria.
Photo by David Coulson, Trust for African Rock Art (TARA)

FIGURE 4.2
The area around the Pic des Merveilles, near Mont Bégo, France, contains thousands of rock engravings.
Photo by J. Clottes

Choosing a Place

The choice of place influences in various ways the techniques used to create the art. Because this choice was largely a function of belief and myth, rock art generally derives its meaning from a much larger aggregate of significant factors, ranging from religious practices to natural landscape formations, even the weather. For example, the tens of thousands of engravings around Mont Bégo (FIGURE 4.2), at an altitude of between 2,200 and 2,700 meters, are related directly to the mountain's most spectacular climatological function, which is to attract storms during the summer, the only season when the rocks were accessible. In other locales, such as Utah and Baja California, rock paintings might be concentrated in canyons. Decorated sites also often have been linked to the presence of water and to elevated places; this can be observed in all periods and places, from such outdoor Paleolithic sites as Foz Côa in Portugal and Siega Verde in Spain to the Comanche Gap Ridge near Albuquerque, New Mexico. The latter bears many warrior symbols, which demarcate territory and serve as a warning to strangers (see FIGURE 6.7).

Distinctive geologic phenomena have always been incorporated into beliefs, often playing a major role that has been reinforced by rock art. It is surely no coincidence that the famous, profusely decorated Grotte Chauvet was located just a few hundred meters from the Pont d'Arc, an impressive natural bridge hollowed out of the rock by the Ardèche River. In Niger's Aïr Desert, the rock piles containing the largest boulders are those that bear engravings. New rock art sites have been discovered just by seeking out the most imposing of these accumulations of stones. The dark reliefs of the Brandberg massif, in Namibia, can be seen from far

across the desert; these mountains contain more than one thousand decorated sites.

Perhaps the most extraordinary example is Uluru-kata Tjuta, or Uluru, in the heart of Australia. Previously known as Ayers Rock, it is a sacred place, inextricably linked to the myths of the tribes that for thousands of years have gathered there and covered its walls with paintings (FIGURE 4.3). This immense monolith rises in the middle of the desert; at sunrise and sunset it undergoes an impressive change of colors, passing from one glowing red hue to another. These colors appear to have influenced the art that was practiced there. When the archaeologist Charles Mountford visited Uluru, along with its traditional aboriginal owners, more than half a century ago, "he recorded the presence of blood marks mixed with ochre right along the back wall of the initiation cave, a men's sacred site to which all public access is now forbidden."[1]

People around the world have exhibited the same kinds of anthropocentric attitudes. Whatever the culture, we have always had a tendency to consider that we are at the center of things, that the universe revolves around us. For people with no knowledge of geology—that is, for the great majority of humankind—any imposing feature in the landscape is likely to be endowed with meaning and take a place in their beliefs about their genesis or history.

Some natural formations are seen to be places of power where supernatural forces can be tapped. California's Coso Range contains more than one hundred thousand engravings. One of the driest places on earth, it was a gathering place for shaman rainmakers well into the nineteenth century. Because the supernatural world was thought to be the exact opposite of the world of the living, these sites, so inhospitable for humans, were seen as particularly suitable for invoking supernatural assistance in the search for life-giving water.[2]

In addition to myths and beliefs, the nature of the support—the surface on which the art was created—influenced the selection of technique. Certain granular rocks, for example, do not lend themselves to fine engraving but are more suitable for deep engraving, pecking, or painting. Caves, meanwhile, may contain old concretions, which are fairly easy to sculpt (as in Guatemala), or clay, which facilitates modeling and engraving on the ground (as in the French Pyrenees). Sculptures last a long time, whereas the more vulnerable engravings and modelings will be less likely to survive, even in deep caves. As for outdoor images, engravings generally withstand the elements better than do paintings. The exposure of the decorated rock and the quality of the surface also play an important role in the permanence or premature disappearance of works.

The choice of place also influenced the longevity of the images. From the evidence at

FIGURE 4.3
Uluru-Kata Tjuta, formerly known as Ayers Rock, has long been revered by the indigenous people of Australia. An initiation cave there is adorned with markings. Public access to this cave is forbidden.
Photo © Australian Tourist Commission

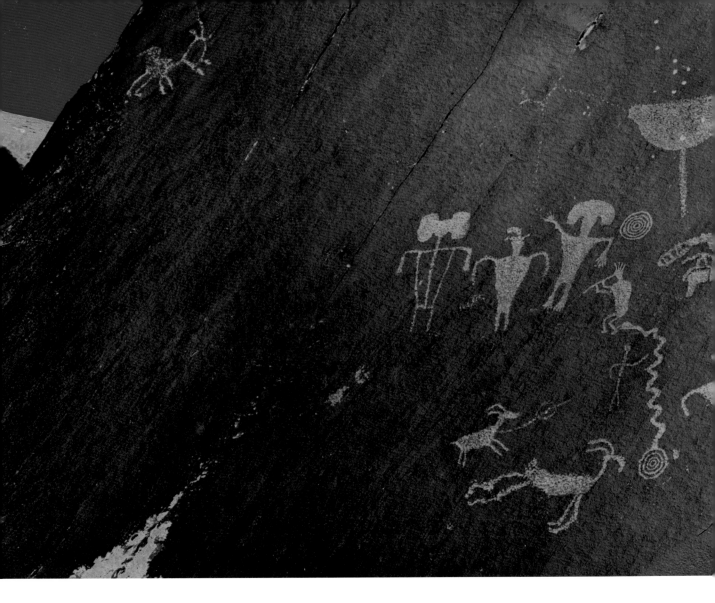

our disposal, however, it does not appear
that the long-term preservation of the
images was a criterion people considered
when choosing locations to make the art.

Generally, therefore, it is meaningless to
isolate paintings and engravings from their
natural settings. They are not individual
works on the walls of cliffs or on rocks, like
paintings hanging on the walls of a museum.
Their full meaning can only be appreciated
in a broader context, in which water, cliffs,
shelters, rocks, and weather—and the sacred
stories attached to them—are every bit as
significant as the images created by men
and women.

Pictorial Techniques

Although it is generally thought that paint-
ing is the most important technique used in
rock art, probably because rock paintings are
often so impressive, rock engravings, or pet-
roglyphs, are in fact much more numerous.
Perhaps this is because paint, when exposed
to the elements, erodes and disappears more
quickly than do engravings. Not a single
open-air Paleolithic rock painting has been
found, for example, whereas a number of
outdoor Paleolithic engravings recently have
been discovered, in the Iberian Peninsula
(they have not been found in the harsher
northern latitudes).

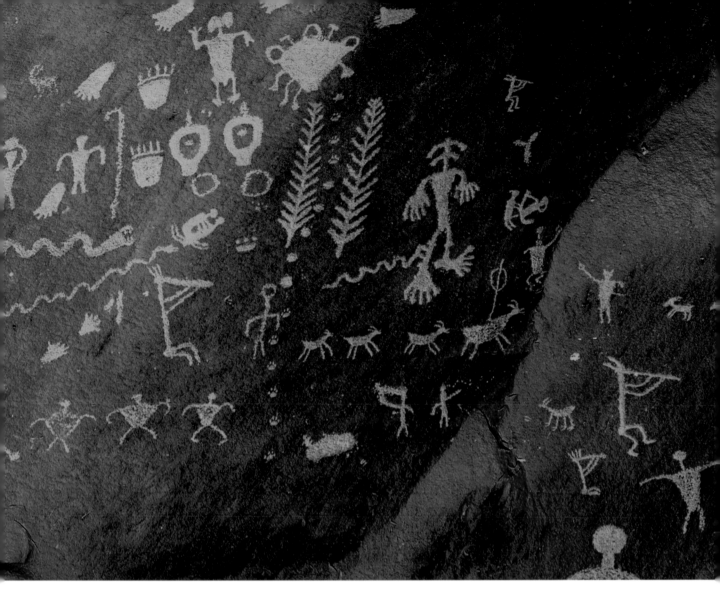

ENGRAVINGS

To engrave is to remove or displace matter on a given surface, using a tool to create a line. The choice of technique depends on the quality of the rock, the tool used, and the force exerted. These factors, differently combined, result in different techniques and, of course, produce different kinds of engravings.

Ancient engravings are patinated. This means that their surface has undergone a secondary alteration, which makes them increasingly similar in appearance to the rock surface on which they were made. Generally, the older the engraving, the more pronounced the patination. This also depends on its exposure to the elements. In many cases, the engraving has become less visible over time. When it was created, the action of the tool broke the rock's thin and often dark surface layer to reveal the bright color of the mother rock underneath (FIGURE 4.4). We know through experimentation that fresh engravings can be seen every bit as easily as paintings. They stand out—in white or pink, depending on the rock used—against the surrounding surface. Even the finest engravings, in other words, were once clearly visible.

There are six principal rock engraving techniques: finger flutings, fine engraving,

deep engraving, pecking, scraping, and polishing. Frequently, several techniques were employed in the creation of a single work.

Finger flutings are found only in deep caves (FIGURE 4.5). They were made using one or several fingers on the soft surface of walls and vaults covered with clay or *mondmilch*—a whitish, claylike substance created by calcium carbonate precipitation. They can occupy dozens of square meters, with stripes and whirls crisscrossing each other in all directions. Animals may have been drawn with this technique, which was used throughout the twenty thousand years of European Paleolithic art. Examples have also been recorded in Australia, in Paleolithic as well as in more recently decorated caves.

In a few rare prehistoric caves, drawings were made on the clay ground, using either a finger or some kind of instrument. If such drawings still exist today, it is only because they were not gradually effaced by people walking on them or obliterated by natural erosion. It is likely that this type of work once existed in many cultural contexts but—not surprisingly, in view of its intrinsic vulnerability—has long since disappeared.

Fine engravings are also common in European caves, whose hard walls were decorated using flint tools. Fine engravings are more difficult to recognize in the outdoors, where they are not as well preserved. However, modern research techniques have allowed us to discover them on sites dating from all periods and in various non-European sites, ranging from the southwestern United States to the Sahara and Australia. Limestone and schist surfaces are well suited to fine engraving.

Deep engravings are found everywhere. They can be made on all types of rock and are easily seen and preserved. They have been created using a number of techniques, including repeatedly working over a series of parallel lines until the outline reaches the desired width and depth and repeated pecking to form a single groove. The engravings of the Messak in Libya are among the most spectacular in the world (FIGURE 4.6). The inside of the large line is sometimes polished to finish and improve its appearance.

Pecking (FIGURE 4.7) is rare in European caves but is the most commonly used rock art technique elsewhere in the world.

FIGURE 4.5
An abstract swirl of flutings, made by artists of the European Ice Age, who used their fingers to trace patterns on the soft clay, covers a wall of the Grotte Gargas, France.
Photo by R. Robert

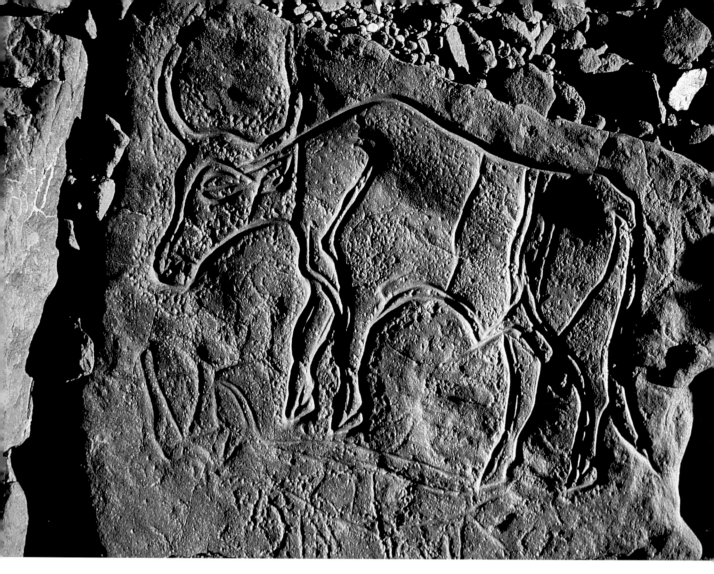

Volcanic rocks with very dark patination are especially well suited to this technique, as we can see in the Rio Grande Valley in New Mexico and in the ancient lava flows of Hawaii.

Scraping was often used to give a light, painted effect on large surfaces, sometimes within the bodies of the animals or people depicted and sometimes to emphasize their silhouettes.

After scraping, the rock was occasionally polished. *Polishing* surfaces and engraved lines erased all traces of earlier work and guaranteed the evenness and unified appearance of the engraving.

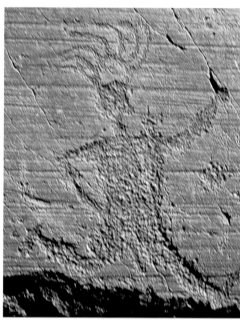

FIGURE 4.6
Deep engraving of a bull, with polished lines, in the Messak region of Libya.
Photo by A. Van Albada

FIGURE 4.7
This engraving of a running man with a flamboyant headdress, in Naquane, Italy, was created using the pecking technique.
Photo by J. Clottes

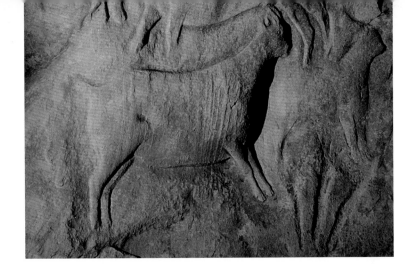

SCULPTURES

Sculpture is perhaps the most impressive rock art technique used on walls. It required the most time and work. Although it is known to have been used from the late Paleolithic, it is relatively rare. The very early images were bas-relief, in which figures protrude a few centimeters from the rock background to which they adhere. In France, the Magdalenian friezes of the Roc-aux-Sorciers (Angles-sur-l'Anglin; FIGURE 4.8) and of the Cap Blanc in the Dordogne are rightly famous. Clay modeling is an unusual form of sculpture, present only in the French Pyrenees during the Magdalenian. In Montespan (Haute-Garonne), true statues depicting a bear and a cave lion have been found. In Le Tuc d'Audoubert (Ariège), two splendid clay bison were discovered in 1912; they have been dated to about 14,500 B.P., based on the radiocarbon dating of a burned animal bone found at the site (FIGURE 4.9). Sculpture was sometimes combined with engraving, as in the case of certain panels of the Messak in Libya (FIGURE 4.10) and with the Dabous giraffes in Niger (FIGURE 4.11).

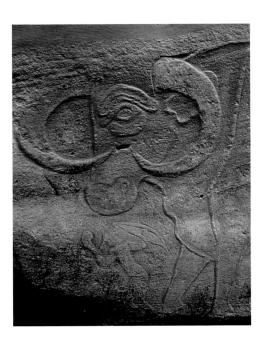

FIGURE 4.8 (top)
Wall sculptures of an ibex and, at lower right, a woman's lower body, from the Roc-aux-Sorciers shelter, in Angles-sur-l'Anglin, France.

Photo by J. Clottes

FIGURE 4.9 (above)
These bison, modeled in clay in the Caverne du Tuc d'Audoubert, France, date to the Magdalenian period, between 14,000 and 15,000 years ago. They are the first Paleolithic sculptures ever found.

Photo by R. Bégouën

FIGURE 4.10
Bas-relief sculptures of a large steer, with engraved features, and a small man, in the Messak region of Libya.

Photo by A. Van Albada

FIGURE 4.11
The spectacular deep, polished engravings of giraffe at Dabous in Niger have been carved into a rocky outcrop near an ancient lake bed. From head to back heel, the large giraffe measures 6.3 meters; in other words, the scale is life-size. The spots are rendered in bas-relief.

Photo by David Coulson, Trust for African Rock Art (TARA)

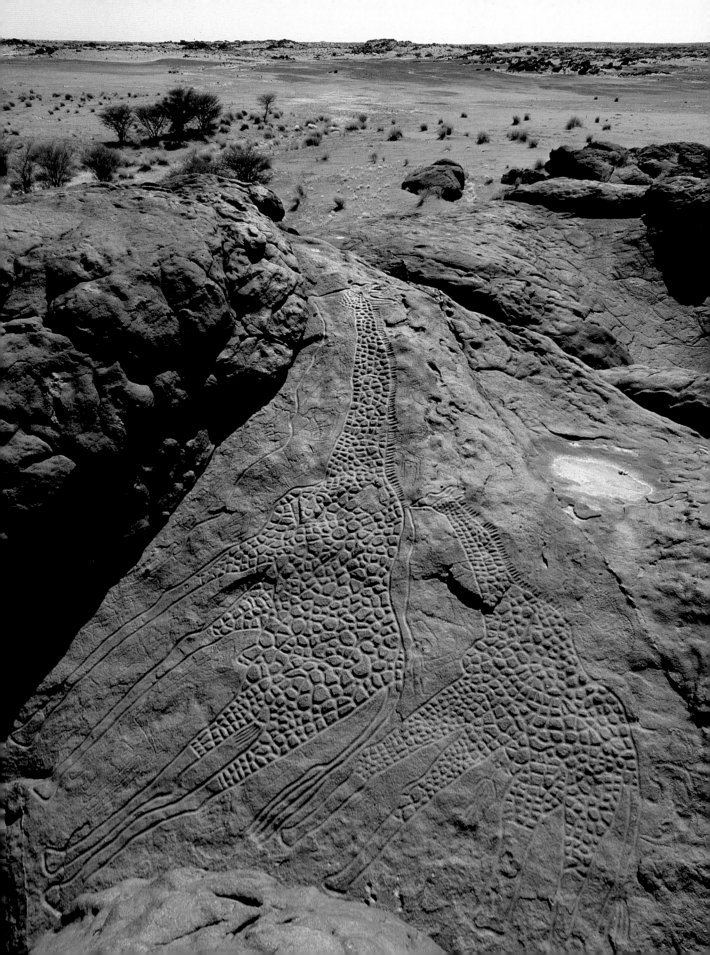

66

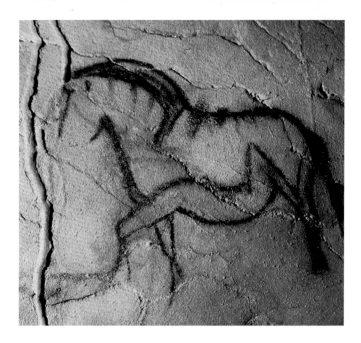

FIGURE 4.12
For simple silhouettes, like these in the Magda-lenian Portel cave in the French Pyrenees, it is difficult to distinguish drawings from paintings. This horse is one of a number of such drawings along a narrow gallery. On another wall in the same cave, the animals depicted are mostly bison.

Photo by L. de Seille

PAINTINGS AND DRAWINGS

Although perhaps not as spectacular as sculptures, rock paintings invariably elicit awe and wonder from modern-day visitors. As techniques, painting and drawing allow for far more diversity than engraving, because artists have been able to choose among an infinite range of colors.

To paint or draw, of course, is to add matter, not remove it, as in engraving. In examining a work, it is often difficult to distinguish painting from drawing (FIGURE 4.12). For drawings, the artist uses a solid coloring agent, which he handles like a pencil. Charcoal was often used to obtain blacks, for example. Naturally occuring iron oxides were used for reds and yellows. Their color depended on their degree of oxidation; the less oxidized goethite was used for yellow, and the more oxidized hematite was used for dark reds. In some regions of Australia, drawings have been made by applying beeswax to a wall (see FIGURE 5.7).

Paint requires what modern artists call a binder to give it cohesion. This could be a material such as egg white or fat. In Australia and in southern Africa, blood was used for its symbolic value. Water was sometimes used to give paint fluidity. An extender was at times added to the paint, usually a mineral in powder form. The extender serves to economize on pigment, facilitate the application of paint on the rock, and keep the paint from cracking or flaking as it dries. Physico-chemical analyses have revealed the existence of true pictorial recipes, including various extenders, in the Magdalenian in the French Pyrenees, between 14,500 and 13,000 B.P.[3]

As a technique, painting allows many stylistic variations (FIGURE 4.13). Some figures are simple silhouettes with no internal detail,

similar to drawings and engravings. With others, the entire interior of the body is a single flat color. Modeling effects were sometimes achieved through stump drawing—the irregular application of paint, either by hand or with a pad, to obtain the desired texture. The earliest known examples of this technique, which are truly masterly, can be found in the Grotte Chauvet; they were executed more than thirty thousand years ago (see pp. 44–45). Two colors (bichrome) or several colors (polychrome) were often combined to obtain the desired effect. These techniques are not limited to a given place or era. They can be found everywhere paintings have been preserved, from European Paleolithic works up through those created by Bushmen in southern Africa in the nineteenth century.

Paint might be applied with a finger, a stick or bone, a leather pad, or a paintbrush with animal hair bristles. A painstaking study

FIGURE 4.13
In this well-preserved panel at a site in eastern Zimbabwe, a procession of human figures seems to parade past other, older images, including a dark buffalo. Layers of images were often superimposed by generations of San artists working at sites like this.
Photo by David Coulson, Trust for African Rock Art (TARA)

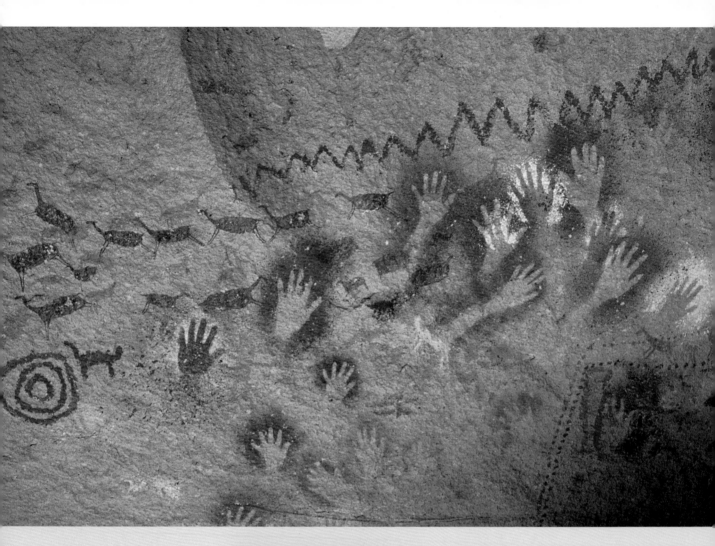

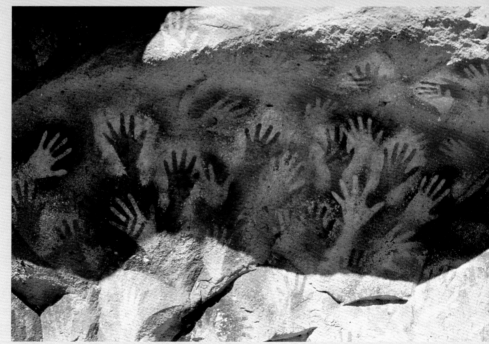

Above
Hand stencils, guanacos, and geometric designs in the Cueva de las Manos.
Photo by J. Clottes

Above, right
The Cueva de las Manos site, in the center of the photograph, was selected for its special position in the landscape.
Photo by J. Clottes

Right
A few of the hundreds of hand stencils at the Cueva de las Manos. They were made by blowing red, white, or black paint over a hand pressed against the wall.
Photo by J. Clottes

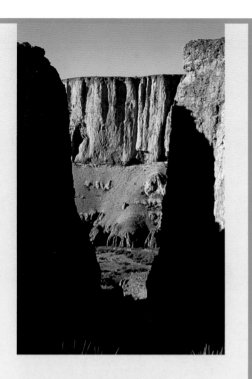

CAVE OF HANDS
Cueva de las Manos, Patagonia, Argentina

The Cueva de las Manos is one of about a dozen rock art sites on UNESCO's World Heritage List. It is spectacularly situated overlooking a verdant canyon in the exact geometric center of a towering cliff that dominates the Río Pinturas. For about eight thousand years the site was constantly visited and used. The most likely access to the cave was from the arid plateau above, by means of a very steep descent between two tall walls into the canyon. Thousands of hand stencils were probably made in the cave, during ceremonies whose exact meaning is now lost. About 830 of these are still preserved, together with many drawings of animals, including local camelids called guanacos, as well as depictions of humans and geometric signs. Argentinian archaeologists have dated the earliest drawings to 9300 B.P.

of lines generally allows us to determine the technique or techniques that were used.

In spite of its oddity, *spraying* was also used in all periods and on all continents. Rather than apply paint by hand, an artist would blow or spray it from his mouth; the person's breath was sometimes believed to pass into the painting and give it life. The most common motif produced using this technique is the hand stencil. A hand was placed on the rock and paint sprayed on and around it. When the hand was removed, its shape appeared, in negative, as a stencil. Other objects could be used as well. In the Cueva de las Manos, in Patagonia, bird feet were painted using this technique, in the midst of countless hands. The stencil technique has occasionally been used—in Lascaux and Pech-Merle, for example—to draw the outlines of animals and to render the effect of color gradation.

Beginning in the Paleolithic and continuing to much later times, painted and engraved animals are most often represented in profile. This is so widespread, in all sorts of cultures, times, and places, that the reason cannot be cultural. From a distance, animal silhouettes are far more distinctive when seen in profile than when seen from the front or the rear. An observer will be able to tell whether the animal is an aurochs or a bison, a male or a female, and so on. The proportions of the body, the anatomical details of the head, the horns, or the ears, the line of the back and the tail—these provide a wealth of detail that can be depicted when the animal is sketched in profile. Humans, by contrast, are often shown from the front.

Many art historians have claimed that spatial perspective was invented during the Italian Renaissance. In fact, it was reinvented then. Paleolithic artists used various means

to render perspective as early as the Aurignacian, more than thirty thousand years ago. In the Grotte Chauvet, for example, the horns of seven rhinoceroses drawn side by side are represented in true perspective, with the figures in the foreground being the longest and successive figures gradually decreasing in length as they recede into the background. An understanding of perspective is also evident in works made more than ten thousand years later, in the Lascaux cave, but not in many other painted caves during the long intervening period. The artistic representation of perspective, in Europe then as in other parts of the world since, is one technique among the many that must have been repeatedly invented and lost and invented again in the course of human history.

GEOGLYPHS

These figures—so called because they are made directly on the ground, not on rock—have always captured our imaginations. Geoglyphs are often so large, sometimes several hundred meters in length or in diameter, that they can be seen only from the air. This means that the indigenous populations who created them a few centuries or millennia ago understood proportion, even on an immense scale, and certainly not that these forms had been fashioned by aliens, as some people have wildly fantasized.

Geoglyphs can be found in a wide range of locales, from England to Peru, from the deserts of Sinai to the deserts of Arizona and California. The figures depicted include human beings, snakes, geometric designs, and various animals, such as the huge (110-meter-long) Bronze Age horse in Uffington, England. In Chile there are hundreds of sites (FIGURE 4.14), with figures ranging from ten centimeters to up to one hundred meters, such as the "Atacama Giant" (FIGURE 4.15). At the famous site of Nazca, in Peru, a number of animals are depicted among spirals and other geometric shapes, including straight lines up to several kilometers long.

The techniques used for creating geoglyphs vary from place to place. At some sites, stones were arranged to form the outlines of the figures depicted, as in the case of a snake in Ohio that is more than two hundred meters long. At other sites, the ground has been scraped and stripped of the stones that covered it, so the figures appear light against the dark, rocky ground. At one site in California, the creators of these unusual works simply turned the stones upside down, for the bottoms of the stones are whitish while their tops are covered with a black patina.

FIGURE 4.14 (below) and FIGURE 4.15 (opposite) Geoglyphs—figures made directly on the ground—are often immense. There are hundreds of such sites in Chile, including these two in the Atacama Desert. Various human and geometric motifs can be seen (below). The "Atacama Giant" (opposite) is more than 100 meters long.

Photos by Ph. Plailly/Eurélios

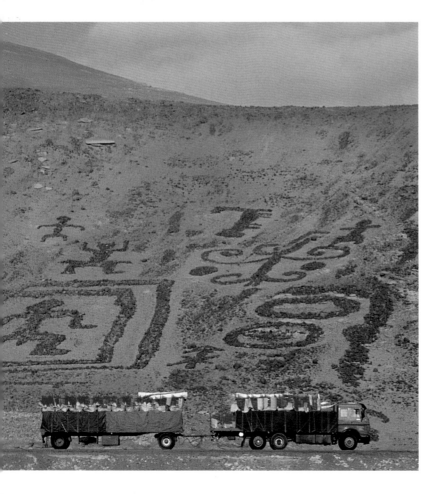

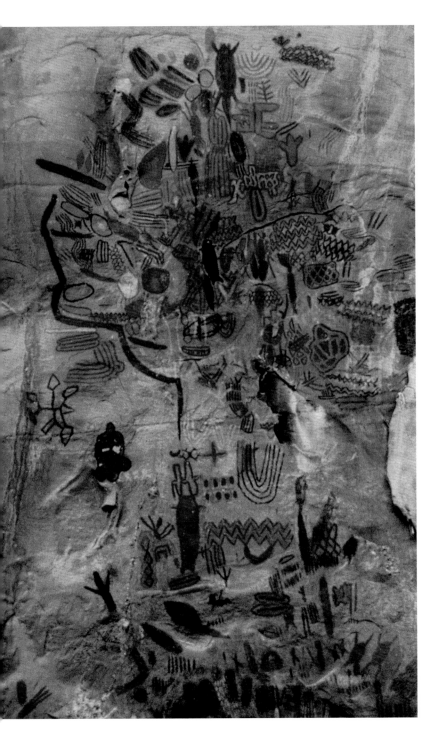

FIGURE 4.16
In the shelters of Brazil's Rio Peruaçu, such as this one at
Desenhos, ladders or scaffolding must have been used to
make some of the paintings. Those seen here reach
heights of more than seven meters above the ground.
Photo by J. Clottes

Applying the Techniques

Artificial light was indispensable in deep
caves. Most of the time torches were used,
and resiny wood is fit for this purpose. All
one had to do was bring a provision of
torches adequate for the time to be spent in
the cave. Fat-burning lamps were also used.
They were made of a stone, either chiseled
out or naturally hollow, in which fat and
one or more wicks were placed. This type of
lighting, which can be reproduced easily in
our own experiments, brings cave walls to
life: as the flame flickers, shadows move on
the rock, emphasizing the surface textures
and enhancing the impression of the myste-
rious and the supernatural. The choice of
locations on which paintings were made
was undoubtedly influenced if not deter-
mined by these tiny, moving lights, which
create a special atmosphere, ideal for envi-
sioning images on rocks.

Outdoors, things were different. The var-
ious rock surfaces selected for their relation-
ship to the landscape and the environment
were used in very different ways. Sometimes
paintings were made high up on walls. On
the banks of the Zuojiang River in China's
autonomous region of Guangxi, for example,
1,818 figures—mostly of people—between
0.3 and 3 meters tall, are concentrated up to
a height of 40 meters on a single cliff, called
Hua Shan (the Mountain of the Paintings).
These images were made, with the help of
ladders and scaffoldings, about three thou-
sand years ago (see FIGURE 2.10).[4] In Brazil's
Peruaçu jungle (north of Minas Gerais), in
several painted rock shelters, there are works
that reach up to 12 meters above the ground
(FIGURE 4.16). Hand stencils up to heights
of 10 meters have been found in some
recently discovered caves in the jungles of
Kalimantan, in Borneo. This suggests the use
of ladders, as well as the willingness to climb
as high as possible, however difficult that
might have been.

It is rare to find surfaces that were actually prepared before painting. This happened, occasionally, in the Grotte Chauvet: the cave wall was scraped in several places before the paintings were made. Perhaps this was because of the thousands of cave bear claw marks on the walls. The artists simply might have wanted to clean the walls or, more likely, get rid of the claw marks, which they could have perceived as a "bear magic" that had to be destroyed before their own magic could be practiced.

In general, however, surfaces were used as they were found. Artists sometimes even took advantage of natural contours and reliefs. This is especially true in Paleolithic caves, where this process was systematic and undoubtedly corresponds to the artists' beliefs in the presence of supernatural forces residing within the rock. Elsewhere, whether in Africa, the Americas, or Australia, snakes are often depicted either entering or emerging from cracks in the rock. Occasionally (as in California, Canada, and Bolivia), hollows in the rock were looked upon as vulvas and drawn as such (FIGURE 4.17). Thus the nature of the rock surface itself played a role in the creation of paintings.

To fashion these works, various tools were necessary. Pigment had to be collected and mixed, with or without an extender. Sometimes paint was prepared on the spot; if not, it was brought in a container. Brushes might have been required. For fine engraving, pointed stones such as flint or obsidian were necessary. Pecking required a kind of stone hammer now frequently found at the base of cave walls marked by engravings. These hammers are generally of quartz and show traces of the work they carried out. Such artifacts, so indispensable to the application of these various techniques, are now a part of the archaeological context. Anyone

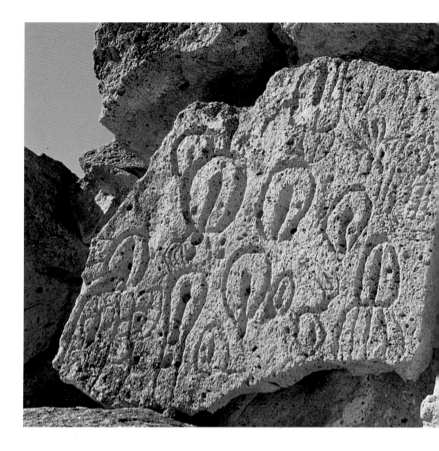

finding one of these tools today must resist the temptation to pick it up and carry it away.

On many rock surfaces we find an accumulation of paintings or engravings. They are sometimes inextricably superimposed. Such groupings were elaborated chiefly for two reasons. The first is psychological: one drawing leads to another. This is evidenced today in graffiti: Wherever it may be and for whatever reasons it was created, as soon as one sign is made, others are added. The second reason is more profound—a phenomenon that could be called sanctification. When the first painting has been made, the wall is, by that very fact, invested with power. The addition of new pictures both benefits from this power and adds to it. In this case, the sacred invokes the sacred (FIGURE 4.18).

FIGURE 4.17
Engravings of vulvas on a sheet of rock in Chalfond, California. Sometimes natural hollows in the rock surface were used in making these images.
Photo by J. Clottes

FIGURE 4.18 (overleaf)
As is often the case in Baja California Sur, Mexico, this immense mural at Cueva Pintada teems with multiple layers of giant, superimposed human and animal figures. Since more recent paintings often obscure older ones, we can surmise that it was perhaps the act of painting at this sacred place, rather than the final image itself, that was most valued by the people who made this art many hundreds of years ago.
Photo by R. Viñas

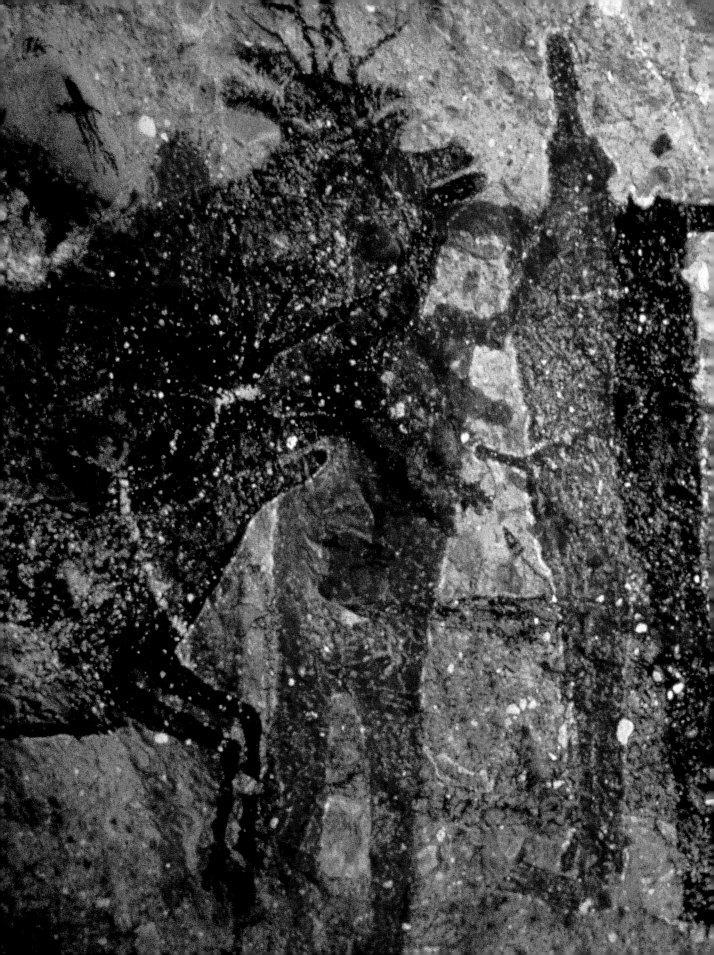

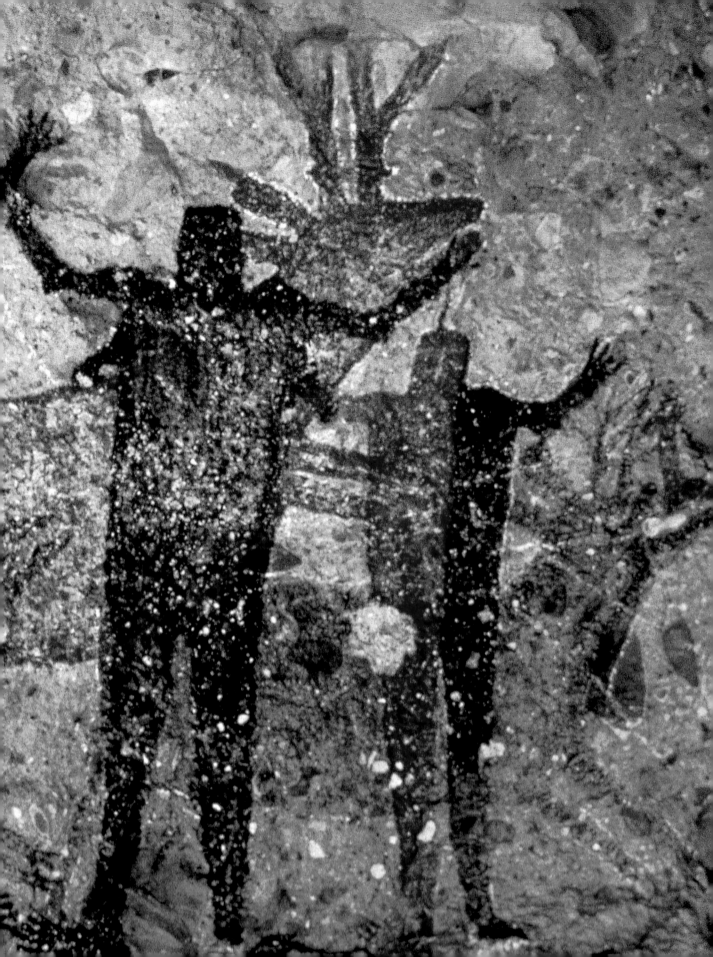

The Meaning of Techniques

In considering pictorial techniques as different as painting and engraving, we are faced with the question of their respective meanings. Were certain techniques more valued than others? Did these have their own meanings? We know that paintings were made in all colors, although red is the most prevalent; were there specializations, with a particular color or technique being devoted to a specific meaning or to specific people—men and women, various levels of initiates, and so on?

In most cases, we can only speculate (FIGURE 4.19). For example, in Magdalenian art of 13,000 to 15,000 years ago, some caves contain only paintings or drawings (Niaux), others only engravings (Les Trois-Frères, Les Combarelles). The reasons why are unknown to us. In the Grotte Cosquer, where the pictures are older—about 19,000 B.P.—it has been noted that engraved animals were often pierced with shafts, whereas painted animals never bore spearlike signs. It has been suggested that the engravings may have been made by men—because in most hunting-and-gathering societies men, as the hunters, generally carry arms—and the paintings may have been made by women; however, this remains merely a hypothesis.[5]

We do have accounts of the value attached to various techniques by more recent peoples, although in some cases

FIGURE 4.19
Traditional peoples sometimes attributed specific significance to certain colors, although it is often impossible for us to know what this may have been. While yellow, red, white, and green all were used in this painting at the Pleito Creek shelter, California, for example, we cannot say what—if anything—they signify. The meaning of this image remains a mystery.
Photo by J. Clottes

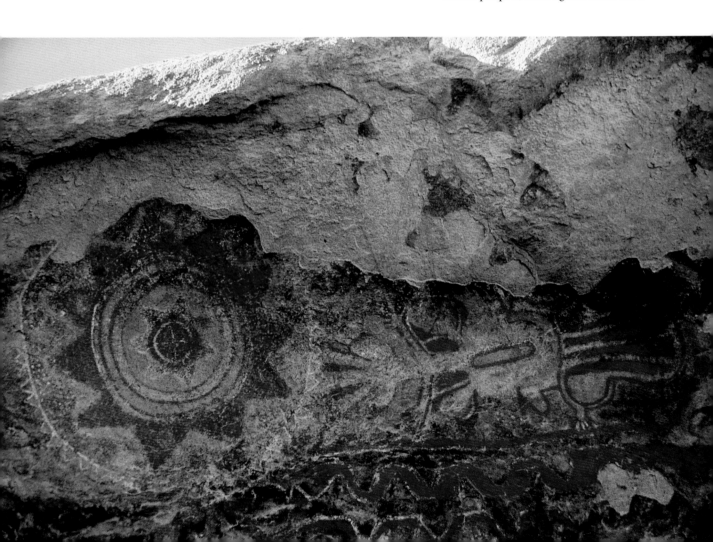

these accounts are contradictory. For the Algonquin of North America, for example, techniques were interchangeable, and figures were made using one technique or another without in any way influencing their meanings.

Often, however, various techniques are endowed with specific meanings. In many regions of Australia, repainting images was a sacred duty. Fading paintings were considered to be "dying," and they needed to be cared for according to age-old customs in order to preserve their power (see p. 103). The spraying technique was not without significance, for through it vital energy—breath—passed into the image and gave it life. Some white paintings, even hand stencils, however, interested no one in the Kimberleys or elsewhere, and so they were dubbed "rubbish paintings."[6] In this case, the quality of paint itself (and perhaps the subject chosen) was more important than the way in which the paint was used.

Technique was also meaningful in southern Africa. In 1930 an elderly San named Mapote, born in the nineteenth century, showed the wife of the local magistrate in Lesotho how he painted.[7] For red, he needed *qhang qhang*, a special type of hematite that is hard to find in the region's basalt mountains. The pigment had to be prepared outdoors, under a full moon, by a woman who heated it on a fire until it was red hot. Once the pigment was finely ground, the binder would be added. This was supposed to be the blood of a recently killed eland, for the eland was thought the most powerful of all animals. As eland's blood was not available, Mapote used ox blood instead. To make black paint, he used charcoal and water, and for white paint, he used white clay and the juice of a milkweed plant (*Asclepia gibba*).

Colors might also be linked to particular subjects. For example, in the 1870s a South African /Xam Bushman described a conversation a boy and girl had before they began painting. "I've got some //*hara* [black pigment]," the boy said, "so I'll paint a gemsbok." His companion replied, "I've got some *tó* [red hematite], so I'll paint a springbok."[8] Why does a particular color dictate what will be depicted? We do not know.

In any case, it is clear that color can bear meaning. In Arnhem Land, dull-colored drawings were associated with death, whereas bright, vivid paintings were associated with life. If red has been used so often throughout the world, it is not only because pigments of this color are easy to find. Red, at all times and in all places, has symbolized blood and life. For some groups in southern California, this color was considered most appropriate for women and their ceremonies (an association that should not be generalized). For the Ojibwa of Canada, as for many indigenous American peoples, red ocher was sacred and in itself had a curative value. It was believed that this paint came from the spilled blood of giant beavers who, in the mythical past, had changed the face of the earth.[9]

NOTES
1 Flood, *Rock Art of the Dreamtime*, 227.
2 D. S. Whitley, *A Guide to Rock Art Sites: Southern California and Southern Nevada* (Missoula, Mont.: Mountain Press, 1996).
3 J. Clottes, "Paint Analyses from Several Magdalenian Caves in the Ariège Region of France," *Journal of Archeological Science* 20 (1993): 223–35.
4 Zhao Fu, *Découverte de l'art préhistorique en Chine*.
5 Clottes and Courtin, *The Cave beneath the Sea*.
6 Chaloupka, *Journey in Time*, 87.
7 D. Lewis-Williams and T. Dowson, *Images of Power: Understanding Bushman Rock Art* (Johannesburg: Southern Book Publishers, 1989), 19.
8 Ibid., 18.
9 Conway, *Painted Dreams*.

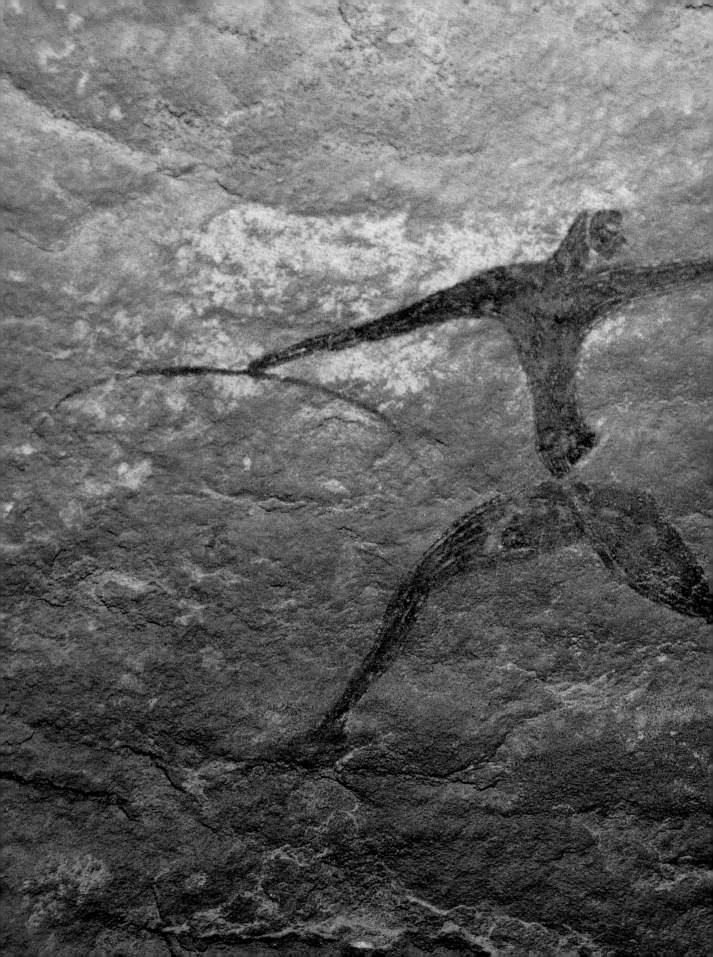

THE DIVERSITY OF THEMES

Whether hiking down a canyon in Utah in search of ghostlike images on high cliff walls, or driving for days through the Aïr Mountains of Niger looking for petroglyphs lost among great piles of dark boulders, we are drawn by the desire to find, to admire, and to study the works and worlds of people who lived in times long past. These works present us with a remarkable range of themes and motifs (FIGURE 5.1).

FIGURE 5.1
This running human figure carrying a bow, on the Tassili-n'Ajjer, Algeria, probably dates from the Pastoral Period, more than four thousand years ago.

Photo by David Coulson, Trust for African Rock Art (TARA)

Indeed, the images depicted on stone throughout the world—in terms of both the subjects they portray and the way they are arranged and ordered—are even more diverse than the techniques used to create them. There are several recognizable motifs, however, which allow us to classify the images into a few broad categories: people, animals, objects, geometrical designs, and so on. There are also universals—subjects that are found repeatedly in very different contexts, although from one culture to another they are likely to have different meanings.

That said, to isolate a motif from its larger context is a dangerous undertaking, comparable to studying a decorated site independent of its environment. A painted rock shelter takes on its full value only if we know why it was chosen. Similarly, the meanings of rock paintings and engravings can be properly understood only in the contexts of the myths, beliefs, and ceremonial or secular practices that helped to spawn them. We risk misunderstanding these figures when we try to interpret them solely on the basis of their visual appearance. When we examine them keeping all these factors in mind, however, we can sometimes discern a remarkable conceptual richness, even when—as is so often the case—their primary meanings have been lost.

Humans and Their Similars

Humans, of course, are portrayed in practically all forms of art. But the ways in which they are depicted vary widely. This is also true of rock art.

Images of human beings abound in most rock art traditions. The subject is so common that one might expect to find a certain uniformity in how it is rendered, but that is far from the case. There are figurative motifs and techniques that occur repeatedly, such as

"stick figure" drawings in which bodies and limbs are sketched in just a few lines—without detail or fleshing out (Hawaii, the Spanish Levant, and Australia; FIGURE 5.2). One type common in many different contexts is the orant—schematically drawn portrayals of people, often in groups, with their arms raised to the sky (Valcamonica in Italy; Argentina; Bolivia; Hua Shan in China; Baja California, in Mexico; Australia) (FIGURE 5.3; see also FIGURE 4.18). Generally, however, images of human beings are strikingly original and quite different from culture to culture. In Australia, for example, the Bradshaw figures of the Kimberleys—long, elegant, covered with body ornaments—are immediately distinguishable from the stereotypical figures of people found in the Laura region. In the Bohuslän, in Sweden, humans were drawn with legs of exaggerated length. In the art of the Aïr, in Niger, people sometimes have odd, crescent-shaped heads. In some rock art, sexual characteristics are lacking and people are sexually undifferentiated. In other instances, men are portrayed with penises and sometimes with weapons (for example, Scandinavia). Figures of women are sometimes drawn with vulvas and, often, with breasts. In the Laura region of Australia, the bigger the breasts, the older the woman (FIGURE 5.4).[1] Children are rarely portrayed.

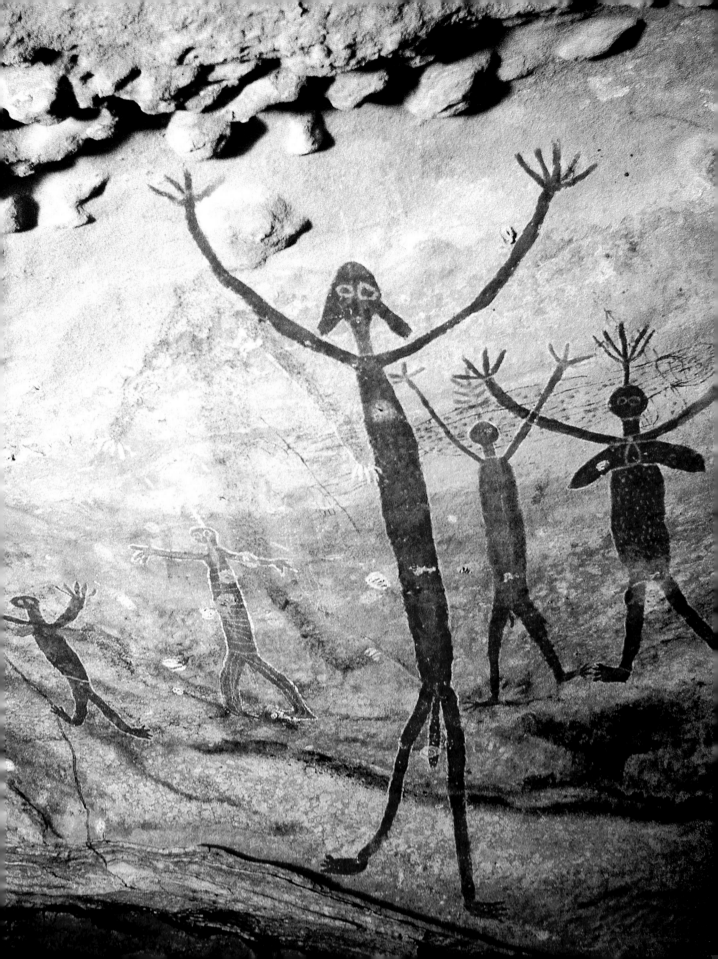

FIGURE 5.4
Paintings of three recumbent figures—two women and a man—rendered in the X-ray style often found in the Arnhem Land region of Australia. Though this style schematically depicts the skeleton and internal organs, it generally serves not to provide accurate representations but to illustrate how certain parts of the body were infused with special meaning.
Photo by J. Clottes

In certain types of rock art, there are relatively few images of humans. Animal footprints dominate in the Panaramittee tradition of Australia, for example, along with circles, lines, furrows, human footprints, and lizards. There are nonetheless some very expressive human faces. In European Paleolithic art, animals and geometric designs likewise make up the great majority of images, but people appear occasionally: Sometimes only the head has been drawn, from the front or in profile (Fontanet, Marsoulas); and sometimes the body is more or less complete, either engraved (Sous-Grand-Lac), painted (Lascaux), or sculpted (the women of Angles-sur-l'Anglin and La Magdelaine).

Perhaps the most extraordinary figures found in rock art are therianthropes—characters with both human and animal attributes—and mythical characters (FIGURES 5.5, 5.6). The most famous therianthropes are those of the Paleolithic, such as the "Sorcerers" of Les Trois-Frères and of Gabillou. In the San art of South Africa, men sometimes are depicted with antelope heads and hooves (see FIGURE 6.5). In New Mexico, portrayals of snakes with human heads have

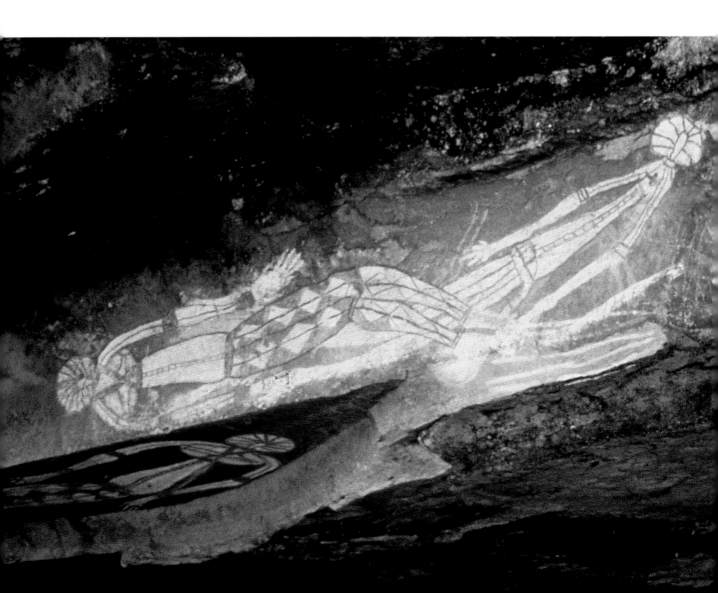

been found. In Texas and Mexico, people are occasionally rendered with eagle wings. At times, human attributes dominate, but occasionally the opposite is true. Such images can be observed worldwide (FIGURE 5.7).

Some archaeologists have claimed that therianthropes represent men wearing costumes, masks, or animal skins, but this interpretation—even when true—may be misleading. In many cultures, to don an animal hide or mask is to transform oneself and fundamentally change reality. That such figures, with all their variations and in all their diversity, are so widespread reflects the universality of ancient beliefs relating to the permeability of boundaries between the human and animal worlds. It was possible, people believed, to pass from one domain to another; men could be endowed with the qualities and potentialities of a given animal species.

Certain therianthropes, which may in fact be mythical characters, have a strangely human appearance, and they often lack animal attributes altogether. The most common are evil spirits, or "tricksters." In northeastern Australia, spirits known as Quinkans are said to live in rock crevices. They come out

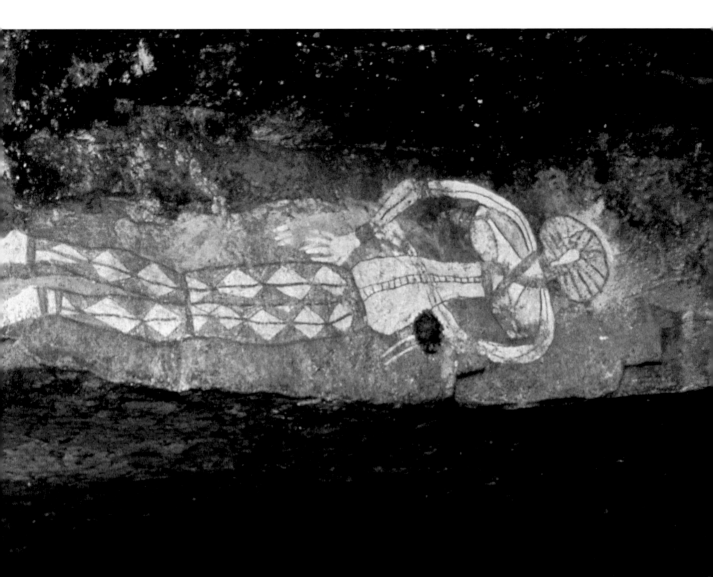

ANCESTORS OF THE DREAMTIME
Kimberleys, Australia

In the Kimberleys region of western Australia, traditional peoples believe in the Wandjinas, supernatural spirits involved with the coming of the rain, so important here after the long dry season. Rain makes the grass grow and the kangaroo plentiful. These spirits are also associated with bounty, fertility, and good hunting. The dots around their heads represent lightning and thunder; the white inside their faces represents clouds. Wandjinas have two round eyes and a nose but no mouth, because if they had a mouth the rain would never stop and the world would be flooded. When the paint cracks and falls off, their power is seen to diminish, and they must then be repainted. By taking care of the Wandjinas, people help to bring about the rain and the turn of seasons.

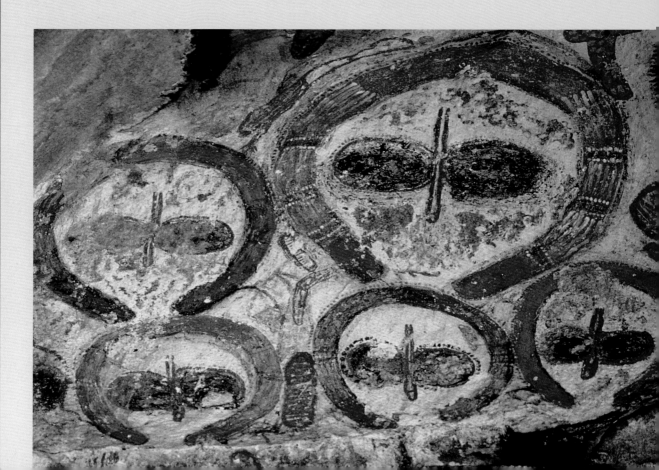

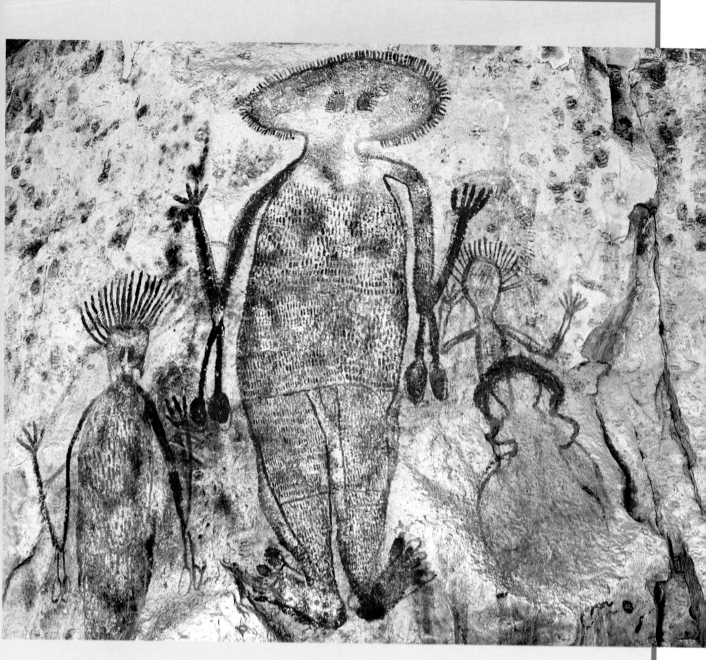

Above left and left
Group of Wandjina figures painted at an
unknown time in a shelter next to King
Edward River Crossing in the Kimberleys.
They have probably been repainted again
and again to rejuvenate their power.
Photos by J. Clottes

Above
Wandjinas at Chamberlain Gorge,
in the Kimberleys.
Photo © Australian Tourist Commission

FIGURE 5.5 (top)
Therianthrope with a dog head, in the Messak region of Libya.
Photo by A. Van Albada

FIGURE 5.6 (above)
Mythical figure engraved on a rock at Rinconada, in Petroglyph National Monument, New Mexico.
Photo by J. Clottes

FIGURE 5.7 (right)
This figure, which combines human, animal, and mythological attributes, was made with beeswax on a rock wall at the Guri Birang Doi Shelter, Kakadu National Park, Australia.
Photo by J. Clottes

at night and amuse themselves by leading travelers astray. The male Quinkan has an enormous, bloated penis, which he uses to leap and spring through the bush, kilometers at a time. On Vancouver Island in Canada, a spirit called Kwatiyot was also a feared trickster, and the Nootka people who lived in the area believed that the rock art on the island was made by him. In South Africa, a potent spirit called /Kaggen was also seen as both trickster and creator. In what is today the southwestern United States, a flute player, familiarly called Kokopelli, was portrayed on countless rocks. According to some scholars, this figure, with his hunched back and erect penis, was both considered a threat to young women and thought to also play an essential role in keeping the world in balance, bringing clouds and beneficial rain and encouraging the fertility of the human, animal, and vegetable worlds.

Animals

Animals are also found in the rock art of all types of societies. For hunter-gatherers, animals are both a source of life, through the food they furnish, and a source of death, through the danger they represent. For herders, of course, animals are daily companions. All cultures have attributed particular virtues and powers to animals, and they have long played a role in mythologies. Their prominence in rock art, therefore, is not surprising.

Though the animals depicted are by necessity those who lived near the sites where their images are found, we should not assume that animal paintings accurately represent the variety and respective importance of the local fauna. These images are the result of cultural choices, which usually have nothing to do with the more or less significant presence of a given species in the biotope—the region and its population

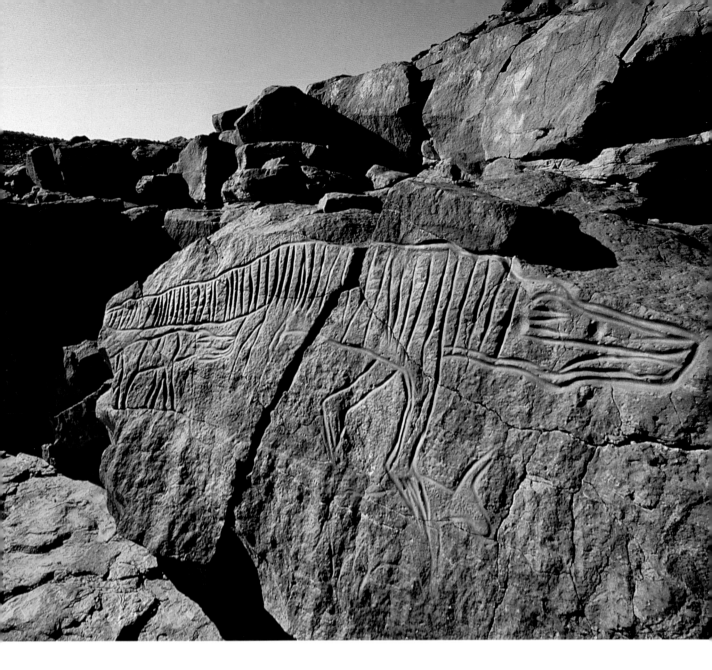

of animals and plants (FIGURE 5.8). Images of mammoths dominate in the Magdalenian cave of Rouffignac, for example, although they were uncommon in the Dordogne at this late period of the Paleolithic. In California's Coso Range, more than half of the engravings represent bighorn sheep, not because such animals were particularly plentiful in these desert places, but because they were crucial in local shamanistic rain-making rituals.

At times, the images we encounter of animals that still exist today seem to possess an almost incantatory power to invoke the distant past. The eland, the largest of southern African antelopes, was often painted in the foothills of the great escarpments of the Drakensberg, as it too played a crucial role in local rituals (FIGURE 5.9). The eland still lives in the wild, and after admiring the red-and-white painted images of a herd of elands on these rocks, it is deeply moving to see a herd nearby, as if the San who painted them so long ago had just left the cave. One can have a similar experience when visiting the Cueva de las Manos, located in a deep canyon

FIGURE 5.8
This remarkable engraving of a crocodile, in southern Libya, may have been made six or seven thousand years ago, when the central Sahara was a greener place, with lakes and rivers.
Photo by David Coulson, Trust for African Rock Art (TARA)

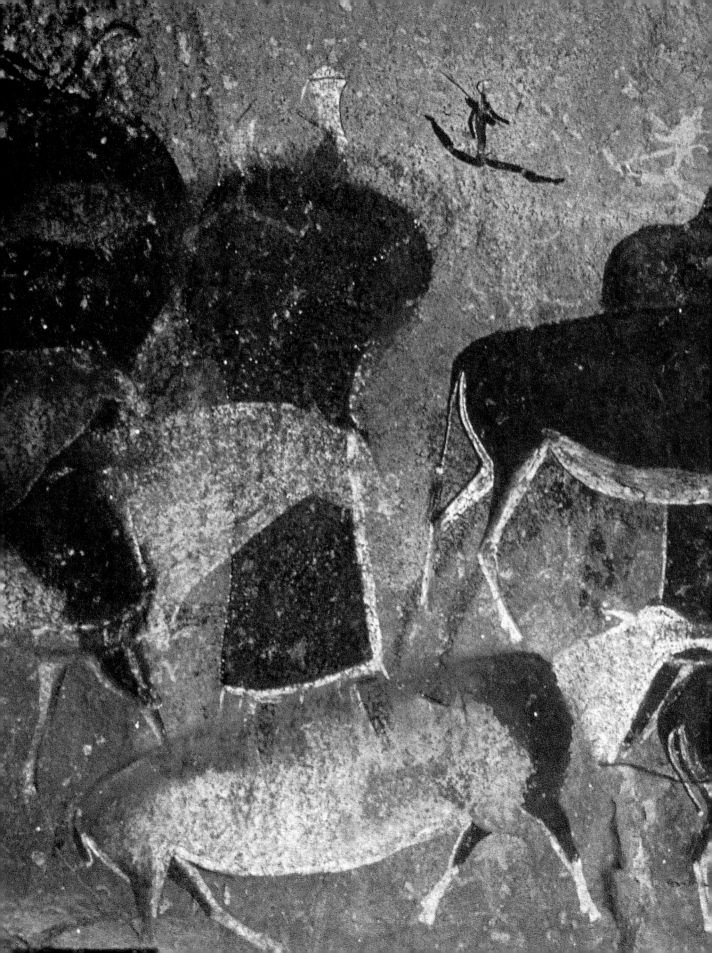

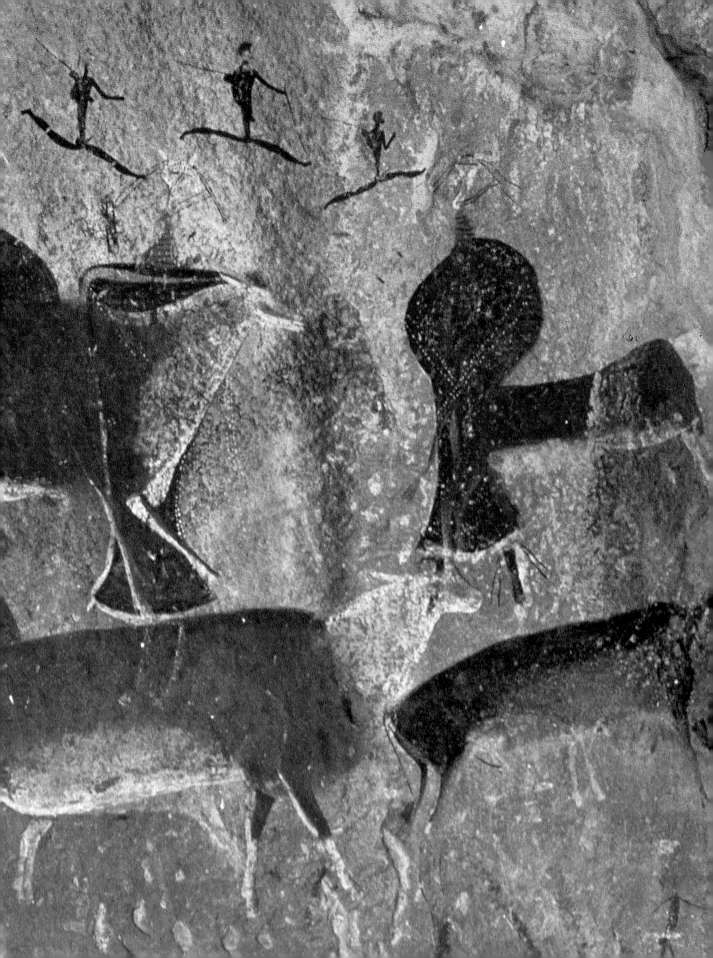

FIGURE 5.9
(preceding pages)
The frequency with
which eland were
depicted in the Drak-
ensberg region of South
Africa is poignant testi-
mony to their impor-
tance in San ritual and
belief—ways of life that
have now almost entirely
disappeared.
Photo by J. Clottes

gouged into an immense grassy plateau of
Patagonia. After inspecting the splendid rock
paintings of guanacos, a visitor is likely to
come across a number of these elegant crea-
tures, with their long, slender necks, light
brown fur, and white stomachs. They might
cross the trail leading along the towering
cliffs and flee across the facing slopes, then
stop and stare back at you. Birds, such as
ñandus (a small ostrich) and the choiques—
big, awkward-looking but fast—are also
painted on the cave's rock walls; these too
can be observed nearby, on a plateau that
extends as far as the eye can see, just as they
would have been seen by the prehistoric
hunters who made these paintings thousands
of years ago.

Some of the animals depicted on rocks
were indeed hunted, and rock art enthusi-
asts, specialists and amateurs alike, have

always been tempted to interpret almost all
animal portrayals as depictions of prey. This
point of view presupposes a sort of hunting
magic, which did exist in some places but
had nowhere near the importance that has
been attributed to it. Ethnological reality—
that is, the beliefs and practices of traditional
peoples—is always much richer and more
complex than such single-minded interpreta-
tions would suggest. This is confirmed by
archaeology. Each time we have been able to
compare, based on remains collected on site,
the images of animals depicted on walls with
the fauna that was actually hunted, we have
noted the absence of strong correlations.
The Magdalenian age inhabitants of the
Grotte de la Vache (Ariège, France), for
example, mainly killed and ate ibex; however,
in the Grotte de Niaux, located in the same
valley, just across from the place where they
lived, they drew chiefly bison and horses.
These images were not necessarily related
to hunting; as we shall see, they had a much
larger significance.

Depictions of animals that do not exist
in nature—and therefore could not have
been hunted—have been found in nearly
all places and all periods, including the
Paleolithic. This underscores observations
regarding the complexity of human beliefs
and again suggests it would be naive to
maintain that such images merely represent
the simple relationship between hunters and
prey. These fantastic beasts might be two-
headed (as in the Coso Range), or they
might have anatomical characteristics
belonging to different species (snakes with
feathers), or they might be purely imaginary
(fire-breathing dragons). Here human imagi-
nation knows no bounds.

Some kinds of animals, such as insects,
were rarely depicted in rock art (FIGURE 5.10).

FIGURE 5.10
This centipede, in a
shelter at Tule River,
California, is one of the
few known depictions
in rock art of an insect.
Photo by J. Clottes

Objects

Objects are depicted in various ways. Their importance and role vary greatly from one culture to another. Theoretically, they could have been as important in art as humans and animals. After all, objects—tools, weapons, jewelry—have always been part of human life. They are the means by which we assert our mastery over the world. And yet they are hardly ever depicted in European cave art, except for thrown weapons (spears) that are drawn on the bodies of a few animals (Grotte Cosquer). (Some geometric designs could be objects that we cannot identify.)

Objects have occasionally been drawn in isolation, independent of images of people or animals. In Australia, for example, boomerangs have often been stencil drawn, with enough details to identify the different types that were used. In Scandinavia, boat images are very common—with or without people—in Bronze Age art (FIGURE 5.11). Boats are even the primary motif in the north of the Swedish Bohuslän. They are also quite common in Hawaii. In North American art, in California, for example, atlatl have been drawn singly or in numbers (see FIGURE 3.10), as have daggers and halberds at Mont Bégo in France. Many other unmistakable objects belonging to forgotten civilizations around the world remain a mystery to us.

Most of the time, however, objects are associated with people, who are often shown using them. Dating back to the Paleolithic, men have borne arms in many cultures. This was also true of herders, metallurgists, and hunters in non-Paleolithic cultures in more recent times. These hunters might be shown using bows and arrows, as in the Spanish Levant. In Scandinavia, warriors wield axes, swords, spears, and shields. In Niger, they have lances; in Australia, projectiles of various sorts. People are occasionally portrayed playing musical instruments, such as Kokopelli's flute. In Australia, the didjeridoo, a long tube played only by men, is often shown. Women—who are depicted less often than men in rock art—do not bear arms. They (and men too) might carry baskets (called "dilly-bags" in Australia) or "digging sticks," which are typical for women in Australia and southern Africa.

FIGURE 5.11
Painted engravings at Tisselskog, in Sweden, showing an acrobat, apparently observed by several armed men, leaping over a boat.
Photo by J. Clottes

FIGURE 5.12
Cupules—circular cavities hollowed out of the rock—
are found throughout the world. Seen here are cupules
and engravings in Grosio, Italy.

Photo by J. Clottes

Universal Themes

In addition to the general motifs, such as
people and animals, found throughout the
world, there are other kinds of depictions
that are quite specific and yet are found in all
periods and places. The recurrence of such
motifs reflects the universality of the human
mind. The specific reasons for their preva-
lence, however, often remain obscure. The
most common universal motifs, recorded all
over the world, are cupules, hands, feet, ani-
mal prints, and signs.[2]

CUPULES

Generally, cupules are shallow, circular
cavities just a few centimeters in diameter
that have been hollowed out of a rocky sur-
face. The surface may be vertical, but more
often than not it is horizontal or slanted.
Cupules might appear singly or, as is fre-
quently the case, collected into groups of
various sizes (FIGURE 5.12). They are to be
distinguished from *basins*, which are larger,
deeper cavities, often used in the grinding
of pigments or the preparation of food.

Cupules have been reported on all con-
tinents, dating back to very distant periods:
The oldest known engraved rock was a
block bearing cupules associated with a
Neanderthal tomb at La Ferrassie. Even in
Europe, a number of rocks engraved with
cupules have been found in much more
recent contexts, such as in Scandinavia; in
the Spanish province of Galicia, where they
are extremely numerous; and in the Alps.
They are every bit as abundant elsewhere.

The meanings associated with cupules
vary considerably. They may simply be the
result of a practical action—for example,
scraping the rock to extract powder—and
have no intrinsic symbolic value; in such
cases, they, like basins, should not be consid-
ered rock art. Very frequently, however, they
have feminine connotations, the cupule

being associated with the vulva; they are also associated with fertility. In Hawaii, the *poho*, made until recently, are often complex cupules (FIGURE 5.13), with concentric circles in which the umbilical cord of a newborn baby (*piko*) was placed to assure it a long life.[3] In the Bohuslän, a cupule between the legs of a human figure denotes its femininity. In northern California, the "Baby Rocks" of the Pomo-speaking Hokan Indians are covered with cupules, which were hollowed out of the rock as part of a fertility ritual (FIGURE 5.14): Before having sexual relations, which took place on the same spot, a couple would gather the rock powder from the hollowed-out cupule and place it on and in the woman's body as a cure for sterility. Feminine sexual symbols are seen in the same places.[4]

Elsewhere in California, cupules and furrows were made during rituals for controlling the weather. Hollowing out cupules was believed to produce wind and rain; scraping furrows was thought to make it snow. The rock was thought to contain a power released and made controllable by hollowing and scraping its surface.[5]

A similar ceremony, which attests to the presence of the same mental processes in extremely distant societies, has been witnessed in central Australia. During rites intended to favor the procreation of certain birds that were important in the lives of the aboriginals—birds they hunted and whose eggs they collected—the aboriginals would hammer and hollow out cupules from a particular rock. This was done to release the birds' vital essence, which they believed impregnated the rock and was symbolized by the powder that rose into the air as the cupule was being hammered out. Airborne, this essence would fertilize the female birds, which then would lay more eggs.[6] In other contexts, for which we have no oral tradition, cupules may have had many different meanings.

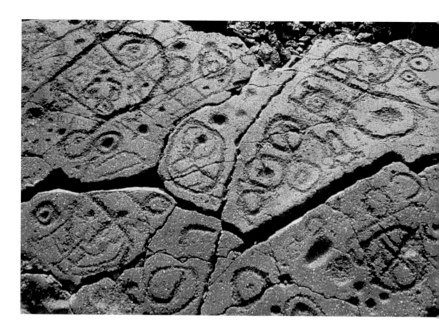

FIGURE 5.13
These complex cupules and circles in Hawaii are associated with rituals that take place after childbirth. The umbilical cord of the newborn baby would be placed inside them to ensure that the infant would enjoy a long life.
Photo by J. Clottes

FIGURE 5.14
The so-called "Baby Rocks" of northern California, such as this one at Keystone, get their name from the fertility rituals that the Hokan Indians practiced at these sites. It was believed that the rock powder generated in hollowing out the cupule would facilitate conception when placed in a woman's body before she had coitus.
Photo by J. Clottes

FIGURE 5.15 (below) Handprints cover a wall of this shelter near Canyon de Chelly, Arizona. It was likely a sacred site for the Native Americans who lived in the region. White prints frame a mysterious figure at center, bottom.
Photograph by Alain Briot © 2002

FIGURE 5.16 (opposite) Red handprints and zigzags depicting rattlesnakes, which during the trances of puberty ceremonies were seen as spiritual helpers, decorate this rock wall near Riverside, California.
Photo by J. Clottes

HANDS AND FEET

The portrayal of isolated hands is one of the most common rock art motifs. The outline of a hand may be painted or engraved, but more often than not hands are either prints or stencils. The handprint is made by coating the palm and fingers with paint, then pressing them firmly to the wall. To create a hand stencil, the spraying technique is used (see chap. 4). Like cupules, these two motifs are known as early as the Paleolithic, in the Chauvet and Cosquer caves, for example, though we do not know if they had a distinct meaning.

Occasionally, the fingers are incomplete and are missing one or more bones (the Grotte Gargas, in the French Pyrenees). This is also true elsewhere in the world. In parts of Australia, such images represent a kind of sign language, and this is probably the case elsewhere as well. Most hunter-gatherer cultures have a sign language, very useful for communicating during the hunt. Sign language can also be used to communicate with the spirits during ceremonies.

Australian sites, among many others, tell us that the hand can be used as a signature. Such images had a relatively limited secular meaning and value, as opposed to a religious one. In Argentina's Cueva de las Manos, they have accumulated in the same place over millennia, with new handprints covering old ones, over and over again. Such an accumulation at a carefully chosen site may indicate that the images had a specific ritualistic meaning or function (FIGURE 5.15).

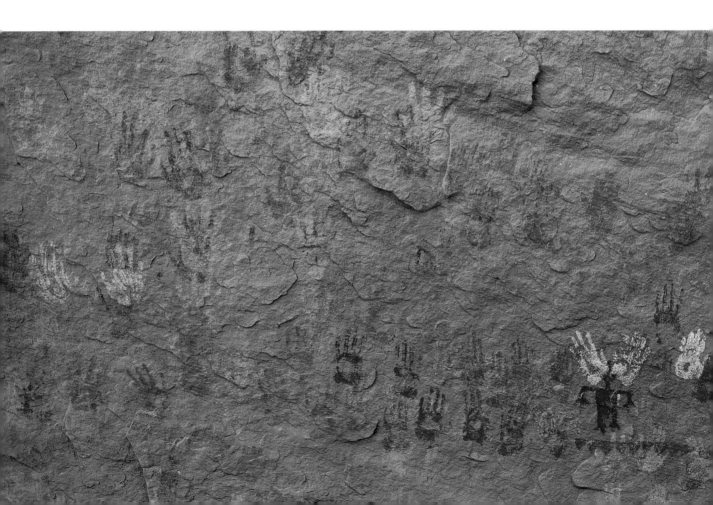

Similar examples exist in southern California. In Riverside County, this type of art is known as the "southwest painted variant" of California rock art. In the indigenous cultures of the region, until the end of the nineteenth century, young girls were taken into the desert for several days for their puberty ritual. They suffered hardships, fasted, and were supposed to have visions. At the end of their initiation, they participated in a race from one decorated rock shelter to another; the winner would supposedly live longer than the others. They would leave handprints on the wall in red, which was considered a woman's color, to show they had been in contact with the supernatural (FIGURE 5.16).[7]

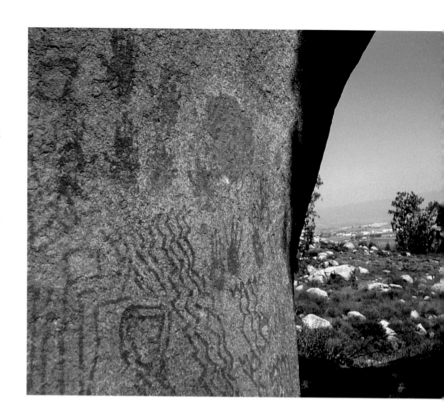

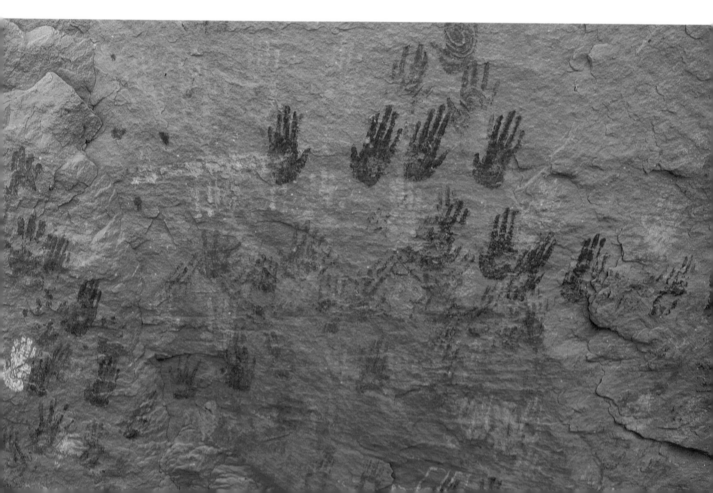

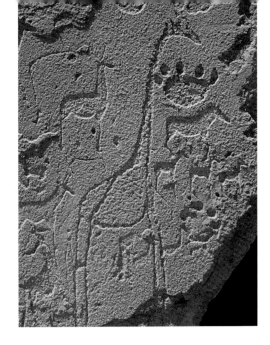

FIGURE 5.17
Depictions of animal footprints can be found in rock art throughout the world. Such images often were made during hunting rituals and were meant to symbolize prey. These prints are engraved among pictures of giraffes and other animals in Twyfelfontein, Namibia.
Photo by J. Clottes

FIGURE 5.18
Among the most enigmatic rock art motifs are a wide range of marks that do not correspond to any clearly recognizable object or idea. While we may try to interpret the meanings of such signs, we can rarely be sure of our explanation. Seen here are mysterious geometric designs, along with a painting of a snake emerging from a crack in the rock, in the Rio Peruaçu region of Brazil.
Photo by J. Clottes

The portrayal of isolated feet is much less common, but it too can be found throughout the world (Valcamonica in Italy, Har Karkom in the Sinai, Cáceres in Spain). Such motifs are quite common in Scandinavia. In Bolivia the feet have six toes. Most of the time, these images are engraved or pecked. Their meanings have not come down to us.

Depictions of animal prints are also known worldwide, from Australia to Africa (FIGURE 5.17), Europe, and the Americas. Their basic symbolism is obvious: For the hunter, the print is the animal itself, located in time and space. It gives him information about the animal. That does not mean that the portrayal of prints has a didactic function: They were not, as has often been claimed, anatomical diagrams used to teach children. The observation of actual animal footprints on the ground, in the wild, was far more practical and efficient for that purpose.

SIGNS

In relation to rock art, the use of the word *sign* in a way reveals our ignorance. To a person outside of the culture that created them, a great many rock art marks do not correspond to any immediately recognizable reality: zigzags, undulating stripes, lines or clouds of dots, geometric figures (circles and rectangles, filled in or empty, crosses, cones, etc.), straight lines, either isolated or in groups, either vertical, oblique, or horizontal. Some of these signs may suggest to us a specific meaning, but we do not know if they really meant what we think they did. For example, a radiating circle suggests the sun, but its true meaning may be completely different. These signs, which at times are quite complex and varied (for example, in the art of Rio Peruaçu in Brazil; FIGURE 5.18; see also FIGURE 4.16), are the most mysterious type of rock art, as they bear witness to long-dead conventions of thought and belief to which we no longer have access.

We do know that certain recognizable motifs never—or very rarely—appear. Rock art was not used to portray landscapes, for example, at least not in a way that we can readily recognize. Trees, waterfalls, and mountains are absent. Stars are rarely depicted (although they are portrayed at Chaco Canyon in the United States). Rock art, with its many forms and motifs, was not intended to mirror the surrounding world but to transcribe reality through filters of belief, tradition, and ritual.

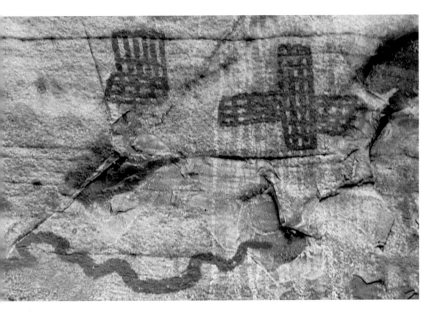

SCENES

Scenes are quite common in most types of rock art. They might include only animals (herds, animals hunting, FIGURE 5.19); mating, or animals and humans together. In the latter case, hunting scenes and fishing scenes (Norway, Australia) are the most numerous and the most common throughout the world (FIGURE 5.20). But shepherds with their animals are also depicted, as are animals being milked (Sahara), horsemen (European Iron Age; art of the Contact Period in the Americas, South Africa, and Australia) and camel herders (Sahara). Images depicting sexual relations between men and animals have also been reported (Scandinavia, Sahara, South America, central Asia); largely because of the influence of Western culture, these have occasionally provoked contro-

versy. Some people have rejected—even sought to destroy—these ancient images, which reflect practices now considered shocking.

Scenes are extremely rare in European Paleolithic art. There are a few animal scenes, like the lion hunt in the Grotte Chauvet or the maternal scene at Le Portel, with a female bison facing her calf as an old male wanders off (see p. 41). People are only exceptionally portrayed with animals during this period. In the Scène du Puits in Lascaux, a man is shown falling back before a wounded bison, whose insides are spilling out. That the man has a bird head—a detail echoed by the image of a bird perched on a stake—keeps us from considering this ensemble the simple account of a hunting accident. In this type of

FIGURE 5.19
This engraving shows dogs harrassing a bighorn sheep, near Saada, in Yemen.
Photo by M. A. Garcia

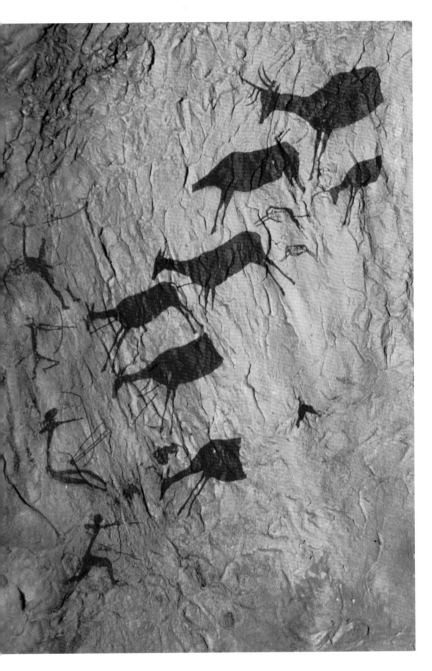

art, wall depictions of births or sexual intercourse are unknown.

In most rock art, scenes featuring people show them engaged in all possible activities. We recognize domestic, familial scenes beneath a tent (India), dances (frequent in southern Africa), sexual intercourse (Australia, Africa [frequent in the Messak], Siberia), boat travel (Canada), with occasional acrobats leaping over small boats (a theme unique to Scandinavia), skiers (Siberia, Scandinavia), plowing, duels (Scandinavia, alpine art; FIGURE 5.21), groups of archers in battle (the Spanish Levant, North America), and white men armed with rifles against indigenous populations (southern Africa, the Americas, Australia).

In certain cases—such as that of the white men with rifles—it is possible to have chronological information, even details about the scenes in question, confirmed historically. This rock art gives us the point of view of indigenous peoples. Usually, however, we do not know what these scenes really mean. Do they have a purely narrative, secular significance? Or do they relate sacred stories? What point are they trying to convey? More than any other type of image, scenes pose the problem of interpretation, to which we now turn.

FIGURE 5.20 (above)
Hunting scenes are widely depicted in rock art. Seen here is a reproduction of a deer hunt from Cavalls shelter, near Valltorta, Spain, in the Valltorta Museum.
Photo by J. Clottes

FIGURE 5.21 (opposite)
Warriors of the Bronze Age wield swords, shields, and axes in this engraving at Vitlycke, Sweden.
Photo by J. Clottes

NOTES
1 Flood, *Rock Art of the Dreamtime*, 275.
2 These motifs are the most frequently represented in Australian rock art. See Flood, *Rock Art of the Dreamtime*, 144.
3 G. Lee and E. Stasack, *Spirit of Place: The Petroglyphs of Hawai'i* (Los Osos, Calif.: Bearsville and Cloud Mountain Presses, 1999).
4 D. S. Whitley, *The Art of the Shamans: Rock Art of California* (Salt Lake City: University of Utah Press, 2000).
5 Ibid.
6 Flood, *Rock Art of the Dreamtime*, 146–47.
7 Whitley, *A Guide to Rock Art Sites* and *The Art of the Shamans*.

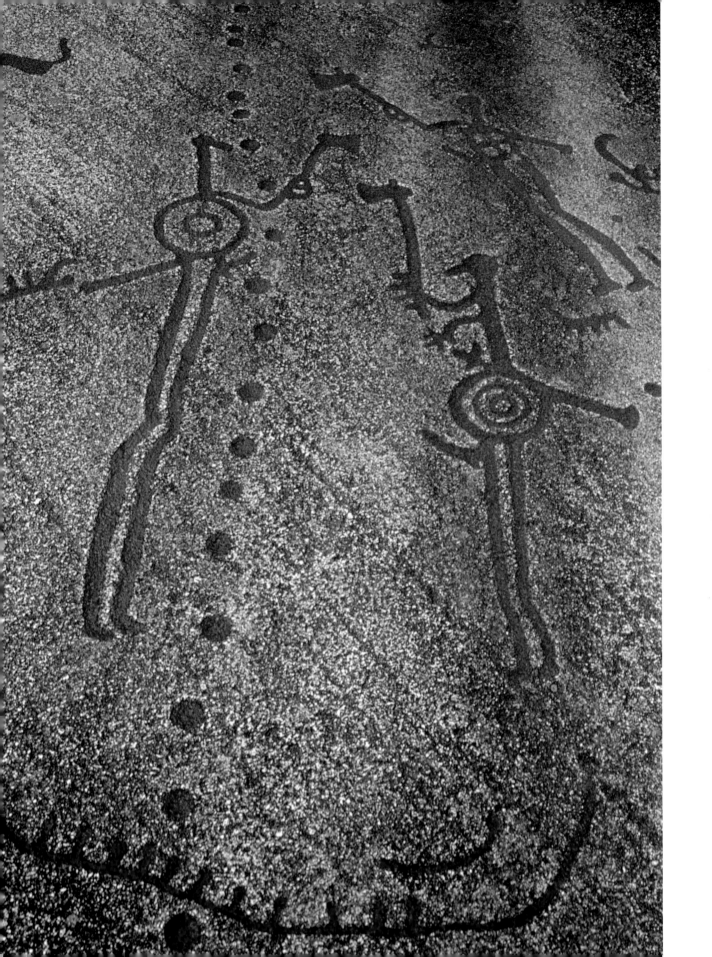

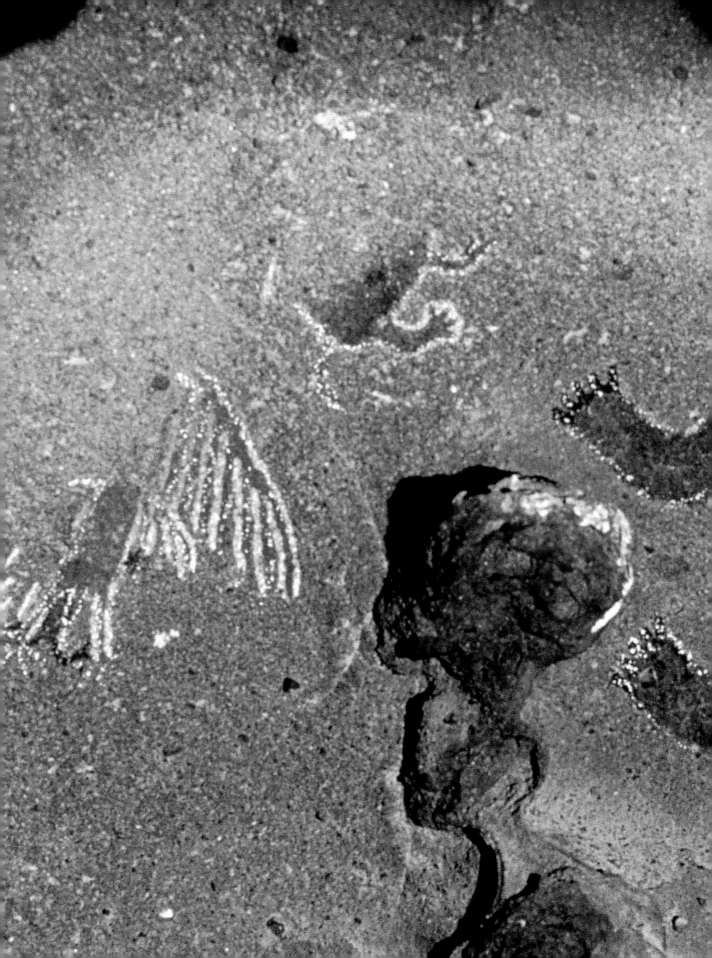

INTERPRETATION AND MEANING

When it comes to deciphering their meaning, the mysterious images of rock art pose many complex problems. The universal impulse to communicate by making symbols is a principal characteristic of our species; this explains why humans have felt it necessary to leave millions of images painted, engraved, and sculpted on rocks. Answers to thorny questions regarding the specific meaning of these images, however, are not easily found. We approach the problem differently when the traditions responsible for the art still live and when the culture and its stories have long since disappeared.

FIGURE 6.1

Interpretation of rock art when ethnological data is lacking, as with these images on Chumash territory at Mutau Flat, north of Los Angeles, is particularly difficult. Does the abraded red painting of a bird (at left) depict an eagle, a supernatural spirit, or a visionary shaman during the flight of his soul? Is the figure of a bear (at right) meant to portray a grizzly or a human transformed?

Photo by J. Clottes

In either case, however, much remains uncertain. In instances where these traditions survive, we have no way of knowing, when native informants elucidate an image for us, whether the art really means what they say it means. Their understanding can be influenced by various factors—by their gender or status, for example; and they may modify their explanation of the art when speaking to outsiders deemed unqualified to share meanings so sacred or secret. And when dealing with art for which no ethnological data are known, our predicament is worse still. What appears obvious may not be obvious at all. Does a painting of a bird depict an eagle, a supernatural spirit, or a shaman whose soul has taken flight? Is a bear really a bear, or a human transformed (FIGURE 6.1)?

Some archaeologists think that it is impossible to know what rock art means and that the researcher's role is to study motifs and techniques, try to date the works, establish as far as possible whether these images were structurally linked, but *not* attempt to interpret them. From their point of view, we are faced with a choice: either say nothing at all about meaning, or make up stories that might seem interesting but would lack any objective, scientific basis.

Others feel that it is a pointless exercise to pursue classifications that lead only to dry statistics, or to establish the existence of general structures—relationships among different types of images—that we can perhaps record but not explain. They are right. Faced with the twin dangers of pursuing an arid intellectual exercise, on the one hand, and indulging in baseless fabrications, on the other, we must steer a careful course. In doing so, in spite of the undeniable difficulties we might face, there are ways to approach the study of meaning in a rigorous and scholarly fashion.

Interpretation and Living Tradition

For the first time in the history of the world, going back forty thousand years or more, rock art is no longer practiced on most continents, where it could be called a fossilized art. Yet oral traditions connected to both its making and its meanings still exist in certain regions of the Americas, Africa, and especially Australia. In southern Africa, the art of the San died out only relatively recently, in the nineteenth century, when they were exterminated—except in the Kalahari, where there are few rocks. Ethnologists, missionaries, and travelers have collected observations and confidences that reveal some of the influences inspiring the creators of rock art in these areas. In the rare regions where such traditions have been preserved and where a few living initiates still know what the rock paintings and engravings mean, it is possible to preserve this ancestral knowledge (FIGURE 6.2). Such preservation is—or should be—the researcher's highest priority and first duty.

FIGURE 6.2
Interpreting rock art is a challenging endeavor. We were certain that these paintings at Rocky Hill in central California portrayed human beings. However, we were then told by a member of the Yokuts tribe that they actually depict bears. When the shaman was visited by his spirit-helper, he apparently transformed himself into a bear but remained a man. "One or another," our informant added, "bear or man, it's the same thing."
Photo by J. Clottes

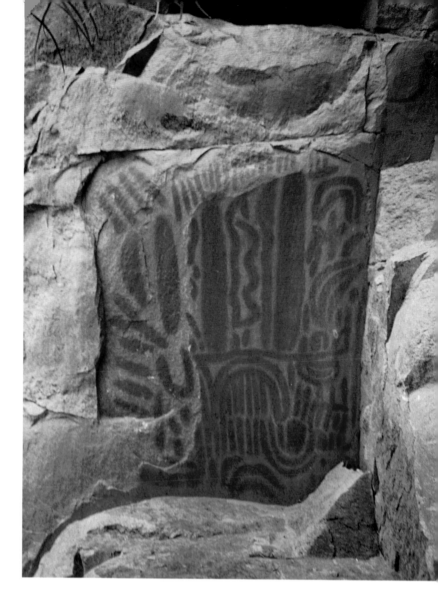

Some traditional peoples are becoming more aware of the need to preserve their ancient knowledge. They rightly fear that those who have such learning—the elders—are dying without transmitting it to the younger members of the community, who are often less interested in such traditions, attracted as they are to the ways of the modern Western world. "Now the people are gone from most of those places," the elder David Mowaljarlai said, speaking of the sacred rock art sites in the Kimberleys. "They don't come back. They don't repaint the Wandjina in the sacred caves anymore. The Wandjina waits for his children to visit him, but the children don't come back. Nobody's coming there to touch him up. The paintings get dull after the years go by. The Wandjina's sad and sorry to be left alone. Nowadays everything's sad, everything's sorry."[1] Entire cultures are disappearing, along with their rich, sophisticated worldviews. It is an irreparable loss for humanity.

In an attempt to address this situation, in 1997 UNESCO organized a day on the rock art of the Ngarinyin of the Kimberleys. Four aboriginals, three of them elders, came to Paris to participate in the event, to speak of and help perpetuate their customs and the meanings of their art. Since then, at least one of them, Mowaljarlai, has died.

Even when "those who know"—or say they know—reveal their knowledge, however, we cannot be sure we have understood what the paintings mean. In fact, the people who claim such knowledge are often far removed in both time and space from the rock art they tell us about. Australia's Laura region was completely depopulated in the nineteenth century, for example, as its traditional inhabitants were driven away by the ruthless policies of colonial rule. Although many aborigines have since returned, they have long been cut off from the source of

their culture and its ancient knowledge.[2] While many stories, both sacred and secular, are still being transmitted, they may evolve and be transformed over time. Here, as elsewhere, researchers encounter the significant problem of the mutability of important oral traditions.

Moreover, a painted or engraved work (or group of works) often has meanings that vary according to a number of factors (FIGURES 6.3, 6.4).[3] The meanings may differ based on the gender, age, or status of the person recounting them. They may also change according to the moment, according to the changing seasons and the ceremonies and rituals they might represent or be part of.

FIGURE 6.3
We do not know the meaning of these mysterious signs at the Melbon Painted Site in Australia's Selwyn Range.
Photo by J. Clottes

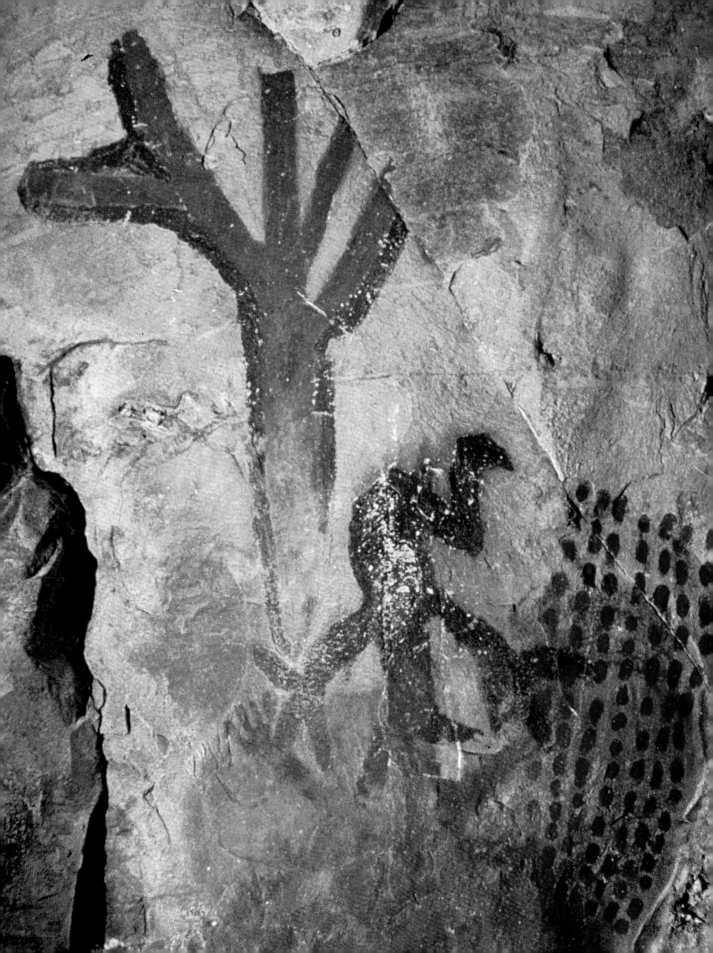

For example, aboriginals in Arnhem Land distinguish five types of rock art. One of these, known as the *bim gurrmerrinj*, contains images whose meanings are discernible in different ways by different groups. Depictions of ancestral creatures, such as the Rainbow Serpent, can be seen by women, children, and uninitiated men, although their deep meaning is not revealed. Ritually important portrayals and sacred drawings are accessible and thus known only to initiates; the meanings of paintings of evil spirits and other dangerous creatures are accessible only to elders who know how to respect the paintings, for it is believed that any interference with them could cause the evil spirits to multiply.[4]

The transmission of this knowledge—already partial and biased—also depends on who is receiving it: different things might be revealed to different researchers, depending on whether they are male or female, young or old, on whether they have been known for a long time or only recently met, and so on. Some informants, in their haste to please, may embellish or misrepresent reality, a well-known problem for ethnologists.

Finally, in a great deal of rock art, particularly in Australia, the symbols depicted present a fundamental ambiguity in and of themselves, for they are a part of a belief system from which they cannot be removed. A circle, for example, illustrates the range of possible conceptual complexities behind an apparently simple image: It may represent a water hole, a piece of fruit, fire, a yam, the base of a tree, a woman's breast, or a circular path. In addition, the physically featured object may refer to and invoke the metaphysical, creative power of the earth in which the object is rooted or from which it emanates. In such a case, notes one scholar, "the circle ultimately represents the source of all life and nourishment."[5]

We must therefore approach the study of rock art images on several different levels. Confronted with a given image, it will generally be possible for us to proceed with a primary interpretation: It is an animal of this or that species (a lion, a kangaroo), or a geometric design (a circle, a zigzag, a dot), or a person (man, woman, indeterminate). Even in this early stage—the most elementary and apparently the easiest—obstacles abound, both for nonfigurative images, as in the case of the circle, and for figurative images, as in the case of the image of a man in central California that actually depicted a bear.

The second stage of our research consists of establishing structures—the elements of a scene, the repetitions and associations (if any) of motifs, and the techniques used to create them. This is the syntax—the arrangement of units of meaning—of the discourse we are trying to decipher.

The third stage is the actual interpretation. This too involves several levels. Ideally, an informant who knows the meanings of the works explains them to the researcher. This is the highest and generally most reliable level of interpretation. In certain cases, when no one can reveal directly the meaning of rock art images, it is possible to approach it by using the data furnished by local ethnology. This is what David Lewis-Williams and his colleagues have been doing for the past twenty years with the paintings of the Drakensberg (FIGURE 6.5) in particular and with those of southern Africa in general.

FIGURE 6.4 (opposite) What could be the meaning of this scene portrayed at the Janelão shelter, Rio Peruaçu, Brazil, in which a man apparently is shown falling from a tree into a field of red dots? *Photo by J. Clottes*

FIGURE 6.5 (above) In this detail of a painting at Game Pass, in the Drakensberg, South Africa, a shaman with the head and hooves of an antelope is shown touching the hindquarters of a dying eland. The San viewed the eland as a power animal, whose death was believed to release its potency. By touching the dying animal, the shaman acquired its powers—symbolized by the shaman's antelope features. *Photo by J. Clottes*

FIGURE 6.6
Various motifs are repre-
sented on this panel at
Garfish, in the Laura
region of Australia—fish
(including the large red
figure at top), white hand
stencils, humans, and, at
far left, a flying fox (a
kind of big bat), shown
hanging upside down. In
this region, when people
are portrayed lying
down, the image often
represents subjects of
sorcery; we can surmise
that the human figure at
bottom depicts someone
bewitched.
Photo by J. Clottes

We know something about how the San think, how they view the natural and super-natural worlds, how they act, and so on. By studying San rock paintings through this conceptual filter, researchers have been able to renew interpretations of an art that because it is no longer practiced was previously thought to have also become uninterpretable.[6]

An Art of Many Uses

Rock art is not a characteristic of any single culture or ethnic group, nor can it be reduced to the representation of a single specific kind of activity. Capable of rendering all human concerns, rock art reflects life in all its richness. Like life, it is varied and complex, but beneath this complexity recurrent practices and themes can be discerned (FIGURE 6.6). The great events that mark our passage through life, for example, all give rise to ceremonies:

birth, puberty, marriage, initiation, death. Every culture has myths of its origins and future, its legends and sacred stories. In the bosom of their respective cultures and within the framework of traditional beliefs, people strove to influence their destinies. To various degrees and in different ways, such universal concerns inspire all rock art.

Questions are often asked concerning the sacred or secular character of a given painting or engraving. In a few extreme cases, we can distinguish between these types: in Australia, for example, white "rubbish paintings" are not related in any way to the *bim gurrmerrinj*. More often than not, however, such distinctions are difficult or impossible to make. For most traditional peoples, the secular world and the sacred world are one, and the multiplicity of nuances behind a given motif or group

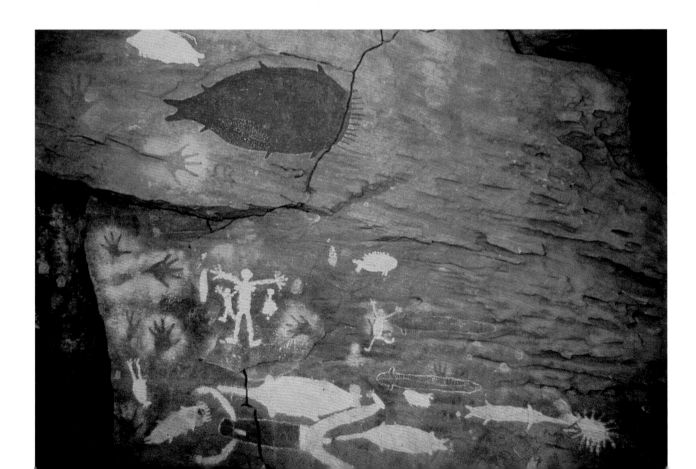

of drawings may, for the initiate, *simultaneously* refer to the most prosaic reality and to what *we* would call the supernatural or mythical world.

With these qualifications in mind, it is nonetheless possible, for the sake of convenience, to classify the known explanations for rock art under three main headings. These divisions are ultimately artificial, of course, for they often overlap.

1 *The affirmation of a presence.*

This is the most common explanation for so-called secular paintings. Some of them— and not only handprints or hand stencils— have played this role, which can be compared to graffiti in the Western world. It means "I (or we) have passed this way"—a signature or a memento, if you will. Some images of animals painted by aboriginals on long rainy days in the rock shelters of the Laura region may well have had no other cause.[7] The individual may thus mark his presence, a relatively mundane act, except when it was done during a ceremony, such as a puberty rite. In such cases, as has been reported with the Iranga of Tanzania, for example,[8] a sacred dimension ("I have been in contact with the supernatural")[9] is added to the affirmation of personal presence.

We move to a higher level in dealing with the socially constituted group, whose symbols belong to the tribe or clan and reinforce its power and cohesion. Their inscription in the landscape is rarely gratuitous. It demarcates a space, whether sacred or secular or both. It also constitutes a warning to potential intruders. This is why Comanche Gap Ridge in New Mexico has been carved with many warrior motifs (FIGURE 6.7). Such symbols are intended both for the group itself and for the rest of the world. They mark natural borders and traditional territory at the same time that they give meaning to the landscape.[10]

2 *A testimony.*

This is rock art's best-known role, and rightly or wrongly it is the first one that comes to mind. All art is communication, and all art transmits a message. This occurs on many levels.

There is a narrative or commemorative art that fixes the memory of significant events, in particular, during the era of the Contact, when indigenous populations were brutally confronted with the arrival of white men. In southern Africa, Australia, Indonesia, and the Americas, we see Western ships drawn on rocks (FIGURE 6 8), occasionally with detailed rigging that allows us to

FIGURE 6.7

This engraving of a warrior behind a decorated shield, at Comanche Gap Ridge, New Mexico, would likely have had a range of related functions. It imparted meaning to the landscape, demarcating traditional territory and warning potential intruders, as well as enhancing the warrior's power by representing his symbol.
Photo by J. Clottes

identify them. The white men have distinctive headdresses and are often armed with rifles. There are a great many scenes of battle, as well as of such practices as cattle rustling (Lesotho) or horse rustling (Navajo art in the southwestern United States) that indigenous populations carried out against the invaders. This narrative art may represent more than the simple commemoration of a catastrophe or a glorious feat. Among certain North American Indians of the Great Plains, the depiction of an exploit not only adds to the status of the person who accomplished it; it also reinforces his luck and his power.[11]

It also happens that rock art has been used for such purposes as sorcery, to cast a spell on an enemy or a person who has broken a taboo. Depictions of these practices are generally rather recent, often belonging to the period of the Contact (FIGURE 6.9).

FIGURE 6.8 (top)
Art of the Contact Period. European sailing ship is painted next to a gloved or decorated hand, in Arnhem Land, Australia.
Photo by J. Clottes

FIGURE 6.9 (above)
This sorcery scene at Big Wallaroo, in the Laura region of Australia, portrays an outstretched woman, who is probably under a spell, with a snake biting her heel. Animal figures have been superimposed.
Photo by J. Clottes

Other testimonies refer to personal experiences in the context of the beliefs and practices of the group, as in the case of initiation ceremonies. In southern California, young girls painted spirit-helpers—often a rattlesnake—that they had seen in a vision (see FIGURE 5.16).[12] On the Columbia Plateau in the American Northwest, men and women seeking the aid of the supernatural would go into isolation and await a vision in which a spirit would appear, bringing chants or objects that would be of use to them in their lives. Afterward, they would draw this event on a rock with their own symbols to preserve its memory.[13]

Myths concerning the creation of the world are among the universals of human thought. They are infinitely varied, with a few constants. In America, the cosmos was held to contain a number of worlds that were superimposed both spatially and metaphorically; a people would move during a long quest from one world to the next, gradually progressing over time, conquering their humanity until they emerged into this world. They were aided in this journey by mythical heroes, animals, and spirits, whose helpful roles are related in sacred stories (FIGURE 6.10).[14] In such sagas, the place of emergence into this world often has a special importance.

All elements of a myth are likely to find a place in art. For the Mojave and Quechuan peoples, for example, the Blythe geoglyphs on the California-Arizona border commemorate the creation of the world by the divinity called Mastamho.[15] Another geoglyph, near the California town of Needles, represents the Fire Clan divinity, its arms spread to show that it had driven off and then kept away the Water Clan.[16] In Australia, in the Kimberleys, the frequently depicted Wandjina is also a spirit-creator (see pp. 84–85). It looked at itself in the water, the

· FIGURE 6.10
A complex group of petroglyphs marks Newspaper Rock, in the Petrified Forest, Arizona. There are snakes, humanlike figures sporting multiple wings, and, at upper right, a two-headed sheep under a crescent moon.
Photo by J. Clottes

legend goes, and saw its own image, which it then painted on the rock that all might see it forever; the Wandjina then created humanity. In one form or another, many other creation stories are embodied in rock art as well.

The same is true of countless other stories and legends, both sacred and secular. These are often rooted in surrounding landscapes and relate tales of mythical heroes. In Australia, such characters belong to the Dreamtime (FIGURE 6.11). They have influenced the formation of the landscape and the history of the tribe, and they inevitably have had extraordinary adventures. When

we know the epics, we see that the paintings simplify them considerably. This simplification was not considered important, however, as those who possessed knowledge knew these stories down to the slightest detail, and none of the stories' many meanings escaped them.

While many stories recounted epic quests and creation myths, others might have been more prosaic. They might teach a social and moral lesson, as in the story of Gin-Gin, from the Laura region of Australia. When Gin-Gin sat on the ground, she did not modestly put her foot in front of her genitals

FIGURE 6.11
This figure at Nourlangie, in Kakadu National Park, Australia, was painted in the X-ray style, like many others in the area. It depicts an evil spirit known as Namand.
Photo by D. Ballereau

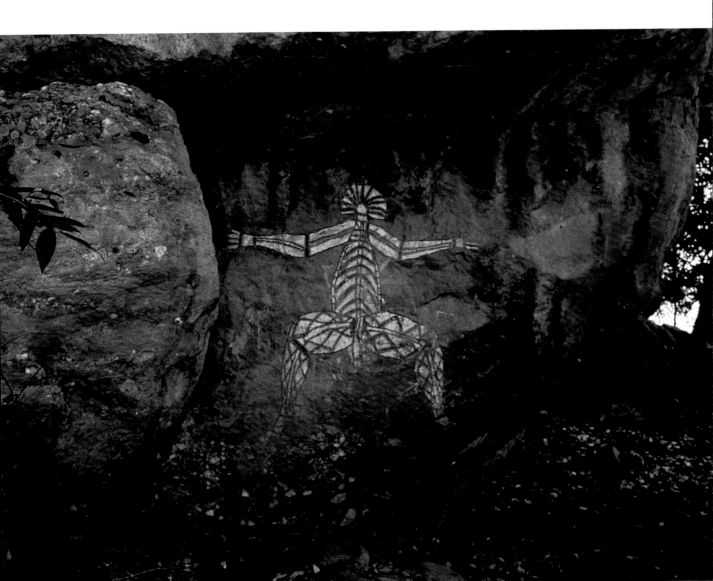

to cover them, as she should have, and they could be seen by all. An elder warned her of her infraction by covering his eyes with his hand and exclaiming, "Oh, my eye, my eye!" Gin-Gin paid him no mind and continued to misbehave. He warned her again and again, but in vain. Finally, she seduced her son-in-law, thus breaking one of the culture's most powerful sexual taboos. Condemned by the elders, she died shortly thereafter.[17] The misfortune of Gin-Gin has been portrayed in a remote shelter of the area in two yellow paintings, one showing a woman sitting correctly and the other, incorrectly. These images cannot be published, because to do so would offend the present aboriginal keepers of the sites.

The artistic representation of these narratives had several objectives. One was educational: The stories thus portrayed were perpetuated, and henceforth no one could forget them. In addition, the commemoration of mythical events, often on the very spot where they were supposed to have taken place, fused mythic time and present time into an indivisible whole.[18] Various bonds were strengthened, both between the group and the places of memory and within the group itself; art thus played a social role. Finally, the images were endowed with power: through them, people sought to influence the course of events in their lives.

3 *Influencing the world.*

Although it is neither as well known nor as popular as the others, this function of rock art is of vital importance. There are several reasons why rock art has been almost universally perceived as a favored means of exercising such influence. Traditional peoples do not dominate nature, as modern Western cultures seek to do: They are one of its elements, and they are conscious of their weakness and vulnerability at the heart of a complex, dangerous world. Yet they are not resigned to this predicament. They think that in this universe where everything is related—past with present, humans with spirits, animals, and indeed all of nature—it is possible for people to act in ways that resolve their problems and better their condition. This is where the image intervenes. Because it is perceived as an emanation of the subject it depicts, the image preserves an affinity—sometimes a complete identity—with the subject, allowing us to reach it, control it, and be helped by it.

Attempts to influence the course of life are represented in many ways. The aboriginal people of northern Australia, for example, believe that the Wandjina "put his picture on the walls to tell us who he is and who we are. He *is* that picture. We're his children, and we're supposed to repaint his picture, get back in touch with his Wayrrull [his lifeforce, his power]. If we don't take care of the pictures, the rain won't come, the lightning won't come. Everywhere there will be destruction and death. The world will die and everyone in it."[19] This statement by the elder David Mowaljarlai is highly revealing and attests to one of the major roles of rock art, which is to fend off danger and contribute to the balance of nature. Australian rock art is believed to come from the Dreamtime, created by the deity itself. The art defines people, who in turn must maintain it.

In America, as elsewhere, rock art has played a preventive and protective role. In the early nineteenth century in the American Northwest, the tribes of the Columbia River were decimated by unknown diseases brought by white men, so they created new images relating to death and disease in order to fight the mysterious ailments.[20] The most impressive is Tsagiglalal, or She Who Watches (FIGURE 6.12). The image itself is powerful; it lives, acts, and gives power to the

FIGURE 6.12
When Native Americans along the Columbia River were being ravaged by diseases brought by white men, they created new images to ward off these mysterious illnesses. One such image is seen here: She Who Watches, a spirit associated with death, at Horsethief Lake, in Washington State.
Photo by J. Clottes

moment was right, the images had to be revived to guarantee their survival. It was an imperative duty. In this way humans contributed to essential balances, the return of the seasons and of the rain, or the reproduction of useful animals. It is said that one of the last things Nayombolmi did, before his death in 1964, was touch up the paintings at Nourlangie Rock (see FIGURE 3.16) in Arnhem Land, for he feared they would lose their sacred reality, and he felt it was his responsibility to preserve them for future generations.[21]

Shamanism

Rock art was often a favored way to come into contact with the spirits of the supernatural world. It allowed people to preserve the powers acquired through this contact, especially within the framework of shamanistic religions or religions with a strong shamanistic component. Shamanism, of course, cannot explain all of world rock art, which has a multiplicity of meanings. Nevertheless, given the range of shamanistic religions among traditional peoples, and given that until only recently such peoples inhabited Siberia, the Arctic, the Americas, and a good part of Africa and can still be found in Asia, this conceptual framework is quite useful for attempting—albeit cautiously—to understand rock art when direct ethnological testimony is lacking.

Shamanism is found in egalitarian societies—in particular, in hunter-gatherer cultures—which are responsible for most rock paintings and engravings. Yet not all hunter-gatherers practiced shamanism (they did not in most of Australia), which can also be found in cultures with other types of economies. The ubiquity of shamanism does not generally result from its being transmitted through contact, direct or indirect, among distant peoples. Rather, it may

place in which it resides. But it is not eternal: with time and neglect, its power fades and may vanish altogether.

Indeed, in Australia, as was no doubt true in much of the prehistoric world, sacred, living paintings did not keep their identity or their power forever. Like the people who made them, they disappeared and, it was believed, died. This could bring about catastrophes. When their colors or contours began to fade and the elders decided that the

well have been caused, at least in part, by
the inevitable human need to explain and
exploit altered states of consciousness,
a need that finds expression, in one form
or another, in all human societies. Indeed,
the human mind is such that there will be
some people, whatever their culture, who
are prone to have visions or hallucinations.
In traditional cultures (as opposed to our
own), these "waking dreams"[22] are often
seen as a form of contact with the powers
of the beyond.

Of the many components that make up
the shamanistic worldview and social system,
certain characteristics seem essential. The
first is the view of a complex cosmos in
which one or more additional worlds coexist.
These worlds, which may be parallel to or
superimposed on our own, interact with our
world, and most events in our world are seen
to be influenced by these other dimensions
of reality.

Second, the group believes that certain
people can, largely for practical reasons,
deliberately have direct relations with these
other worlds, to heal the sick, to remain on
good terms with spiritual forces, to restore a
broken harmony, to bring rain to arid lands,
to improve or allow hunting by speaking
with a "Master of the Animals," to predict
the future, and, at times, to cast evil spells.

The third essential characteristic is the
way in which this contact between worlds, or
domains of reality, takes place. It occurs
through the visitation and aid of spirit-
helpers—often animals—that come to the
shaman or that the shaman goes to visit. The
shaman is often identified with such a spirit;
indeed, he is believed to transform himself,
partially or totally, into it. The shaman can
also send his or her soul into the other world
to meet spirits and obtain their protection
and aid. He or she does so while in a trance
(FIGURE 6.13). The shaman thus serves as a

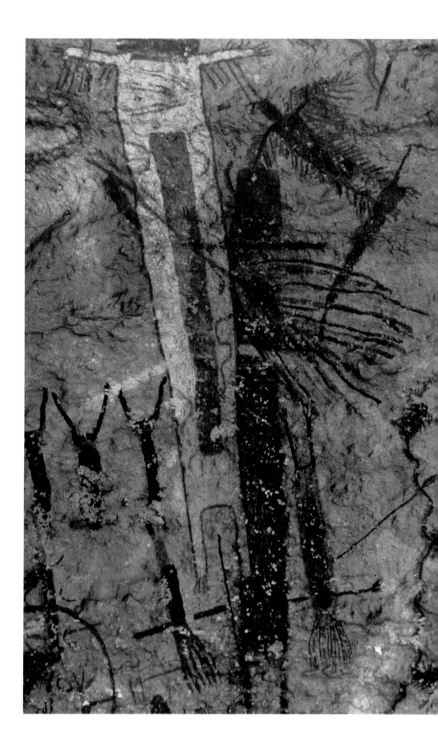

FIGURE 6.13
At White Shaman shelter, Texas, we can see images of people
flying or transformed into birds—a classic metaphor for the
trance state, in which a person's soul is believed to soar out
of his body and journey into the spirit world.
Photo by M. Rowe

114

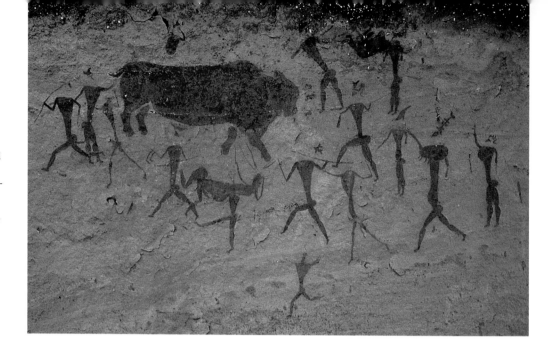

FIGURE 6.14

Various animals, both real and mythical, played roles in San rainmaking rituals. During such ceremonies, a shaman might enter a trance in which he would have visions of the killing of the rain-bull, a mythical animal said to live in a water hole. Such a vision is likely depicted in this scene, painted by a San artist, perhaps in the nineteenth century, at Bamboo Hollow, Natal Drakensberg, South Africa. In the words of one nineteenth-century San informant, "Where they kill the rain-bull, there the rain runs along the ground" (quoted in D. Lewis-Williams, *Images of Power*).

Photo by J. Clottes

mediator between the "real" and spirit worlds and performs a social role by looking after the welfare of the group.

Most reported examples of rock art in a shamanistic context come from Africa and the Americas.[23] Shelters decorated with rock art are often considered openings on the supernatural world. These "doors" function in two ways. Spirits can come out, and privileged individuals can go in, thus entering the beyond. Such sites are powerful places, fitting for seekers of visions: someone who would receive the visit of a spirit-helper or travel to the other world typically would go alone to the foot of the decorated walls. In many places, including Nevada and California, after the trance (the "voyage"), the vision had to be materialized, or embodied; otherwise the person would lose it and die—hence the image on the rock or wall (see sidebar, overleaf). Each image added to the wall drew on and strengthened the power of the images that preceded it. In southern Africa, the shaman would look at the decorated walls as he danced. The power of the eland, which had been imparted to paintings by use of a pigment mixed with the animal's blood, spilled out into him. He in turn projected his vision into the painting; as his vision blended with the painting, the shaman passed into the supernatural world.[24]

The images often had to do with visions—with the perilous voyage into the world of the beyond and encounters with the powers that inhabit it (FIGURE 6.14). Rock art revealed this other world metaphorically. For example, the trance is a metaphor for death, because when in a deep trance the shaman would lie or recline, as if he were dead, his soul gone. In California's Coso Range, killing a bighorn sheep, considered the rain animal, meant that the shaman was going into the supernatural world to bring rain. The portrayal of this event on a rock, therefore, had nothing to do with depicting an ordinary hunting scene; it had a much vaster significance.

Shamans inhabited by their spirit-helpers could be transformed, or perhaps, during their travels, they might encounter creatures similar to yet different from themselves. Hence the many therianthropic images that can be found in southern Africa, for example.[25] Those creatures, endowed with both human and animal features, which to us appear so strange, testify to age-old beliefs in a mythical world where there are no clear boundaries between humans and animals, a world of power to which, through shamanic rites, present-day humans can still gain access.

Interpreting Ancient Art

The vast majority of rock art images now lack direct explanations, even in such countries as Australia where the tradition has continued virtually up to the present day. The stories for the strange Gwion Gwion paintings of the Kimberleys, for example, are far less detailed than those about the more recent paintings of Wandjinas. Moreover, when explanations for a relatively ancient art are available, we cannot be sure that they reflect the original meaning. Religions evolve, as we know, and the beliefs and the symbols that express them change as well. As for prehistoric art, for which we obviously have no direct informants or any ethnological context, we can approach its thousands of images through analogies with more recent, better known art. To interpret prehistoric paintings and engravings, in Europe as elsewhere, we have three basic tools at our disposal: ethnological analogy, the subjects and the way in which they are depicted, and their location.

It would be foolish and naive to want to attach an aboriginal or a San explanation to rock art in European caverns or in the Sahara, or to compare similar images of very different types of rock art and conclude that they have an identical meaning. However, ways of thinking, of conceiving the world, and of acting are often similar in cultures that are at similar stages in their economic and social development, that have a comparable manner of life and social organization. For tens of thousands of years, people throughout the world have had the same brain, the same nervous system, the same abilities, and the same drives, emotions, needs, and reactions. Because of this, we can use analogies with relatively recent cultures, where the traditions and some of the meanings of the art have been preserved, to help us understand the art of more ancient peoples, where its actual meanings—and often the cultures themselves—have long since vanished.

Taking into account the broad differences among the societies that produced rock art, it can be classified in four main categories. The first is the practical art of archaic hunter-gatherers, in which scenes are rare, animals and signs are frequent, and paradigms have a universal value. The second is the art of evolved hunters, different from hunter-gatherers in that they used the bow and arrow, in which the depiction of scenes—often of a surreal character—is quite common; this art is more localized but still contains many characteristics common around the world. The third is the art of the shepherd–cattle breeders, with its depictions of domestic animals and scenes of everyday life. And fourth, there is the art of complex

FIGURE 6.15
Art of the Bronze Age: A pair of lovers are shown embracing in this painted engraving at Vitlycke, Sweden.
Photo by J. Clottes

RAIN SHEEP OF THE DESERT
Coso Range Petroglyphs, California, United States

The Coso Range, near Death Valley, was used by shamans, who used to come, sometimes from long distances, to participate in rainmaking ceremonies there. Because it was believed that the supernatural world was the reverse of our own world, the very dry Coso mountains were seen as the most appropriate place to carry out these ceremonies. During their visions, shamans would see bighorn sheep; because the vision had to be embodied for it not to be lost, they would then depict these "rain animals" on the nearby rocks.

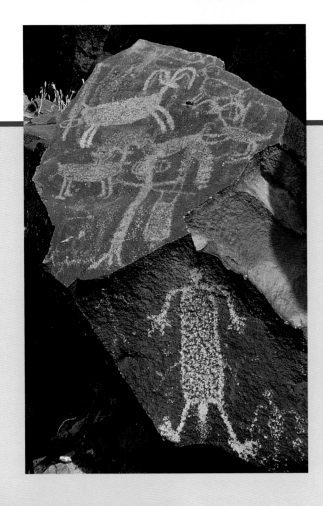

Engravings of bighorn sheep and human figures.
Photo by J. Clottes

Bighorn sheep pecked on the rocks at Big Petroglyph Canyon in the Coso Range. They are superimposed over older figures with a different patina.
Photo by David Whitley; from Whitley, *Art of the Shamans.* Used with permission.

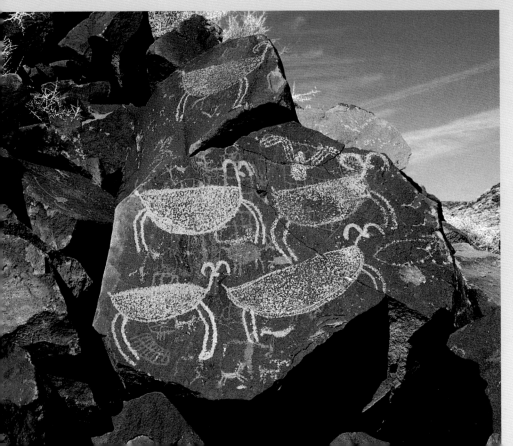

societies (FIGURE 6.15), in which there are scenes of a mythological character and many signs.[26]

In some instances, the many convergences we notice of image and motif allow us at least to propose interpretive frameworks. This is an important nuance: Although the details of ancient sacred stories are forever lost to us, it is quite legitimate to attempt to establish the framework, the overall set of beliefs in which they are situated. These efforts allow us to posit hypotheses, which will be strengthened—or weakened—as new discoveries are made.

Our attempts to interpret ancient rock art can be based on an analysis, informed by our understanding of more recent art, of the ancient images and the way they are depicted (FIGURE 6.16). This is made clear by a few examples from the art of the European Paleolithic. Geometric signs, as numerous in this type of art as in others, could represent the series of dots, lines, zigzags, and grids—what are called entoptic signs—that accompany visions, especially in the first moments of a trance.[27] In a similar way, the therianthropes of ancient times (the "sorcerers") are conceptually identical with those we have found in more recent art—in southern Africa for instance—that we know to be shamanistic. And finally, the way in which certain animals have been portrayed in both ancient and more modern times, using the natural relief of the walls so that the animals seem to emerge from the walls' fissures and cracks, suggests that for Paleolithic peoples, as for many other shamanistic cultures, the wall was but a veil between the reality of this world and that of the supernatural. For these people, spirits in animal form were right there, literally within arm's reach. Painting them called them forth from the beyond and allowed them to be brought under some measure of human control.[28]

The places selected give other clues to the meanings of images depicted on rocks. The meaning of ancient cave art, for example, had much to do with its location. Caves are universally considered another world, the place of choice of the supernatural (see chap. 2). Drawings made in deep caverns, where people never lived, are often seen as especially sacred. As many modern explorers have experienced, caves often have a kind of hallucinogenic character, where cold, humidity, darkness, and sensory deprivation facilitate visions. We can logically suppose that in ancient times people also experienced caves in this way. These caverns may well have had several related functions, facilitating altered

FIGURE 6.16
Snakes and birds are often considered powerful spirits because they belong simultaneously to two distinct domains: earth and underground, on the one hand, and earth and sky, on the other. Seen here is a shamanistic figure at the Head of Sinbad site, Utah. Painted in the Barrier Canyon Style, it is likely several thousand years old. Birds are widely associated with the celestial flight of the shaman, a theme perhaps reinforced by the feathers emanating from the figure's head.
Photo by J. Clottes

or visionary states of consciousness and allowing people to contact the spirit realm on the other side of the wall.[29] When the shaman-artists of the Paleolithic entered the absolute darkness of such places, they, like more recent traditional peoples, believed they were entering the spirit realm, and they expected to encounter its inhabitants.

In a similar way, we know that boundary zones—places where two worlds come into contact—often had a special significance (FIGURE 6.17). Mountains bring together sky and earth. Canyons, because they sink into the ground, unite earth and water. A motif such as the hand stencil, considered an uninteresting signature by its authors and beholders in certain regions of Australia, can assume another kind of significance altogether when it is found in an exceptional place such as a boundary zone. This is true of the hands in the Cueva de las Manos, which, along with animal paintings and signs, accumulated over the course of millennia, around a cave in a very special location, in the middle of a spectacular series of cliffs overlooking a lush valley. We find this also on Borneo, where hundreds of images of hands have recently been discovered in remote caves located in the heart of the deepest jungles, at heights ranging to more than ten meters above the ground.[30] These hands cannot possibly represent a common, individual gesture. They were undoubtedly painted during important ceremonies, whether initiations or contacts with spirits, held in these very special places, and they therefore must have had ritual meanings.

This is also the case in the Arakao region of Niger, where the vast golden dunes of the Ténéré Desert flow into the first black foothills of the Aïr. Rocks strewn about a narrow valley opening into this magical place are covered with hundreds of petroglyphs. Such adornment is not a coincidence. The engravings assume their significance and their meaning from their privileged placement, here at the convergence of two worlds.

For thousands of years, men and women have inscribed their vision of the world in deserts and in caves, at the foot of cliffs, on canyon walls, and in mountaintop shelters. In doing so they hoped to mark their passage, to express what they saw, to seek assistance from the supernatural in order to change the course of their lives. Although these testimonies remain cloaked in mystery, they never fail to move us, for they establish a bridge that links us with all those who have gone before. These images belong to the heritage of humanity. Yet everywhere they are threatened; in many cases they have long since begun to vanish. The problem of their conservation, therefore, to which we now turn, takes on an unprecedented urgency.

NOTES
1 Mowaljarlai, quoted in H. Arden, *Dreamkeepers: A Spirit-Journey into Aboriginal Australia* (New York: HarperCollins, 1994), 204.
2 R. Layton, "Relecture de l'art rupestre du nord de l'Australie," *L'Anthropologie* 99, nos. 2–3 (1995): 467–77.
3 B. David and J. Flood, "On Form and Meaning in Rock Art Research," *Rock Art Research* 8, no. 2 (1991): 130–31.
4 Chaloupka, *Journey in Time*, 87.
5 R. Lawlor, *Voices of the First Day: Awakening in the Aboriginal Time* (Rochester: Inner Traditions International, 1991), 289–90.
6 Lewis-Williams and Dowson, *Images of Power*.
7 Layton, "Relecture de l'art rupestre du nord de l'Australie."
8 Anati, *Preservation and Presentation of Rock Art*, 32.
9 Whitley, *Guide to Rock Art Sites*, 26.
10 P. Schaafsma, *Rock Art in New Mexico* (Santa Fe: Museum of New Mexico Press, 1992), 5, 135.
11 M. A. Klassen, "Towards a Mindscape of Landscape: Rock Art as Expression of World Understanding," in *The Archaeology of Rock Art*, ed. C. Chippindale and P. S. C. Taçon (Cambridge: Cambridge University Press, 1988), 50.

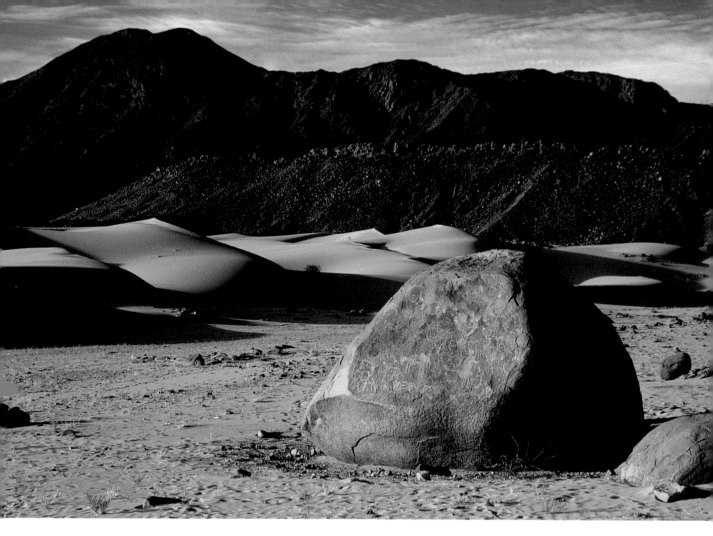

12 Whitley, *Guide to Rock Art Sites*, 25.

13 J. Keyser, *Indian Rock Art of the Columbia Plateau* (Seattle: University of Washington Press, 1992), 68.

14 J. J. Brody, *The Anasazi: Ancient Indian People of the American Southwest* (New York: Rizzoli, 1990), 67.

15 Whitley, *Guide to Rock Art Sites*, 125–26.

16 F. Waters, *Book of the Hopi* (New York: Penguin Books, 1977), 87.

17 Trezise, *Dream Road*, 61, 88–89.

18 M. J. Young, *Signs from the Ancestors: Zuni Cultural Symbolism and Perceptions of Rock Art* (Albuquerque: University of Mexico Press, 1988), 173–78.

19 Mowaljarlai, quoted in Arden, *Dreamkeepers*, 208.

20 J. Keyser, *Indian Rock Art*, 101–2.

21 J. Cowan, *Sacred Places in Australia* (East Roseville: Simon and Schuster, 1991), 120–22.

22 C. Lemaire, *Rêves éveillés* (Paris: Les Empêcheurs de Penser en Rond, 1991).

23 The basis of Australian aboriginal beliefs is totemic (i.e., implying a very special relationship with animals or other living creatures), even if, like most religions, they bear on occasion some shamanistic elements, such as visions and trances. A. Lommel, *The Unambal: A Tribe in North West Australia* (Carnavon Gorge: Takarakka Nowan Kas Publications, 1997).

24 D. Lewis-Williams, T. Dowson, and J. Deacon, "Rock Art and Changing Perceptions of Southern Africa's Past: Ezeljagdspoort Reviewed," *Antiquity* 67 (1993): 273–91.

25 Lewis-Williams and Dowson, *Images of Power*.

26 Anati, *L'art rupestre dans le monde*.

27 Lewis-Williams and Dowson, *Images of Power*.

28 J. Clottes and D. Lewis-Williams, *The Shamans of the Caves: Trance and Magic in the Painted Caves* (New York: Harry Abrams, 1998).

29 J. Clottes, "La piste du chamanisme," *Le Courrier de l'UNESCO*, April 1998, 24–28.

30 J. M. Chazine and L. H. Fage, "Hand Stencils in the Caves of Borneo," *INORA* 31, 2–9.

FIGURE 6.17
Many of the rocks strewn about at the edge of the Ténéré Desert in Niger are covered with engravings, many of which are likely between two thousand and three thousand years old. We do not know the exact meaning of these images, but it is no doubt related to their location, in the zone where the desert and the Aïr Mountains mingle.

Photo by David Coulson, Trust for African Rock Art (TARA)

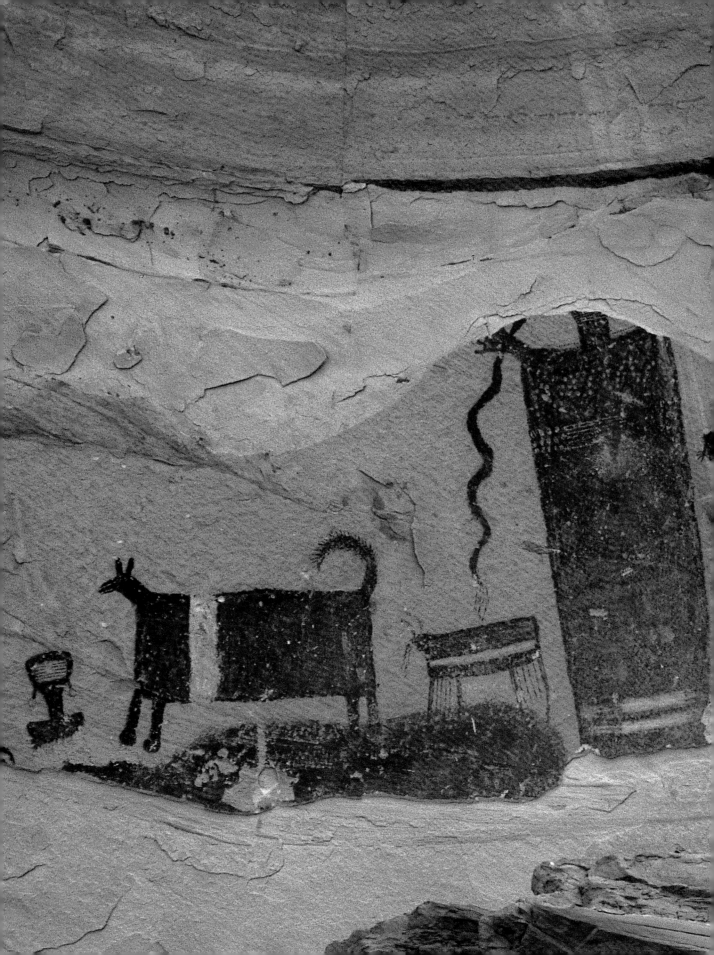

AN ENDANGERED HERITAGE

The millions of rock engravings and paintings that are found throughout the world could be said to constitute the greatest art museum on the planet, a vast natural gallery representing the more than forty thousand years during which humanity has attempted to express an inner vision of life. But this museum's remarkable collection is almost entirely unprotected from the ravages of both nature and man.[1]

FIGURE 7.1
Natural exfoliation of the walls has amputated this magnificent frieze in Temple Mountain Wash, Utah. Since this photo was taken, the frieze has been further damaged by vandals, who have marked it with graffiti.
Photo by J. Clottes

This situation is not new. From its very beginnings, rock art has had an ephemeral existence at best; over the millennia countless paintings have vanished. To understand how much of this heritage has disappeared, let us consider works from the European Paleolithic, which are better preserved than many other types of rock art because they were made in deep caverns. There are fewer than three hundred known painted caves, stretching from the Urals to the southern Iberian Peninsula. Though this may seem like a fair number, it is actually quite small given the immensity of this region and the hundreds of centuries during which the art has been made. For this tradition to have been perpetuated over so many millennia, knowledge and techniques must have been transmitted from one generation to the next, from one people to the next; it is therefore reasonable to calculate that there were once thousands—perhaps tens of thousands—of such sanctuaries. The paintings and engravings that remain with us today represent but an infinitesimal part of the rock art that has been created through the ages.

The surviving works, therefore, are all the more precious (FIGURE 7.1). This is particularly true in light of the fact that today rock art is no longer being created, and that, as a result of human activities, it is perishing much more quickly than ever before. However, we now know the causes of—and have the means to prevent—its disappearance.

Destruction and Deterioration

Many factors contribute to the loss of this heritage. The damage wrought by the elements is the oldest cause. The countless Paleolithic paintings made outdoors obviously could not have survived thousands of years of exposure to sun, rain, sleet, and snow; and works fashioned more recently in countries with harsh climates or in exposed shelters could not last very long either. Rock art sites around the world are in various states of preservation. Some have been badly damaged by water; at others layers of the rock surface have gradually flaked off, and the rock has crumbled and collapsed (FIGURE 7.2). The nature of the rock itself plays a crucial role: for example, certain types of sandstone exfoliate regularly, such that paintings on the surface layer are destroyed. Frost and thaw also break up rock surfaces. Inside caves and shelters, paintings are

FIGURE 7.2
The ineluctable forces of nature gradually damage most rock art sites. At the Cueva de las Manos, in Patagonia, Argentina, many blocks have broken off over the centuries.
Photo by J. Clottes

affected by concretions—deposits of minerals (FIGURE 7.3). In Australia, for example, analyses of samples taken from apparently bare walls have revealed several layers of paint that were covered with deposits and rendered invisible.[2] At some outdoor sites the roots of plants have invaded art-bearing rocks, or lichens have settled on or around them.

Animals also play a role in the deterioration of rock art. Bird and insect nests are sometimes built directly on the art; birds soil painted rocks with their droppings; lizards and other small animals slip into the cracks of slightly fissured rocks and break off the crumbling surfaces; large mammals take shade in decorated shelters and rub away the paintings. The latter phenomenon is especially serious in areas where animals are being bred (FIGURE 7.4).

FIGURE 7.3
This Paleolithic drawing of a bison at Réseau Clastres, in Niaux, France, has been covered with calcite.
Photo by J. Clottes

FIGURE 7.4
By rubbing against the wall, the cattle that seek shade in the shelter at Sego Canyon, Utah, have effaced the entire lower half of these ghostlike figures, painted many centuries ago in the Barrier Canyon style.
Photo by J. Clottes

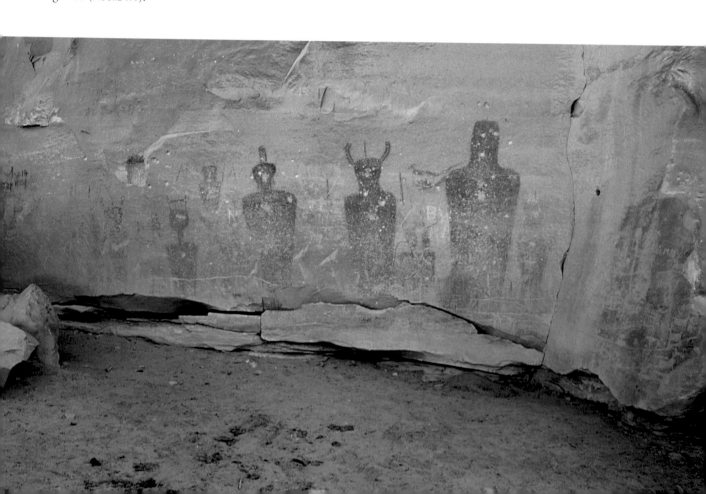

FIGURE 7.5
Before these engravings at Alta, Norway were discovered by rock art researchers, many were damaged during a construction project there.
Photo by J. Clottes

Such damage has been occurring since time immemorial; today, however, humans are responsible for most of the damage to rock art. Sometimes the damage is accidental, sometimes a consequence of development, sometimes intentional, and sometimes a result of tourism.

There are various types of accidental damage. Fires, both accidental and deliberately set (for example, to strip areas of trees or brush) split rocks open and destroy the works they bear. The acid rains of northern Europe, though they may not seem as destructive as fire, are in the long run actually much more dangerous. A relatively recent phenomenon, caused by industrialization and its pollution, such poisonous downpours threaten unprotected Scandinavian rock art with near-total destruction in the next few decades, particularly as the engravings generally have been made not on walls but on horizontal and sloped surfaces that are directly exposed. The rain attacks the rock surface and, along with winter frost, causes the rock to exfoliate. The only solution, aside from eliminating industrial pollution, is to cover the rocks whenever possible.

Development, we know, is disastrous for archaeology in general and for rock art in particular. It is possible to excavate archaeological sites before construction occurs, but painted and engraved rocks are not excavated; they are either preserved or destroyed. Faced with the exigencies of economic growth, rock art preservation is all too often pushed aside. This is true in both industrial and developing countries. Incalculable damage to rock art worldwide has already been caused by the building of roads, dams, quarries, and other projects (FIGURE 7.5). Dams have drowned hundreds of painted sites, including some of major importance. In Norway in the 1940s, the site of Namforsen

was partially destroyed in this way. In the 1950s it was the Dalles, on the Columbia River in the northwestern United States. More recently, tens of thousands of engravings in Portugal's Tagus Valley were covered by water when a dam was built. In the same country, construction of a dam at Foz Côa was halted when hundreds of Paleolithic rock engravings were discovered and a great protest arose—a fine example of how changing views and a courageous political decision can help to save this heritage. But how many priceless paintings and engravings on stone will disappear during the proposed construction of a great dam on one of the major

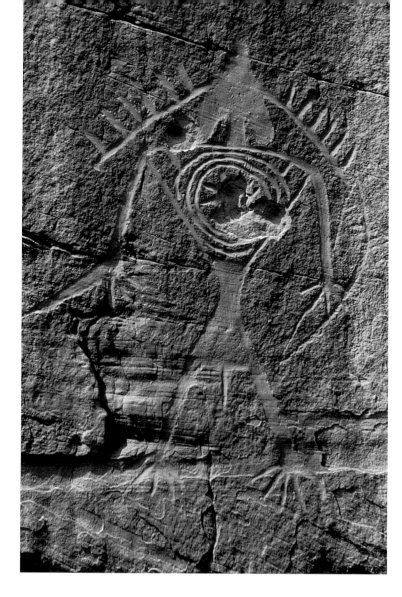

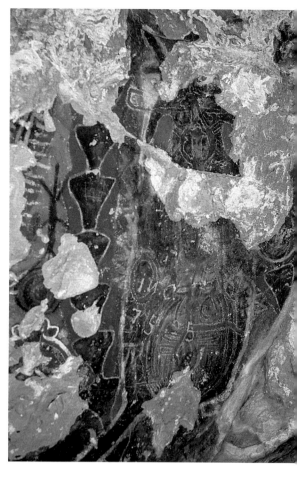

rivers in China? In Peru, blocks decorated with engravings were taken from the Toro Muerto site and used in the construction of houses and of a church in a neighboring village. In Namibia, stone quarries engulf entire sites. And the remarkable Borbón caves in the Dominican Republic are also surrounded by quarries; they too may be destroyed. Unfortunately, there are many such examples all over the world.

Among the factors contributing to the disappearance of rock art worldwide is the loss of traditional practices and knowledge. The art's meaning has often been forgotten, the sacred aura that enveloped it for so long has disappeared, and few people still value it. In instances where some of these practices may continue, the cultures in which they are found have been the victim of prejudice, and have been considered alien or even inferior. This was the case in southern Africa, where the San people were long scorned. In the western United States, many paintings on stone have been destroyed by gunfire (FIGURES 7.6, 7.7), a practice often motivated by hatred for the Indians who made them. Less malevolent in intent, perhaps, but even more destructive, are graffiti, a universal affliction usually the result of ignorance and stupidity, a sort of unconscious vandalism,

FIGURE 7.6 (left)
This petroglyph is one of many at Seyber Canyon, Utah, that was damaged by gunfire—perhaps, as was often the case, motivated by scorn for the Native Americans who made the images.
Photo by J. Clottes

FIGURE 7.7 (above)
The magnificent paintings at Painted Rock, California, were destroyed by gunfire.
Photo by J. Clottes

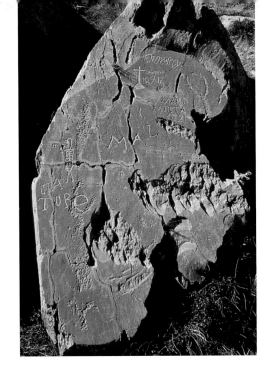

FIGURE 7.8
This decorated rock in
the Vallée des Merveilles,
Mont Bégo, France,
has been marked with
graffiti.
Photo by J. Clottes

FIGURE 7.9 (above)
These drawings, which
imitate Paleolithic paint-
ings, are in fact an
extraordinary form of
graffiti. They were cre-
ated and signed by the
famous French speleolo-
gist Norbert Casteret in
1965, in the painted cave
at Tibiran, France.
Photo by J. Clottes

FIGURE 7.10 (opposite)
The site at Kamkoes,
Namibia, was virtually
destroyed in order to
remove many of these
blocks, which are deco-
rated with engravings
of animal footprints.
Photo by J. Clottes

often practiced by tourists (FIGURES 7.8, 7.9).
The art and knowledge of bygone cultures
can be erased in minutes by such actions,
which could be compared to burning a
library of rare books. Vandalism is so preva-
lent that sites are often kept secret to protect
them from harm.

Indeed, the perverse effects of tourism
can be seen throughout the world. In
southern Morocco, decorated blocks are
systematically broken up, hauled away in
four-wheel-drive vehicles, and sold in the
souk. Engraved and painted rocks small
enough to be carried are simply taken away;
others are broken up with chisels and ham-
mers and carried off in pieces. Such occur-
rences have been reported at sites from
France to the United States, from Peru to
Namibia (FIGURE 7.10).

Even cultural tourism can imperil rock
art sites. When paintings have grown faint,
either because they have faded over time or
been exposed to the elements, some people
wet them to brighten their colors and get
better photographs. Repeated dousings mod-
ify the paint and its rock support chemically
and microbiologically and destroy the
dynamic balance between the rock and the
atmosphere.[3] The long-term consequences
are disastrous with water and are even worse
when other liquids are used.

Drawing over rock art and rescraping
engravings are equally reprehensible prac-
tices. They have the same goal as wetting:
to render the figure more readable and
make photography possible. Throughout
the world, one can see blurry engravings
whose contours have been heightened with
chalk (FIGURE 7.11) or sharpened by rescrap-
ing, which irreparably destroys the prehis-
toric line.

A similar selfish attitude—the willing-
ness to ruin an original artwork to preserve
a copy of it for oneself—motivates amateur

FIGURE 7.11 (above)
In order to make them more visible, often for purposes of tourism and photography, faint engravings, such as these at Kalleby, in Tanum, Sweden, have sometimes been drawn over with chalk. From a conservation point of view, this practice is undesirable for several reasons: It ruins the original line, it can compromise future dating, and it is a subjective process that risks misrepresenting the art.
Photo by J. Clottes

FIGURE 7.12 (above, right)
Careless molding by rock art enthusiasts seeking a copy of the art for themselves ruined these engravings of horses at Kori Elailei, Niger.
Photo by J. Clottes

casters. Lacking the necessary skills, they nevertheless proceed to mold rock engravings. When they remove the mold, traces of latex or silicone stick indelibly to the surface of the rock and the appearance of the work of art is compromised permanently (FIGURE 7.12). Often the mold, when being stripped from the surface, removes the patina of age; but what is worse, chemical contamination very likely will invalidate future analysis—particularly dating.

Without being overly pessimistic, we can be certain that a great deal of rock art will be destroyed in the coming decades. This heritage is in very serious danger.

The Challenge of Preservation

Saving this worldwide heritage is obviously a monumental task. Where should our priorities lie? Should we attempt to save it all? Should we focus on the oldest, the most spectacular, the rarest examples, those that are most threatened? If it is not possible to save all, how much of the scarce resources available should be allocated to documentation of the art that will certainly be lost, how much to protection and conservation, how much to public education, and how much to opening sites for public visitation and tourism? When sites are visited, what is the cost to the community of maintaining them, monitoring their condition, and interpreting them? Can such sites be economically self-sustaining or even generate benefit; put bluntly, can they make a profit? In times of economic stringency, hard decisions are needed. These and other conundrums face conservationists and cultural heritage managers throughout the world.

The situation facing rock art varies from country to country, depending on the number of sites, how isolated they are, their relevance for the dominant culture, the density of the population, and many other factors. Sites are occasionally classified as monuments of historical or cultural significance and thus benefit from legal protection. For the most part, however, they are not protected in this way. Only thirteen groups of rock art sites as such have been placed on UNESCO's World Heritage List: they are found in Algeria (Tassili-n'Ajjer), Libya (Acacus), Argentina (Cueva de los Manos), Australia (Kakadu), Brazil (Capivara), Mexico (Sierra de San Francisco), Spain (Altamira; the Levant), Portugal (Foz Côa), France (La Vézère), Italy (Valcamonica), Sweden (Tanum), and Norway (Alta).

Just as early attempts at interpretation of rock art were often hampered by the cultural biases of the West, preservation of rock art, particularly that outside of Europe, has also been hampered. The traditional view of experts, who are often from outside the region, about how rock art should be valued and managed in various parts of the world has often ignored the views of local populations, with their affiliations and cultural connections to the art. Small wonder that imposed solutions have not taken root and conservation measures have not proven effective. In some instances, in Africa in particular, physical protection barriers and the like have been vandalized or exploited by the local people as building materials, or put to other uses. All this can change rapidly when local communities have a stake in and a potential benefit from the sites. Miserable management failures can be transformed into success stories.

Strategies will inevitably vary from one site or one region or country to another. Generally, though, we can say that the successful preservation of rock art requires several kinds of related activities. There is of course the conservation of the art itself and its immediate environment. Also necessary is the dissemination of knowledge about particular sites, as well as broad campaigns to inform the public about the need to preserve them. Finally, new strategies are being developed to conserve rock art that bring local populations into the process, giving them back a stake in their heritage and their future (see overleaf).

In recent decades, traditional views that denigrated indigenous populations have been changing, in such countries as South Africa, the United States, and Australia. The opinion and influence of indigenous populations fortunately carry more and more

Cueva del Ratón, or Cave of the Mouse, was named for the creature depicted in the corner of this image, below a large bichrome human figure with hands upraised. The name has persisted, though today the image is interpreted not as a mouse, but as a puma or mountain lion.

Photo by Neville Agnew

Conservation team members examine paintings on the ceiling of Cueva del Ratón. Many caves have painted ceilings well out of reach. It is thought that the makers of the art also must have used ladders or scaffolding.

Raised wooden walkways with viewing bays and interpretive panels run the length of the site.

Photos by N. Stanley-Price

PRESERVING THE ROCK ART OF BAJA CALIFORNIA

by Neville Agnew

In Mexico's Baja California Sur, the long, rugged peninsula that extends southward from California, spectacular rock art has been known since the eighteenth century. Jesuit missionaries reported seeing painted rock shelters with huge red and black images of human figures, arms typically raised (see pp. 74–75); deer, mountain lions, and other creatures of the region, some mythical; even marine animals such as whales and manta rays, which are still found today in the Gulf of California to the east. Although the shelters were described again at the end of the nineteenth century, it was only in the early 1950s that Baja rock art aficionados began more systematic discovery and recording of the art so long hidden in the deep canyons of the Sierras.

Who the painters were and when the art was made is not really known. The Jesuits reported the legend of the local Cochimí that the paintings had been made by giant people from the north. Even at that time the Jesuits adjudged the art old.[4] From various circumstantial evidence it is cautiously thought today to be between about 500 and 2,000 years old. One carbon 14 date, in dispute, gives 5000 B.P., but dates as early as this need to be checked.

That the art is old, mysterious, impressive in scale, and striking in execution is apparent. It is also true that its significance in the scale of heritage in need of protection was long overlooked. The reasons may be found in the distance of Baja California from the center of government and Mexico's other great archaeological heritage that tended to overshadow this geographic backwater. But gradually, through the efforts of a few dedicated people, recognition came. In 1993 the sites

The rugged terrain of the Sierra de San Francisco. The project site, Cueva del Ratón, is located in the rock wall in the left center.
Photo by N. Stanley-Price

in the Sierra de San Francisco were inscribed on the World Heritage List. Most of these sites are accessible only by foot or on muleback and then only with the help of guides from the mountain villages of the region. By this time, however, a thriving adventure tourism industry to the sites had developed, mainly for visitors from the United States. Local guides participated in conducting tourists to the more accessible sites. It became urgent to develop management and conservation plans to safeguard these sites.

In 1994 the Instituto Nacional de Antropología e Historia (INAH), the GCI, the government of the state of Baja California Sur, and AMISUD (a private organization dedicated to conservation and knowledge of Baja California Sur's cultural heritage) launched a project to conserve and manage the area's sites. The objectives went beyond the sites of the region through the participation of conservators from Mexico, Argentina, Bolivia, and Chile, and through the involvement and consensus of local people in developing a conservation and management plan. One of the most accessible and therefore most visited sites, Cueva del Ratón, was chosen as the prototype for the project.

Extensive documentation of the art was undertaken, causes of natural deterioration were investigated, photographs were examined for evidence of the rate of deterioration, in particular to ascertain whether accelerated deterioration was occurring, and walkways for visitors and interpretive signage were erected. INAH set up a museum and visitor center in San Ignacio, the nearest town, where trips to the Sierra de San Francisco can be arranged. What had been at best a curiosity, forgotten by authorities and appreciated only by a few specialists, is now widely acknowledged as being of the first significance and a vital source of employment and income for the local community. Today villagers benefit economically from their work as guides to the remote sites, as outfitters, and as effective custodians. This strategy of making local people partners in decision making and the principal beneficiaries of the use and management of their heritage is one that is increasingly being adopted as practical and sensible. Indeed, it is almost the only strategy that can be envisioned as sustainable in the long term.

The approach to the site from the road below. The site has been fenced, an access path constructed, and information panels installed.
Photo by N. Stanley-Price

weight. When a freeway was proposed that would have cut across Petroglyph National Monument, near Albuquerque, New Mexico, for example, Pueblo spiritual leaders revealed that these engravings were still very important to them—no one outside their community knew that religious practices were still taking place on the site.[5]

Similarly, rock art initiatives like the one in Baja are becoming the norm in many areas of the world, as government officials, conservators, and site managers recognize the realities of the challenges that confront preservation of a global cultural heritage increasingly under threat from development, population growth, and burgeoning tourism. An ambitious program was launched in 1995 for southern Africa. Here the World Heritage Centre and the International Council on Monuments and Sites (ICOMOS) developed a regional management strategy that brought together representatives from most countries in the subcontinent. This project, the Southern African Rock Art Project (SARAP), has continued with annual meetings in South Africa, Zimbabwe, Tanzania, and Zambia supported by various international agencies, including the GCI, with a focus on collaborative exchange of information, recording, data management, and site protection and management.

In Australia, involvement of the aboriginal leaders and community in decisions on their rock art sites, which are regarded as sacred, has long been practiced. Some of these sites are among the best managed in the world.

Such strategies are also based on the understanding that it is not enough to preserve the rocks themselves; the larger cultural and environmental contexts in which the art exists must be addressed as well.

Since rock art derives so much of its meaning from the landscapes where it is located, the protection of the surrounding environment is particularly important. It is easier to protect art that is located in caves or shelters that can be closed off (as in France and Spain) than it is to protect art found in the open air. One solution is to build a fence around the art. In the best cases, which are quite rare, the fences blend in with the landscape without spoiling it (as in Valltorta, Spain). At times, the protection is symbolic: a taut cord or low barrier is usually enough for most visitors (as in Australia). The best solution by far is the national or cultural park, and fortunately, more of them are being established (Kakadu in Australia, Naquane in Italy, Mercantour and Mont Bégo in France, the parks of Aragón in Spain, etc.). In these parks visitors' paths are organized, guards watch over the sites, and abundant information is available. The Petroglyph National Monument in Albuquerque has drawn some one hundred thousand people annually since it opened, and there are fewer acts of vandalism than when the area was less visited.

The creation of parks also helps to disseminate information on rock art and its cultural relevance. Museums (Alta, Valltorta) do the same thing. Interpretation centers and visitor centers, where documentation is provided to tourists, have also proven valuable. In addition, visitors must be given a sense of responsibility for helping to preserve the art. At some sites in South Africa, in the Drakensberg, for example, authoritarian signs ("Do not go beyond this point!") proved to have little effect. When they were replaced by signs appealing to the intelligence and public-mindedness of the tourists ("Deal with the art as if it were a Rembrandt"), there was less vandalism.[6]

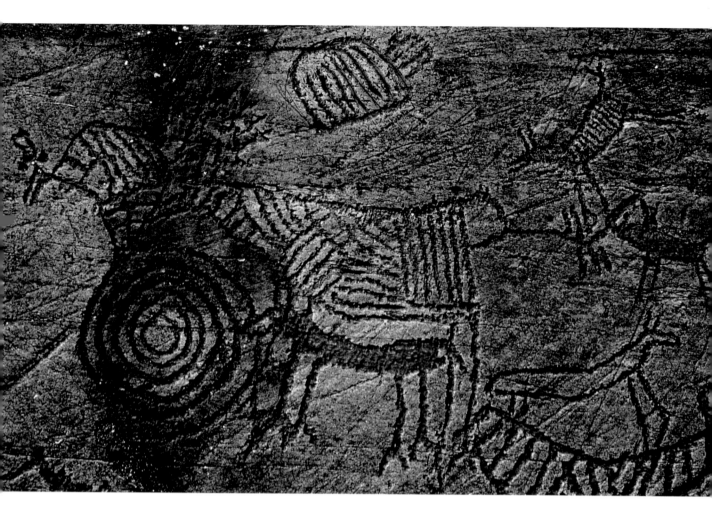

FIGURE 7.13

These engravings at Ausevik, Norway, often almost invisible in the overcast weather typical of the region, have been painted by museum specialists using biodegradable paint. This serves to make them more visible as well as to protect them from tourists and guides who would touch them up with chalk or sharpen them by rescraping, thereby irreparably damaging the original petroglyph. The practice of protective coating, however, is not favored by some specialists, who oppose any direct treatment of the art.

Photo by J. Clottes

Scientific approaches to the conservation of the art itself also continue to evolve. Currently studies are being carried out in a number of countries on various aspects of rock art conservation. Many studies focus on the geologic, chemical, and physical conditions of deteriorating rocks, to find ways to intervene in the process of deterioration. Many more such studies are needed, for each case is unique, and they must always take into consideration both the threatened rock and its environmental context, from which the art cannot be separated. In the meantime, specific solutions must be found and applied immediately.

For decades now, rock engravings in Scandinavia, practically invisible in overcast weather, which is the case most of the year, have been painted periodically so that they will be more visible (FIGURE 7.13; see also FIGURES 3.2, 5.11, 6.15, and 7.5). This painting, which is done by museum specialists using biodegradable paint, has proven to have several benefits: it both emphasizes the engravings for tourists and prevents acts of vandalism, such as touching up fading engravings with a little chalk or with a stone.[7]

The practice of protective painting has provoked criticism from some specialists. In theory, works must never be touched, for any direct action on them is likely to jeopardize future analyses of rock surfaces or patinations. In addition, painting engraved rocks, in cases in which the original engravings have eroded, often calls for subjective interpretation of the ancient image. In fact, conservators have increasingly realized that physical interventions on rock art, whether by means of consolidants to harden the rock or coatings to protect the art, and protective barriers are often useless at best or harmful in the long run, and invariably direct treatment of the art with chemicals compromises the possibility of future analyses and dating.

While this is true, only a very small percentage of Scandinavian engravings (those pointed out to tourists) are actually painted, and the others are left as they are. It will always be possible to make further analyses of those that have not been retouched. The danger of vandalism is much more serious. Consequently, the method adopted by our Scandinavian colleagues seems efficient, safe, and well adapted to local conditions.

Finally, promoting awareness of the value of rock art must be made a priority, for significant progress in protecting it can be made only when protection and preservation are seen as absolute necessities and not as secondary in relation to economic or tourist imperatives. It is now understood that the need for public education and involvement in decision making, economic benefit, and documentation of the art is crucial. This is an essential management and conservation strategy that seeks to preserve and interpret the art while building local capability. This is an issue of cultural education and promotion in the broadest sense. In this area, the shortcomings are glaring: few universities include the study of rock art, except superficially, in their curricula. While there are books being published, television documentaries aired, and exhibits organized occasionally, continuous, concentrated efforts are necessary to make the public sensitive to this issue.

Conserving the Memory of Rock Art

We cannot know in advance which sites will be destroyed in the coming decades. As all losses are irreparable, it is imperative to document anything that could be lost. This means making drawings, taking photographs, and carefully describing the art.

We are able to reproduce rock art images in various ways. Modern techniques such as photogrammetry, photography, and laser recordings allow us to faithfully reproduce painted rock surfaces in their entirety. These techniques, applied primarily to paintings, are used less often to record engravings. In many cases open-air rock engravings can be molded with elastomers, which is less expensive and gives comparable results. It is obviously imperative that the molding be done by professionals, as occurred recently in Niger (FIGURE 7.14), for it must not in any way damage the original.

The technique of reproduction has been fully tested in Lascaux, with the replication

of the major works of this famous cave. The replica cave, Lascaux II, receives some two hundred fifty thousand visitors annually. The significance of reproductions for painting—like that of moldings for engraving on resistant rock surfaces—is profound: replicating works on their natural surfaces allows us to save a fragile art threatened with long-term destruction. Also, in a reproduction it is possible to render deteriorated paintings as they were when they were originally created, provided that documents or techniques (photography, ultraviolet light, infrared) can reveal their original state, as was done in the Grotte de Niaux in the Parc Pyrénéen d'Art Préhistorique at Tarascon-sur-Ariège. In this case, the reproduction is closer to the prehistoric reality than the original in its current state. Finally, reproductions constitute spectacular museographic documents that can be lighted and viewed in the best possible conditions, in exhibits, museums, and other permanent structures easily accessible to the public.[8]

Also important is the development of appropriate centers for rock art documentation and study. A few centers exist, such as the Centro Camuno di Studi Preistorici in Italy, which houses the World Archive of Rock Art (WARA); the Rock Art Archive at the University of California, Los Angeles (UCLA); the Tanum Center in Sweden; the

FIGURE 7.14
When engravings are under threat of destruction, molding is sometimes contemplated. Such work must be carried out by professionals, as was done with the great Dabous giraffes in Niger. The mold is made of elastomer, a plastic that is applied in liquid form, sets into a pliable solid, and then is carefully removed—the step shown here. Positive replica casts are then made. One replica was installed in the airport of the nearby town of Agadez, another went to the National Geographic Society.
Photo by J. Clottes

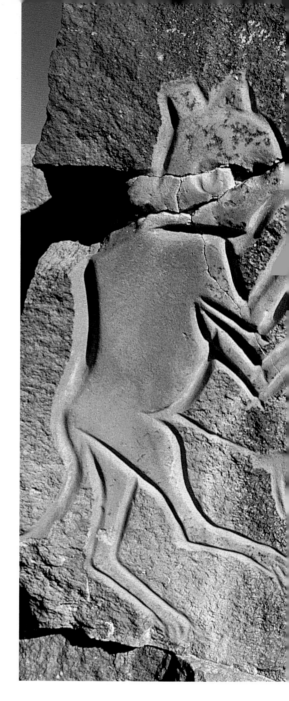

FIGURE 7.15
These two engravings of feline forms, facing each other on a rock in the Messak region of Libya, are in the process of naturally deteriorating; they could be said to symbolize the beauty, vulnerability, and mystery of the world's rock art.

Photo by David Coulson, Trust for African Rock Art (TARA)

Indira Gandhi Museum of Rock Art in New Delhi, India; the Rock Art Research Institute at the University of the Witwatersrand in Johannesburg, South Africa; the Centre national de Préhistoire, at Perigueux, France, and others dedicated to their respective regions or countries. An extensive database of rock art literature, with more than 10,500 entries, recently became available online at the web site of the Bancroft Library, University of California, Berkeley. But means are limited and time is short. The ideal would be a center for world rock art documentation. It would allow specialists to develop standardized protocols in the collecting and managing of such documentation; it would disseminate information to be used for exhibits, preservation, and research; and it could preserve the documentation—photographs, drawings, and so on—under the best possible conditions.

The role of the volunteer amateur rock art aficionado has also long been an important one in locating, recording, and protecting sites. UCLA's Rock Art Archive, for example, organizes field campaigns to sites in California, where enthusiastic and dedicated volunteers, some of whom are aerospace scientists or other highly qualified specialists in their own fields, participate actively in their spare time. Such is the appeal of rock art for the public once it realizes the extraordinary heritage that is often to be found almost at its doorstep.

The world's rock art is part of the book of humanity's past (FIGURE 7.15). Although often only vaguely decipherable now, as we fill in the great gaps in our knowledge of the archaeological record—of which rock art is part—more and more of its meanings may be understood. Looking at the paintings in the caves of Lascaux or in the mountain fortresses of the Drakensberg, we see, at once and with startling force, that there was another time for this place. Another's feet stood where ours stand, another's hand reached out to the rock face in front of us, a hand that traced the line of an aurochs or an antelope. Wipe that line away and that distant human being is, in a very real sense, expunged as well. Worse, the future is also diminished, for generations to come are deprived of their right to look back down the centuries and wonder.

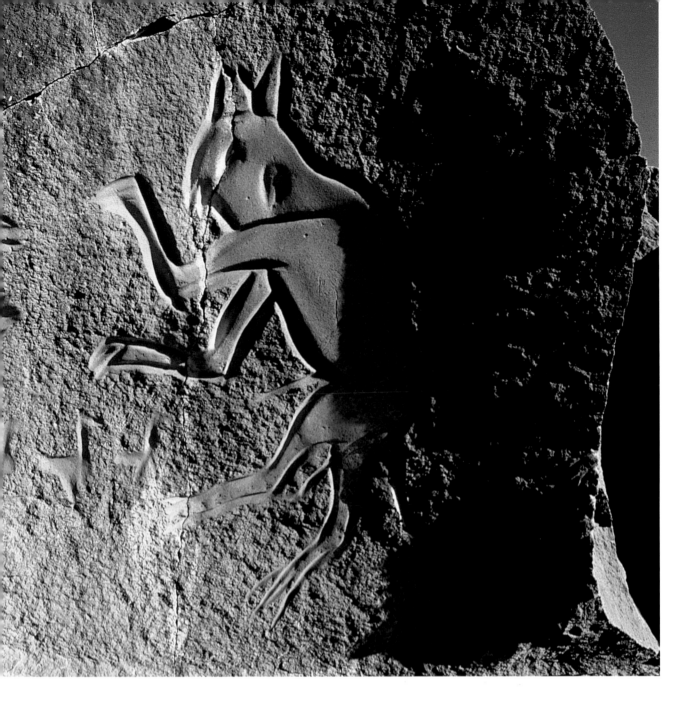

NOTES

1 The following discussion of rock art conservation was written in collaboration with Neville Agnew.

2 A. Watchman, "Repainting or Periodic Painting at Australian Aboriginal Sites: Evidence from Rock Surface Crusts," in *Retouch: Maintenance and Conservation of Aboriginal Rock Imagery,* ed. G. K. Ward (Melbourne: Archaeological Publications, 1992), 26–30.

3 F. Soleilhavoup, "Un art en péril," *Le Courrier de l'UNESCO,* April 1998, 29–31.

4 See Harry W. Crosby, *The Cave Paintings of Baja California: Discovering the Great Murals of an Unknown People* (San Diego: Sunbelt Publications, 1997).

5 B. Weakkee, "Petroglyph Area Is Sacred Place for New Mexico Pueblos," in *La Pintura* 23, no. 2 (1996): 1–2.

6 G. Blundell, paper delivered at the Périgueux Symposium, October 24, 1998.

7 K. Michelsen, "Conservation of Rock Art in Norway," in *Conservation, Preservation and Presentation of Rock Art,* ed. G. Mandt, K. Michelsen, and K. Hauge Riisoen, (1992), 17–52.

8 Clottes, *Rock Art.*

BIBLIOGRAPHY

General

Anati, E. *L'art rupestre dans le monde: L'imaginaire de la préhistoire.* Paris: Bordas, 1997.
———. *World Rock Art: The Primordial Language.* Capo di Ponte: Centro Camuno di Studi Preistorici, 1993.
———, ed. *Preservation and Presentation of Rock Art, 1981–1983.* Paris: UNESCO, 1984.
Bahn, P. G. *The Cambridge Illustrated History of Prehistoric Art.* Cambridge: Cambridge University Press, 1998.
Bahn, P. G., and A. Fossati, eds. *Rock Art Studies: News of the World I.* Oxford: Oxbow Books, 1996.
Brodrick, A. Houghton. *The Abbé Breuil, Prehistorian.* London: Hutchinson & Co., 1963.
Chippindale, C., and P. S. C. Taçon, eds. *The Archaeology of Rock Art.* Cambridge: Cambridge University Press, 1998.
Clottes, J. "La piste du chamanisme." *Le Courrier de l'UNESCO,* April 1998, 24–28.
———. *Rock Art: A Universal Cultural Message.* Paris: UNESCO, 1997.
———. *Le Musée des roches. L'Art rupestre dans le monde.* Paris: Seuil, 2000.
Conkey, M., O. Soffer, D. Stratmann, and N. G. Jablonski, eds. *Beyond Art: Pleistocene Image and Symbol.* San Francisco: California Academy of Sciences, 1997.
David, B., and J. Flood. "On Form and Meaning in Rock Art Research." *Rock Art Research 8,* no. 2 (1991): 130–31.
Helskog, K., and B. Olsen, eds. *Perceiving Rock Art: Social and Political Perspectives.* Oslo: Novus Forlag, 1995.
International Newletter on Rock Art (INORA, 11 rue du Fourcat, 09000 Foix, France).
Klassen, M. A. "Towards a Mindscape of Landscape: Rock Art as Expression of World Understanding." In *The Archaeology of Rock Art,* ed. C. Chippindale and P. S. C. Taçon, 42–72. Cambridge: Cambridge University Press, 1998.
Lemaire, C. *Rêves éveillés.* Paris: Les Empêcheurs de Penser en Rond, 1991.
Lorblanchet, M. *La naissance de l'art: Genèse de l'art préhistorique dans le monde.* Paris: Errance, 1999.
Morphy, H., ed. *Animals into Art.* London: Unwin Hyman, 1989.
Nougier, L. R. *L'art de la préhistoire.* Paris: Librairie Générale Française, La Pochothèque, 1993.
Rock Art Research (P.O. Box 216, Caulfield South, Viv. 3162, Australia).
Soleilhavoup, F. "Un art en péril." *Le Courrier de l'UNESCO,* April 1988, 29–31.
Ucko, P. J. *Form in Indigenous Art.* London: Duckworth, 1977.
Vialou, D. *La préhistoire.* Paris: Gallimard, 1991.

Africa

Bailloud, G. *Art rupestre en Ennedi: Looking for Rock Paintings and Engravings in the Ennedi Hills.* Saint-Maur: Ed. Sépia, 1997.
Coulson, D., and A. Campbell. *African Rock Art: Paintings and Engravings on Stone.* New York: Harry Abrams, 2001.
Dowson, T. A. *Rock Engravings of Southern Africa.* Johannesburg: Witwatersrand University Press, 1992.
Garlake, P. *The Hunter's Vision: The Prehistoric Art of Zimbabwe.* London: British Museum Press, 1995.
Gauthier, Y., C. Gauthier, A. Morel, and T. Tillet. *L'art du Sahara.* Archives des Sables. Paris: Le Seuil, 1996.
Gutierrez, M. *L'art pariétal de l'Angola.* Paris: L'Harmattan, 1996.
Hachid, M. *Le Tassili des Ajjer: Aux sources de l'Afrique 50 siècles avant les Pyramides.* Paris: Ed. Paris-Méditerranée, 1998.
Henshilwood, C., and J. Sealy. "Blombos Cave: Exciting New Finds from the Middle Stone Age." *Digging Stick* 15 (1998): 1:1–4.
Le Quellec, J. L. *Art rupestre et préhistoire au Sahara: Le Messak libyen.* Paris: L'Harmattan, 1998.
———. *Symbolisme et art rupestre au Sahara.* Paris: L'Harmattan, 1993.
Lewis-Williams, D., and G. Blundell. *Fragile Heritage: A Rock Art Fieldguide.* Johannesburg: Witwatersrand University Press, 1998.
Lewis-Williams, D., and T. Dowson. *Images of Power: Understanding Bushman Rock Art.* Johannesburg: Southern Book Publishers, 1989.
Lewis-Williams, D., T. Dowson, and J. Deacon. "Rock Art and Changing Perceptions of Southern Africa's Past: Ezeljagdspoort Reviewed." *Antiquity* 67 (1993): 273–91.
Muzzolini, A. *Les images rupestres du Sahara.* Toulouse: Alfred Muzzolini, 1995.
Pager, H. *The Rock Paintings of the Upper Brandberg. Part I. Amis Gorge. Part II. Hungorob Gorge. Part III. Southern Gorges.* Köln: Heinrich Barth Institut, 1989, 1993, 1995.
Van Albada, A. and A.-M. *La Montage des Hommes-Chiens. Art rupestre du Messak libyen.* Paris: Seuil, 2000.

The Americas

Brody, J. J. *The Anasazi: Ancient Indian People of the American Southwest.* New York: Rizzoli, 1990.
Cole, S. J. *Legacy on Stone: Rock Art of the Colorado Plateau and Four Corners Region.* Boulder: Johnson Books, 1990.
Conway, T. *Painted Dreams: Native American Rock Art.* Minocqua, Wis.: NorthWord, 1993.
Crosby, Harry W. *The Cave Paintings of Baja California: Discovering the Great Murals of an Unknown People.* San Diego: Sunbelt Publications, 1997.
Dubelaar, C. N. *The Petroglyphs of the Lesser Antilles, the Virgin Islands and Trinidad.* Amsterdam: Natuurwetenschappelijke Studiekring voor het Caraïbisch Gebied, 1995.

Guidon, N. *Peintures préhistoriques du Brésil*. Paris: ERC, 1991.

Malotki, E., and Donald E. Weaver, Jr. *Stone Chisel and Yucca Brush: Colorado Plateau Rock Art*. Walnut, Calif.: Kiva Publishing, 2002.

Keyser, J. D. *Indian Rock Art of the Columbia Plateau*. Seattle: University of Washington Press, 1992.

McCreery, P., and E. Malotki. *Tapamveni: The Rock Art Galleries of Petrified Forest and Beyond*. Petrified Forest: Petrified Forest Museum, 1994.

Nuñez Jiménez, A. *Petroglifos del Peru*. Havana: Editorial Científico Técnico, 1986.

Querejazu Lewis, R. "Contemporary Indigenous Use of Traditional Rock Art at Yarque, Bolivia." *Rock Art Research* 11, no. 1 (1994): 3–9.

———, ed. *Arte rupestre colonial y republicano de Bolivia y paises vecinos*. La Paz: SIARB, 1992.

Rajnovich, G. 1994. *Reading Rock Art: Interpreting the Indian Rock Paintings of the Canadian Shield*. Toronto: Natural Heritage/Natural History, 1994.

Schaafsma, P. *Rock Art in New Mexico*. Santa Fe: Museum of New Mexico Press, 1992.

Schobinger, J. *L'arte di primi americani*. Milan: Jaca, 1997.

Schobinger, J., and C. J. Gradin. *L'arte delle Ande e della Patagonia*. Milan: Jaca, 1985.

Steinbring, J., ed. *Rock Art Studies in the Americas*. Oxford: Oxbow Books, 1994.

Turpin, S. A., ed. *Shamanism and Rock Art in North America*. San Antonio: Rock Art Foundation, 1994.

Waters, F. *Book of the Hopi*. New York: Penguin Books, 1977.

Wellmann, K. F. *A Survey of North American Indian Rock Art*. Graz: Akademische Druck- und Verlagsanstalt, 1979.

Whitley, D. S. *The Art of the Shamans: Rock Art of California*. Salt Lake City: University of Utah Press, 2000.

———. *A Guide to Rock Art Sites: Southern California and Southern Nevada*. Missoula: Mountain Press, 1996.

Whitley, D. S. et al. "Recent Advances in Petroglyph Dating and Their Implications for the Pre-Clovis Occupation of North America." *Proceedings of the Society for California Archaeology* 9 (1996): 92–103.

Young, M. J. *Signs from the Ancestors: Zuni Cultural Symbolism and Perceptions of Rock Art*. Albuquerque: University of New Mexico Press, 1988.

Zintgraff, J., and S. A. Turpin. *Pecos River Rock Art*. San Antonio: Sandy McPherson Publishing, 1991.

Asia

Anati, E. *L'arte rupestre del Negev e del Sinai*. Milan: Jaca Book, 1979.

Blednova, N. et al. *Répertoire des pétroglyphes d'Asie Centrale. Sibérie du Sud 2: Tepsej I-III, Ust'-Tuba I-VI (Russie, Khakassie)*. Paris: Diffusion de Boccard, 1995.

Chakravarty, K., and R. G. Bednarik. *Indian Rock Art and Its Global Context*. Delhi: Motilal Banarsidass Publishers and Indira Gandhi Rashtriya Manav Sangrahalaya, 1997.

Garcia, M. A., and M. Rachad. *L'art des origines au Yémen*. Paris: Le Seuil, 1997.

Khan, M. *Prehistoric Rock Art of Northern Saudi Arabia*. Riyadh: Ministry of Education, Department of Antiquities and Museums, 1993.

Kubarev, V. D., and E. Jacobson. *Répertoire des pétroglyphes d'Asie Centrale. Sibérie du Sud 3: Kalbak-Tash I (République de l'Altai)*. Paris: Diffusion de Boccard, 1996.

Martynov, A. I. *The Ancient Art of Northern Asia*. Urbana: University of Illinois Press, 1991.

Mathpal, Y. *Rock Art in Kumaon Himalaya*. New Delhi: Indira Gandhi National Centre for the Arts, 1995.

Munier, C. *Sacred Rocks and Buddhist Caves in Thailand*. Bangkok: White Lotus, 1988.

Sher, J. A. *Répertoire des pétroglyphes d'Asie Centrale. Sibérie du Sud 1: Oglakhty I-III (Russie, Khakassie)*. Paris: Diffusion de Boccard, 1994.

Zhao Fu, C. *Découverte de l'art préhistorique en Chine*. Paris: Albin Michel, 1988.

Europe

Anati, E. *Valcamonica Rock Art: A New History for Europe*. Capo di Ponte: Centro Camuno di Studi Preistorici, 1994.

L'art des cavernes. Atlas des grottes ornées paléolithiques françaises. Paris: Ministère de la Culture—Imprimerie nationale, 1984.

Bahn, P. J., and J. Vertut. *Journey through the Ice Age*. London: Weidenfeld & Nicolson, 1977.

Beltrán, A. *Rock Art of the Spanish Levant*. Cambridge: Cambridge University Press, 1982.

Brunet, J., and J. Vouvé, eds. *La conservation des grottes ornées*. Paris: Ministère de la Culture–CNRS, 1996.

Chapa Brunet, T., and M. Menéndez Fernandez, eds. *Arte paleolítico*. Madrid: Ed. Complutense, 1994.

Chauvet, J. M., E. Brunel-Deschamps, and C. Hillaire. *Dawn of Art: The Discovery of the Chauvet Cave*. New York: Harry Abrams, 1996.

Clottes, J. "Paint Analyses from Several Magdalenian Caves in the Ariège Region of France." *Journal of Archeological Science* 20 (1993): 223–35.

———. *Voyage en préhistoire: L'art des cavernes et des abris, de la découverte à l'interprétation*. Paris: La Maison des Roches, 1998.

Clottes, J., and J. Courtin. *The Cave beneath the Sea: Paleolithic Images at Cosquer*. New York: Harry Abrams, 1996.

———, ed. *La Grotte Chauvet. L'Art des origines*. Paris: Seuil, 2001.

Clottes, J., and D. Lewis-Williams. *The Shamans of the Caves: Trance and Magic in the Painted Caves*. New York: Harry Abrams, 1998.

Coles, J., and L. Bengtsson. *Images of the Past: A Guide to the Rock Carvings and Other Monuments of Northern Bohuslän*. Uddevalla: Hällristningsmuseet Vitlycke, 1990.

Freeman, L. G., and J. González Echegaray. *La grotte d'Altamira*. Paris: La Maison des Roches, 2001.

Groenen, M. *Ombre et lumière dans l'art des grottes.* Brussels: Université Libre, 1997.

Leroi-Gourhan, A. *Préhistoire de l'art occidental.* Paris: Citadelles et Mazenod, 1995.

Lorblanchet, M. *Les grottes ornées de la préhistoire. Nouveaux Regards.* Paris: Errance, 1995.

Lumley, H. de. *Le grandiose et le sacré: Gravures rupestres protohistoriques et historiques de la région du Mont Bégo.* Aix-en-Provence: Edisud, 1995.

Roussot, A. *L'art préhistorique.* Bordeaux: Ed. Sud-Ouest, 1994.

Saura Ramos, P. A., and A. Beltrán, eds. *Altamira.* Paris: Le Seuil, 1998.

Oceania

Arden, H. *Dreamkeepers: A Spirit-Journey into Aboriginal Australia.* New York: HarperCollins, 1994.

Bahn, P. G., and J. Flenley. *Easter Island, Earth Island.* New York: Thames & Hudson, 1992.

Chaloupka, G. *Journey in Time: The World's Longest Continuing Art Tradition. The 50,000-Year Story of the Australian Aboriginal Rock Art of Arnhem Land.* Chatswood: Reed, 1993.

Cowan, J. *Sacred Places in Australia.* East Roseville: Simon and Schuster, 1991.

Flood, J. 1997. *Rock Art of the Dreamtime.* Sydney: HarperCollins, 1997.

Jelinek, *The Great Art of the Early Australians.* Brno: Moravian Museum–Anthropos Institute, 1989.

Lawlor, R. *Voices of the First Day: Awakening in the Aboriginal Time.* Rochester: Inner Traditions International, 1991.

Layton, R. *Australian Rock Art: A New Synthesis.* Cambridge: Cambridge University Press, 1992.

———. "Relecture de l'art rupestre du nord de l'Australie." *L'Anthropologie* 99, nos. 2–3 (1995): 467–77.

Lee, G. *The Rock Art of Easter Island: Symbols of Power, Prayers to the Gods.* Los Angeles: UCLA Institute of Archaeology, 1992.

Lee, G., and E. Stasack. *Spirit of Place: The Petroglyphs of Hawai'i.* Los Osos: Bearsville and Cloud Mountain Presses, 1999.

Lommel, A. *The Unambal: A Tribe in North West Australia.* Carnavon Gorge: Tararakka Nowan Kas Publications, 1997.

Mowaljarlai, D., and J. Malnic. *Yorro, Yorro: Everything Standing Up Alive. Spirit of the Kimberley.* Broome: Magabala Books Aboriginal Corp., 1993.

Njarjno, Ungudman, Banggal, and Nyawarra. *Gwion Gwion.* Cologne: Könemann, 2000.

O'Connor, S. "Carpenter's Gap Rockshelter I: 40,000 Years of Aboriginal Occupation in the Napier Ranges, Kimberley, W.A." *Australian Archaeology* 40 (1995): 58–59.

Trezise, P. *Dream Road.* St Leonards: Allen & Unwin, 1993.

Walsh, G. L. *Australia's Greatest Rock Art.* Bathurst: E. J. Brill–Robert Brown & Assoc., 1988.

———. *Bradshaws: Ancient Rock Paintings of North-West Australia.* Geneva: Bradshaw Foundation, 1994.

ACKNOWLEDGMENTS

Perhaps the oldest form of creative and artistic expression, rock art is among the great treasures of humanity. Today millions of images throughout the world afford us privileged glimpses into the beliefs and worldviews of long-vanished cultures. We are delighted to publish this book, in the hope that it will convey to the general reader the remarkable richness of rock art and the importance of preserving this precious heritage for future generations. We are grateful to Jean Clottes for taking on the challenge of writing this book. Particular mention is also owed to David Coulson, who graciously permitted use of his splendid photographs of African rock art; Neville Agnew, principal project specialist at the GCI, who first asked the author to write the book and encouraged the project throughout its duration; Kristin Kelly, head of public programs and communications at the GCI, who saw the project through to completion; Guy Bennett, who translated the manuscript from French; and, at Getty Publications, Tevvy Ball, who developed the manuscript and oversaw editorial work; Jim Drobka, who designed the volume; and Anita Keys, who coordinated its production.

Timothy P. Whalen
Director
The Getty Conservation Institute

A book of this scope would not have been possible to write without the assistance of people throughout the world. First of all, I would like to warmly thank all the photographers whose work appears in these pages. I would like to thank R. Querejazy Lewis, for kindly providing the photograph of the Pultuma shelter, in Bolivia; N. Cole, for her advice; the Ang-Narra Aboriginal Corporation, for its gracious permission to publish images of the Laura region of Australia; Alain Briot, for his fine photographs of rock art of the American Southwest; David Lewis-Williams, for invaluable guidance in the interpretation of the rock art of the Drakensberg, in South Africa; David Coulson and Alec Campbell, thanks to whom I came to know the Aïr petroglyphs, in Niger; A. Prous, who took me to the painted shelters of Rio Peruaçu, in Brazil; P. Trezise, I. Davidson, G. Chaloupka, and D. Welch, who guided me in various parts of the Australian bush; D. Rolandi, M. Podesta, and M. Onetto, who made it possible for me to visit Cueva de las Manos and other sites in Argentinian Patagonia; A. Schouten, who took me down the steep canyons of Baja California Sur, Mexico; the late Li Wenji, who invited me to see the petroglyphs of the Helan Shan range, in China; J. Keyser, L. Loendorf, and D. Whitley, with whom I visited so many sites in the United States; and all the other colleagues who enabled me to see the rock art of their countries and regions, both in Europe and elsewhere throughout the world. Finally, I would like to thank those at the Getty who contributed to making this book, on so vast a topic, a reality—in particular Neville Agnew and Tevvy Ball. To all I express my heartfelt thanks.

Jean Clottes